Undressing the Ad

Studies in the Postmodern Theory of Education

Joe L. Kincheloe and Shirley R. Steinberg
General Editors

Vol. 54

PETER LANG
New York • Washington, D.C./Baltimore • Boston
Bern • Frankfurt am Main • Berlin • Vienna • Paris

Undressing the Ad

Reading Culture in Advertising

Edited by
Katherine Toland Frith

PETER LANG
New York • Washington, D.C./Baltimore • Boston
Bern • Frankfurt am Main • Berlin • Vienna • Paris

Library of Congress Cataloging-in-Publication Data

Undressing the ad: reading culture in advertising /
[edited by] Katherine Toland Frith.
p. cm. — (Counterpoints; 54)
Includes bibliographical references.
1. Advertising. I. Frith, Katherine Toland. II. Series: Counterpoints
(New York, N.Y.); vol. 54.
HF5821.U53 659.1'042—dc21 97-8541
ISBN 0-8204-3755-7
ISSN 1058-1634

Die Deutsche Bibliothek-CIP-Einheitsaufnahme

Undressing the ad: reading culture in advertising / Katherine Toland Frith, ed.
–New York; Washington, D.C./Baltimore; Boston; Bern;
Frankfurt am Main; Berlin; Vienna; Paris: Lang.
(Counterpoints; 54)
ISBN 0-8204-3755-7

Cover design by Andy Ruggirello.

The paper in this book meets the guidelines for permanence and durability
of the Committee on Production Guidelines for Book Longevity
of the Council of Library Resources.

Printed in the United States of America.

For Marjory Canavan Toland

Contents

viii

Notes on Contributors

Katherine T. Frith is an associate professor in the College of Communications, Pennsylvania State University, University Park. She has been Chair of the advertising major for five years. Her work has appeared in *Journalism Quarterly, Current Issues and Research in Advertising,* and *Media Asia.* She is the editor of *Advertising in Asia: Communication Culture and Consumption* (Iowa State University Press, 1996).

Linda K. Fuller is an associate professor in the communications department at Worcester State College in Massachusetts. Responsible for more than.150 professional publications and conference reports, she is the author or co-editor of more than a dozen books, including *Beyond the Stars: Studies in American Popular Film* (Popular Press, 1990+), and *Community Television in the US: A Sourcebook on Public, Educational and Governmental Access* (Greenwood, 1994). In 1996 she was a Fulbright Professor at Nanyang Technological University in Singapore.

Morris B. Holbrook is the William T. Dillard Professor of Marketing, Graduate School of Business, Columbia University, New York, where he teaches courses in communication and consumer behavior. Besides his articles in various marketing journals, his work has appeared in publications devoted to research on consumer behavior, semiotics, cultural economics, the arts, aesthetics, psychology, organizational behavior, leisure, and related topics. His most recent book is *Consumer Research: Introspective Essays on the Study of Consumption* (Sage, 1995).

Elizabeth (Elli) Pauline Lester is an associate professor in the College of Journalism, University of Georgia, Athens. Her work has appeared in *Critical Studies in Mass Communication, Journal of Communication Inquiry,* and *HowardJournal of Communication,* among others. Her research focuses on U.S. representations of international Others and how mass-media representations influence support for political and economic international relations.

Michael J. Ludwig is assistant professor of education at Winthrop University in Rock Hill, S.C. His work on drug issues has appeared in *The Review of Education/Pedagogy/ Cultural Studies* and in *The Journal of Health Education.*

Ernest M. Mayes completed his graduate studies in the College of Communication at The Pennsylvania State University in University Park where he received his M.A. in Media Studies. He is currently a student in the copywriting program at the Portfolio Center in Atlanta, Georgia.

Matthew P. McAllister is an assistant professor of communication studies at Virginia Tech University in Blacksburg. His research interests include advertising criticism, popular culture, and political economy of media. He is the author of *The Commercialization of American Culture: New Advertising, Control and Democracy* (Sage, 1996), and has published in *Journal of Communication, Journal of Popular Culture,* and *Journal of Popular Film and Television.*

Chemi Montes-Armenteros is an assistant professor of graphic design at The Pennsylvania State University in University Park. He has acted as graphic design consultant in programs developed for the Pennsylvania Department of Health. His work has appeared in publications such as *Print Magazine, How,* and several compilatory books on current design.

Daniel R. Nicholson is a Ph.D. candidate at the University of Oregon School of Journalism and Communication in Eugene. His interests currently are in the political economy of communication, critical cultural studies, and their intersections.

Barbara B. Stern is a professor of marketing at Rutgers, The State University of New Jersey, Faculty of Management, Newark, where she teaches courses in advertising and consumer behavior. She has published articles in the *Journal of Marketing, Journal of Consumer Research, Journal of Advertising, Journal of Current Research in Advertising*, and other marketing publications. She has been active in feminist research since the 1970s and is currently working on a study of gender and narrative.

Angharad N. Valdivia (Ph.D., University of Illinois, 1991) is a research assistant professor at the Institute of Communications Research at the University of Illinois. Her research interests include transnational approaches to the study of gender and culture, focusing on both Latin American and U.S. women. Her work has been published in *Chasqui, Women and Language, The Review of Education/Pedagogy/Cultural Studies*, and *The Journal of International Communications*. She is the editor of *Feminism, Multiculturalism, and the Media* (Sage, 1995) and of the Communication and Culture section of the *Global Women's Encyclopedia*.

Christian Vermehren is a Doctoral student at University of Cambridge, England. He holds an M.Sc. degree in economics and business administration from Copenhagen Business School, Denmark, and an M.A. degree in Media Studies from The Pennsylvania State University, University Park. He is currently working on a dissertation on the field of the production of British advertising.

Preface

Advertisements sanctify, signify, mythologize, and fanta-
size. They uphold some of the existing economic and
political structures and subvert others. Not only does ad-
vertising shape American culture; it shapes Americans'
images of themselves. It is only through learning to criti-
cally deconstruct the codes of advertising that we can begin
to learn the limits of these codes.

This book is designed to introduce undergraduate stu-
dents to critical scholarship on advertising in a way that
makes it accessible and builds on their own media knowl-
edge and experiences. It asks the question, what do
advertisements mean? And attempts to answer that ques-
tion by showing that ads are much more than what
advertisers promise, that is, messages aimed at selling
goods and services.

While there are any number of books that have been
published on advertising, the great majority of these defend
the values, institutions, and lifestyles of consumer capital-
ism. The readings in this book take a decidedly critical
political perspective. Rather than explaining how advertis-
ing works these readings are aimed at teaching the reader
what an advertisement means. The purpose of this book is
to empower readers to become media literate by decon-
structing the consumer culture that surrounds them.

Each of the original chapters in the book was written
with undergraduate students in mind. All of the articles
included are original works that have not appeared previ-
ously in academic journals or other books.

Series Editor Introduction

Shirley R. Steinberg
Adelphi University

No book could have been released in a more timely fashion than Frith's collection of essays on the power agendas involved in advertising. Given the discussions of the past few years involving the accusation of child pornography ala Calvin Klein to the banishment of Joe Camel from the murals and walls of buildings, we are acutely aware that advertising has increasingly defined our collective consciousness. Many arguments, therefore, revolve around not only the political and economic intentions of advertisers but the ethics and pedagogy attached to each and every advertisement. Pedagogy, in this context, involves the production and transmission of knowledge and values, and the construction of identity. These themes play out consistently in all of the books in our Counterpoints Series.

As Katherine Frith opens this collection, she demands the need to "undress" the ad, to "read" the culture of advertising. This call for a pedagogy of advertising is essential in the postmodern era, especially to children and youth. As Brazilian educator Paulo Freire (1997) called for the "reading" of the world—analyzing the texts presented within culture—Frith is calling for a deconstruction and political reading of promotional propaganda involved in the economic dynamics of the late twentieth century.

As a society, we are whirled spun by spin doctors. Our media and advertisers spend vast fortunes working to construct a consumer consciousness. By the age of three, most children throughout the world are able to recognize the

golden arches and their meaning (Kincheloe, 1997). In Southern Brazil, for example, gauchos ride along with Ronald McDonald, demanding that young children have their birthday parties at McDonald's. In Versailles, Ronald accompanies Napoleon through the streets of Paris. The corporate appropriation of history and culture legitimizes the advertising of products. Ads become an educational tool, twisted into a cultural curriculum that fits the needs and interests of each consumer.

The authors in this book call for a pedagogy of media literacy, an ability to understand and teach the hegemonic notions and corporate agendas for the public. Such a pedagogy allows us to consume as intelligent participants in our own lives. This is the nature of empowerment: we make our own decisions on what to consume and how to be entertained. Such are our rights in the mediated cosmos of hyperreality.

REFERENCES

Freire, P. (1997). In P. Freire, ed. *Mentoring the Mentor: A Critical Dialogue with Paulo Freire.* New York: Peter Lang.

Kincheloe, J. (1997). In S. Steinberg and J. Kincheloe, eds. *Kinderculture: The Corporate Construction of Childhood.* Boulder, Colorado: Westview Press.

Undressing the Ad

Reading Culture in Advertising

Chapter 1

Undressing the Ad: Reading Culture in Advertising

Katherine T. Frith

> Historians and archaeologists will one day discover that the ads of our times are the richest and most faithful daily reflections that any society ever made of its entire range of activities.
>
> Marshal McLuhan

INTRODUCTION

Most people think that there is too much advertising, that it makes us materialistic, that it perpetuates stereotypes, that it plays on our fears of not being socially acceptable, that it lies, exploits children, and generally corrupts society. While most of these criticisms are not altogether true, there is some truth to all of them.

As a society we are embedded in a culture of consumption. Neil Postman (1985) notes that by the age of forty the average American will have seen well over one million commercials and have "close to another million to go before his first social security check" (p. 126). In order to comprehend the impact of all this advertising on society we must learn how to see through advertisements, for they are not just messages about goods and services but social and cultural texts about ourselves. Solomon (1988) has pointed out:

> As long as you are unable to decode the significance of ordinary things, and as long as you take the signs of your culture at face

value, you will continue to be mastered by them. But once you see behind the surface of a sign into its hidden cultural significance, you can free yourself from that sign and perhaps find a new way of looking at the world. You will control the signs of your culture rather than having them control you. (p. 8)

In order to understand how to read advertisements critically we must begin to incorporate "popular culture as a serious object of politics and analysis" (Giroux, 1988, 164). While all culture is worthy of investigation, popular culture is often devalorized as "sub-literature or para-literature" (McCracken, 1982, 30). However, in critically reading even something as seemingly mundane as an advertisement we can begin to see "the political, social and cultural forms of subordination that create inequities among different groups as they live out their lives" (Giroux, 1988, 165). This type of critical pedagogy enables teachers and students to view aspects of popular culture within broader social, cultural, and political considerations. In the case of advertising, which has historically been linked to marketing and sales, it allows us to discover the broader social and cultural implications of these seemingly simple messages.

The benefits of critically examining the whole advertising message, not merely the surface or sales message, is that it helps to sharpen one's critical sensibilities. As McCracken (1982) points out this can "counteract the non-critical response so often conditioned by the mass media" (p. 31). The methodological tools we will be using to deconstruct ads are interdisciplinary, drawing on a variety of theoretical positions, including literary theory, feminist critique, postmodernism, Marxism, semiotic analysis, and what Cornel West (1990) terms "the new cultural politics of difference" to name just a few. In fact, demystification of any aspect of mass culture "is most successful when several methodologies are jointly employed" (McCracken, 1982, 31).

UNDRESSING THE AD

The conventional way that marketers define advertising is to describe it as messages that "impart information about products which consumers use to make brand choices" (Domzal and Kernan, 1992). The limitation of this definition is that it falls short of giving us the whole picture. Advertising does much more than impart product information, it tells us what products signify and mean. It does this by marrying aspects of the product to aspects of the culture. Embedded in advertising's messages about goods and services are the cultural roles and cultural values that define our everyday life (Stern, 1992). The products we consume express who we are, they are cultural signifiers. The type of watch we wear, the brand of athletic shoes, or the kind of car we drive tell others a lot about us. Advertising not only tells us about the products we consume it also tells us what those products signify in our culture:

> People 'read' advertising as a cultural text, and advertisers who understand this meaning-based model can create more powerful and intriguing campaigns. (Domzal and Kernan, 1992, 49)

One way to begin to understand "how" an advertisement means (Stern, 1988) is to learn how to deconstruct them. Deconstruction, a critical theory of European origin (Saussure, 1966; Barthes, 1972; Levi-Strauss, 1970; Foucault, 1970; Lacan, 1968), is the reigning school of literary theory. Its proponents find the real significance of texts not in their explicit meaning, nor even in their implied meaning but in their unintentional meanings, or as one author states, "in the slips, evasions and false analogies that betray the text's ideology" (McConnell, 1990, 100). In essence, deconstruction is a way of reading against the text, or as John Fiske (1989) and Stuart Hall (1974) would say, taking an "oppositional" reading. The aim of deconstruction is to expose the social and political power structures in society that combine to produce the text.

By analyzing both the foreground and background of the advertisement-as-text it is possible to reveal the secondary social or cultural messages in which the primary sales

message is embedded. Leymore (1975) explains this holistic
view of advertisements in this way:

> Now if the product is the mental representation conjured up by
> the advertisement and supported by the story and the pictures,
> then the background, which includes users in their various set-
> tings, color, accessories, layout and so on is the signifier. In
> other words, the advertised product is the signified to which the
> background acts as a signifier; together they both form a sign.
> Thus, both are essential and as they are a unity there is no
> sense in asking which is more important or necessary than the
> other. (p. 37)

This means that, in fact, the background of the adver-
tisement is as important as the foreground because it cre-
ates the context without which there can be no meaning.
Analyzing the cultural content of an advertisement involves
interpreting both verbal and visual aspects of the advertis-
ing text to determine not only the primary sales message
but also additional secondary social or cultural messages.
Advertisements reflect society, in a sometimes slightly dis-
torted way (Pollay, 1986), and by undressing or demystify-
ing ads we can begin to see the role advertising plays in the
creation of culture.

ANALYZING LEVELS OF MEANING
The most useful technique for critically deconstructing
both the surface and the deeper social and cultural mean-
ing of advertisements is a form of textual analysis (Dyer,
1982). This type of analysis is based on literary and artistic
methods of critique. To begin, the textual analyst must de-
vise a system of classification for understanding the
meaning in a given text. Since print advertising is easiest to
analyze in a book, we will start with some magazine adver-
tisements. There are at least three ways in which any text,
including an advertising text, can be approached (Scholes,
1985). First, one can read within the text "identifying the
cultural codes that structure an author's work" (Giroux,
1988, 167). The second stage is retelling the story, which
involves elaboration of the story in the text. The final stage
is to "explode" the text, or what Stuart Hall (1974) calls

reading against the text. In this last stage, Scholes (1985) encourages readers to free themselves from the text by "finding a position outside the assumptions upon which the text is based" (p. 62). These three stages of reading an ad can be described as learning how to read the surface meaning, the advertiser's intended meaning, and finally, the ideological meaning.

1. *The surface meaning* consists of the overall impression that a reader might get from quickly studying the advertisement. Research has shown us that most magazine readers spend about 3.2 seconds on an ad. You can describe this surface level of meaning by simply listing all the objects and people in the ad.

2. *The advertiser's intended meaning* is the sales message that the advertiser is trying to get across. Some marketers might refer to this as the strategy behind the ad. It is the "preferred" (Hall, 1974) or expected meaning that a reader might get from the ad; the meaning that the advertiser intends for the reader to take with them. The sales message may be directly about goods and services, but it might also be about lifestyles. Advertisers often try to associate products with certain types of lifestyles, cigarette advertising is a good example of this.

3. *The cultural or ideological meaning* relies on the cultural knowledge and background of the reader. We all "make sense" of ads by relating them to our culture and to the shared belief systems held in common by most people. For example, most Americans deeply believe in the power of democracy, free speech, and rugged individualism. These beliefs are ideological in nature. They appear to be "common sense" beliefs because they are widely held in this culture at this moment in history; nonetheless, they are not universal beliefs (Fiske, 1982).

In addition to the more obvious cultural beliefs, there are also more subtle ideological values expressed in ads. Stereotyping, for example, is based on cultural beliefs. As

William O'Barr (1994) has noted, before the civil rights movement of the 1960s, blacks were only featured in advertisements in subservient roles such as porters, cooks, and bellhops. Stereotyping can appear to be "common sense" until these representations are questioned by a large enough group of people.

Most sales messages are built upon shared cultural or ideological beliefs, and advertising copywriters and art directors rely upon these shared belief systems when they create ads (Leiss et al., 1990). In order to really begin to see how advertising works to support and reinforce certain ideological beliefs it is important to deconstruct the deeper meanings of ads and learn how to take apart the cultural or ideological messages (Williamson, 1978).

As we begin to analyze ads, you may find yourself disagreeing with some of our interpretations of these ads. This is because *not everyone holds the same beliefs*. However, in learning how others deconstruct advertising messages we can begin to realize that advertising only "makes sense" when it resonates with certain deeply held belief systems.

To deconstruct an ad we must take it apart layer by layer, like peeling an onion. As we move from the surface message to deeper social messages we will see how this system of meaning works. As an example, let's take a look at this seemingly simple ad for Clorox Bleach depicted in Figure 1.1. Remember as you read this analysis that it is not the only possible interpretation of this ad. Different people read texts in different ways, however, the purpose of this reading is to show how advertisements construct meaning by referring to cultural myths and ideologies.

The Surface Meaning. We might describe the surface level of meaning in this ad by listing all the objects and people in the ad. For example, the picture contains seven boys who are sitting together on what may be a king-size bed with their feet up and their shoes off. There are five white boys, one black, and one Asian. One boy near the center has a big grin on his face, he also is the only one who has slightly discolored socks. All the other boys have

"whiter than white" clean socks. There is also a bottle of Clorox Bleach in the lower left-hand corner of the ad and a headline runs below the boys' feet that reads: "Guess who forgot the Clorox." The subhead says: "If you want your family to wear their whitest whites... Don't forget the Clorox Bleach."

The Advertiser's Intended Meaning (the sales message). In this case, the advertiser is trying to point out that if "you" (the ad ran in *Woman's Day,* so we can assume that the "you" being referred to is a female reader) want your kids to look clean and well cared for, you should wash their white clothes with Clorox Bleach.

The Cultural or Ideological Meaning. The underlying assumption in this ad is that laundry is woman's work. That is why this ad ran in *Woman's Day* and not in *Gentlemen's Quarterly.* Even though the majority of women in the United States now work full time, they are still regarded by advertisers as the people who do the laundry in most American households. In addition, the ad's headline is playing on a woman's feelings of guilt at being a less-than-perfect housewife and mother.

The implication in this ad is that all the *other* mothers somehow managed to get their boys' socks bright and clean, but you, the female reader, know that your kid often goes out, maybe even goes to overnight parties, with discolored socks (perhaps, the picture of boys on a bed in this ad is supposed to represent a group of boys at a sleepover party). The ad is saying, shame on you, mom.

We might also note the fact that white is the privileged color in this ad. The boys are sitting on a white king-size bed, leaning on snowy white pillows, one boy is eating white popcorn. Most of the boys are white and most of the socks are white. White is endowed in this culture with good connotations. It means cleanliness and health, while dark colors connote death and evil. This is actually a cultural belief rather than a universally held truth. For example, in China white connotes death! While white is definitely the dominant color in this ad, the boy with discolored socks

8

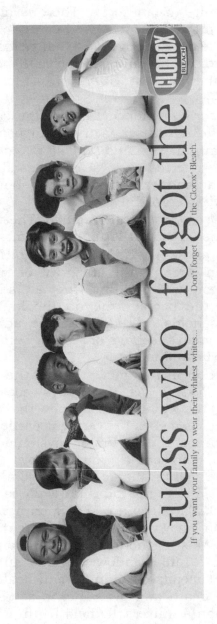

Figure 1.1

doesn't seem too concerned. In fact, the group of boys seem to be happy together and unaware of racial or color differences. But the copy is aimed at the mom. It is the mothers, the older generation, who are more deeply embedded in the cultural belief system, it is they who might see darker colors (including darker colored socks) as a negative.

ANALYZING SOCIAL RELATIONSHIPS
A second method of analyzing the ideology or cultural beliefs in ads is to look at the relationships being depicted between the people featured in the advertising. In his book, *Culture and the Ad: Exploring Otherness in the World of Advertising,* William O'Barr (1994) explains that all advertisements contain ideology. He defines ideology as "ideas that buttress and support a particular distribution of power in society" (p. 2) and notes that ideology is, by nature, always political. Because we are so deeply embedded in our own set of cultural beliefs, it is often difficult for us to see the ideas that buttress and support the social system we live within. Wernick (1991) says that ideology is elided or hidden. In order to undress the ideological messages in advertising, we must ask questions about the roles people play in our society. Who is in charge? Who holds the power? Who is weak? Who is dominant and who is subordinate (O'Barr, 1994)? These types of questions allow us to begin to see the deeper social structures that are circulated and recirculated in advertising. Feminist scholars, for example, are able to expose hidden masculinist assumptions in advertising by using a method of sex-role reversal (Stern, 1992). This is done by asking yourself, can you exchange the man for the woman in the ad? Would the story still make sense, or would it seem ridiculous?

You can begin to analyze the social relationships or power relationships in an ad by describing *the story* that is being depicted. Describe the characters in the ad, the props, the color scheme (Dyer, 1982). Explain what the props or symbols signify and how they might support certain hierarchical relationships.

You can determine the social relationships in the ad by asking questions about power and control. Who appears to have the power or control in the story? How is power expressed? Does one person have *power over* another? We can ascertain the power positions by determining who appears to be stronger, or bigger, or more in control of the situation. For example, if it is an advertisement for a car, who is driving and who is the passenger? If it is an advertisement for a breakfast cereal, who is cooking and serving and who is being served (O'Barr, 1994)?

We can also ascertain historically based power relationships by asking ourselves, are certain historically favored positions being expressed? Does the ad suggest that people who are slimmer, whiter, stronger, or richer have power over others?

The second way to analyze how power is being depicted in the ad is to describe the relationships between the characters *by exchanging the key players in the ad*. For example, you might begin by reversing the roles of the people in the ads. Substitute the woman with a man, a young person with an older person, or a white person with a black. Now retell the story with the roles reversed. Would the message be the same? How would the message change? What does this say about the roles or stereotypes that advertising perpetuates?

This type of analysis reveals the deeper social structures that often go unnoticed in advertising. As Barbara Stern (1992) explains:

> The method's rationale is that exposure of cultural mores depends on a researcher's ability to engage in self-conscious introspection, for only by viewing what appears 'normal' from an outsider's perspective—that of the 'other'—can common assumptions about natural behavior be exposed as merely partial worldviews. (p. 12)

O'Barr (1994) points out that asking these types of questions enables us to discover important facts about social relationships in our society. He points out that while equality is not precluded as a possible message in the discourse of advertising, advertisements are "seldom egalitar-

ian" (p. 4). The most frequently depicted qualities of social relationships in advertising are: hierarchy, dominance, and subordination (O'Barr, 1994). Now let us look at how power is expressed in this seemingly straightforward ad for Toshiba computers shown in Figure 1.2.

The Story. This ad depicts the commonly accepted story of evolution, showing an ape evolving into a Neanderthal who evolves into a "modern man" (in this case wearing a suit and carrying a Toshiba computer). Now let us, for a moment, reverse the roles in this story. Let us depict evolution as beginning with a female ape and culminating with a fully evolved human woman. Does this picture feel right? Or have we become so used to seeing evolution culminate with a man, that using a woman would seem odd? What about replacing the white man wearing a suit and carrying a computer with a black man or a black woman? Could the culmination of the evolutionary process really be a black man?

As Cornel West (1990) points out, demystification is the most desirable form of cultural practice. He asserts that demystification is the intellectual challenge of modern day cultural workers, students, and scholars interested in exposing the ideological undercurrents of society. Myths are preexisting, value-laden sets of ideas derived from a culture and transmitted through various forms of communication. Demystification is to seek the connotative meaning embedded in such myths and to historicize them or expose them. Does this ad reinforce the myth that the white man is the ultimate culmination of evolution?

The Relationships. The second way to look at the cultural messages in this ad is to look for the power relationships. O'Barr (1994) says that ads are seldom egalitarian and that the social relationships most frequently depicted in advertising are: hierarchy, dominance, and subordination. Are there any social relationships in this Toshiba ad? Certainly, the man appears to have dominance over the "lower" life forms, the apes and the Neanderthal. In her book, *The Sexual Politics of Meat: A Feminist-Vegetarian*

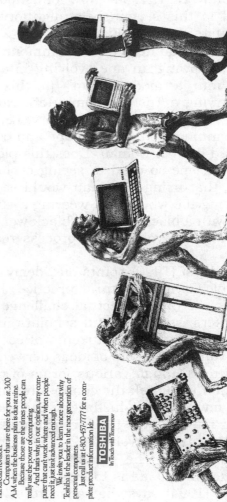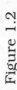

Figure 1.2

Critical Theory, Carol Adams (1991) asserts that in patri-
archal cultures a hierarchy exists in which men are at the
top and women and animals are similarly positioned as
inferior. In this ad, the man wearing the suit is positioned
as superior to the animals.

What gives this man his dominance or superiority? The
symbols used here are his clothing and his computer. The
assumption in this visual is that man is superior to ani-
mals because he has developed socially (clothes) and tech-
nologically (tools). While technology has undoubtedly
solved many human problems, it is not without shortcom-
ings. Some critics (Shiva, 1989; Sheldrake, 1991; Collard
and Contrucci, 1989) argue that it is technological devel-
opment that threatens the ecological balance on the planet
and that is most destructive to the future evolution of the
human race. Nonetheless, the symbol of technology, the
computer, is depicted as representing the culmination of
human evolution and it signifies man's dominance over
animals. Clearly, in this ad for Toshiba computers we can
discern messages related to hierarchy, subordination and
dominance.

In terms of social relationships, the old adage, "the
clothes make the man" might apply here. Social class, as
we know it in the United States, is often described in terms
of clothing—there are the "white"-collar (again that privi-
leged word) workers who wear suits and the blue-collar
workers who might be considered working or lower class.
Just as more elaborate ways of dress connote social domi-
nance in this ad, they also signify social class in our cul-
ture. The man in the suit represents the dominant white
upper class.

CONCLUSIONS
Advertising manipulates symbols to create meaning and in
our society, the values expressed in advertising mirror the
dominant ideological themes. In this chapter we have
traced a few of the methods that can be used to examine
how these themes are expressed in advertising. The argu-
ment here is not so much that advertising creates inequi-

ties in society but that by circulating and recirculating
certain myths advertising shapes our attitudes and beliefs,
and that by learning how to critically deconstruct adver-
tisements we can begin to move away from the role of
spectator to become participants in the making and remak-
ing of ourselves and of a more democratic society (West,
1990).

REFERENCES

Adams, Carol J. (1991). *The Sexual Politics of Meat: A Feminist-Vegetarian Critical Theory.* New York: Continuum.

Barthes, Roland (1972). *Mythologie.* New York: Hill and Wang.

Collard, Andree, and Joyce Contrucci (1989). *The Rape of the Wild: Man's Violence against Animals and the Earth.* Bloomington, IN: Indiana University Press.

Domzal, Teresa J., and Jerome B. Kernan (1992). "Reading Advertising: The What and How of Product Meaning," *Journal of Consumer Marketing,* Vol. 9, No. 3, pp. 48-64.

Dyer, Gillian (1982). *Advertising as Communication,* London: Methuen.

Fiske, John (1982). *Introduction to Communication Studies.* London: Methuen.

Fiske, John (1989). *Reading the Popular.* Boston: Unwin Hyman.

Foucault, Michel (1970). *The Order of Things.* London: Tavistock.

Giroux, Henry (1988). "Border Pedagogy in the Age of Postmodernism," *Journal of Education,* Vol. 170, No. 3, pp. 162-181.

Hall, Stuart (1974). "Encoding and Decoding," *Education and Culture,* Summer, Birmingham, England: Centre for Cultural Studies.

Lacan, Jacques (1968). *The Language of Self.* New York: Basic Books.

Leiss, William, Stephen Klein, and Sut Jhally (1990). *Social Communication in Advertising: Persons, Products and Images of Well-Being,* New York: Routledge.

Levi-Strauss, Claude (1970). *The Raw and the Cooked.* London: Jonathan Cape.

Leymore, Varda (1975). *Hidden Myths: Structure and Symbolism in Advertising.* London: Heinemann.

McConnell, Frank D. (1990). "Will Deconstruction be the Death of Literature?" *The Wilson Quarterly,* No.4.

McCracken, Ellen (1982). "Demystifying *Cosmopolitan:* Five Critical Methods," *Journal of Popular Culture,* Vol. 16, No. 2, pp. 30-42.

McLuhan, Marshal (1964). *Understanding Media.* New York: McGraw-Hill p. 14.

O'Barr, William (1994). *Culture and the Ad: Exploring Otherness in the World of Advertising.* Boulder, CO: Westview Press.

Pollay, Richard (1986). "The Distorted Mirror: Reflections on the Unintended Consequences of Advertising," *Journal of Marketing,* Vol. 50, No. 4, pp. 18-36.

Postman, Neil (1985). *Amusing Ourselves to Death: Public Discourse in the Age of Show Business.* New York: Penguin Books.

Saussure, Ferdinand de (1966). *Course in General Linguistics* (Translated by Wade Baskin). New York: McGraw-Hill.

Scholes, Robert (1985). *Textual Power.* New Haven, CT: Yale University Press.

Sheldrake, Rupert (1991). *The Rebirth of Nature: The Greening of Science and God.* New York: Bantam Books.

Shiva, Vandana (1989). *Staying Alive: Women, Ecology and Development.* London: Zed Books.

Solomon, Jack (1988). *The Signs of Our Times.* Los Angeles: CA: Jeremy Tarcher.

Stern, Barbara (1988). "How Does and An Ad Mean: Language in Services Advertising," *Journal of Advertising,* Vol.17, pp. 3-14.

Stern, Barbara (1992). "Feminist Literary Theory and Advertising Research: A New 'Reading' of the Text and the Consumer," *Journal of Current Issues and Research in Advertising,* Vol. 14, No 1, pp. 9-21.

Wernick, Andrew (1991). *Promotional Culture: Advertising, Ideology and Symbolic Expression.* Newbury Park, CA: Sage.

West, Cornel (1990). "The New Cultural Politics of Difference," in *Out There: Marginalization and Contemporary*

Cultures, eds. Russell Ferguson et al., Cambridge, MA: The MIT Press.

Williamson, Judith (1978). *Decoding Advertisements: Ideology and Meaning in Advertising.* London: Marion Boyers.

Chapter 2

Finding the Path to Signification: Undressing a Nissan Pathfinder Direct Mail Package

Elizabeth Pauline Lester

INTRODUCTION

Let's begin with two questions: First, why would we want to "undress" a Nissan Pathfinder direct mail package? In fact, the Pathfinder campaign is a model of "good" advertising, meaning that it targets a specific audience with a clear, well-unified message (emphasizing a benefit with reference to specific features) in a tone that displays the product to great advantage. The campaign uses a variety of media—television, print, and direct mail—to move prospective buyers into a showroom where a salesperson, further supported by advertising and promotions, could complete a sale. The individual messages are upbeat, positive, intelligent, and entertaining, appealing to the audience's sense of exclusivity and adventure. But we are about to subject this "text" to serious analysis, linking it with "the political, social and cultural forms of subordination...." (Giroux, 1988, 165).

Second, where do we acquire learning and knowledge? Or, what counts as knowledge of, for example, world history or civics, sociology or culture? And of course what does this have to do with advertising and media studies? The interactions between our daily lives (i.e., political-economic social formations) and cultural products (such as advertisements) have been investigated for the last thirty

years with increased attention to mass media genres such as television programs, films, print journalism, popular magazines, and advertising. Increasingly it has been noted that popular culture is an entry point into social education, that as a people we begin to learn early and well from mass media.[1] Even before they can read, children are familiar with the concepts of brand, consumerism, and choice in the marketplace.

It has also been noted that groups within larger societies react to and with popular culture to establish their own distinct identities within industrial and postmodern society, extrapolating "unintended" messages from mass media (Hebdige, 1979; Fiske, 1989). Elsewhere I have discussed that even the more privileged forms of popular media such as elite newspapers and print news for children, borrow techniques from film, television, and advertising to make news palatable (Lester, 1992; Lester, 1996). Popular or mass culture and elite culture are, at this point in the twentieth century, often intertwined and sometimes indistinguishable, with intertextual reminders within both mass and elite genres that our cultural milieu does not respect disciplinary boundaries. The pressures of the marketplace and global capitalism specifically have led to increasing centralization and arguably increasing homogenization of cultural forms. Therefore, advertising as much as the novel or other "important" cultural forms does deserve the critical attention of scholars and citizens. But it is also essential, both as advertisers and as citizens, to understand and to trace to their origins the roots of our "common-sense" knowledge of the world, to question not only what is taught in traditional classrooms, but to question where and how (and in the interest of whom) learning takes place.

The notion of "undressing" an ad leads us to consider that the best advertising may tell us not only something about a product but also about ourselves. The best advertising appears seamless because the ads themselves make

[1] For a discussion of the development of the concept "popular" see *Keywords: A Vocabulary of Culture and Society* by Raymond Williams (Oxford, 1976).

sense, both separately (i.e, the 30 second TV ad; the full-page magazine ad; the direct mail package) and as a whole campaign. In undressing an ad we must pierce the complete whole to break the ad up, not into the component parts of an ad campaign, but into categories of discourse.[2]

CHOOSING THE "TEXT"
When Roland Barthes published *Mythologies* (1973) he broke through the conventions of analysis of culture in a number of ways: he chose popular culture artifacts, treating them seriously as "texts" to be analyzed; he utilized the methods of semiotics, the science of signs, formerly a linguistic technique; and through active political engagement he linked his intellectual work with his daily (political, economic, social, and cultural) life. Barthes took ordinary objects in French life such as wine, the cover of a news magazine, a brand of beer or soap powder, a wrestling match, and showed how they both reflected and helped construct a national (as well as racial, gendered, and class) sense of identity and community. The use of the word "text" suggests that the object of analysis is conferred with significance that places it at the heart of the message creation; but a text, more complicated than a single message, is problematized by codes of meaning on the one hand and social experiences on the other. Texts are the building blocks of discourse and discourse operationalizes "common sense."

Barthes used semiotics to reveal the structural relationships within sign systems and how those relationships generate meanings; thus he was able to show how our common sense understandings are constructed by discourses such as race, nationality, class, or gender.

Since *Mythologies* much work has been done in analyzing our own social "myths," including some work on advertising. For example, Judith Williamson's (1978) *Decoding*

[2] For a discussion of the concept of "discourse" see *Key Concepts in Communication and Cultural Studies* edited by Tim O'Sullivan et al. (Routledge, 1994).

Advertisements analyzes ads showing how they complete their meanings both internally (i.e., with reference to the signs within ads) and externally (i.e., with reference to wider systems of belief). William O'Barr (1994), also influenced by semiotics, explores otherness in the world of advertising by examining a variety of ads and audience responses. He organizes his analysis into three categories: idealized images, social relationships, and inequality and power. Sut Jhally (1988), in an introduction to a series of articles that "deconstruct" both advertising texts and the advertising industry, says that "[t]he marketplace (and its major ideological tool, advertising) is the major structuring institution in contemporary consumer society" (p. 78).[3] He notes:

> Advertising does not work by creating values and attitudes out of nothing. Advertising doesn't always mirror how people are acting but how they're *dreaming*. Advertising absorbs and fuses a variety of symbolic practices and discourses, it appropriates and distills from an unbounded range of cultural references. p. 80)

But we often remain critically unaware of the relationship between seemingly innocuous media formats such as advertising and the larger global political-economy of which we are all part. It is even unclear to many as to why we should be concerned, since phrases like "global political-economy" seem themselves to be mystifications.

Furthermore, as students of media we may feel immune to its effects; we often feel jaded toward the impact of media's texts and images. As we know, few people pay much attention to ads, most commonly spending only a matter of seconds with a less than attentive attitude. We also acknowledge that responses to advertising can vary from interest or entertainment, to incredulity, irony, or ridicule, to

[3] The book in which Jhally's essay appears, *Gender, Race and Class in Media*, edited by Gail Dines and Jean M. Humez (Sage, 1995) contains 11 essays which deal specifically with advertising, as well as sections on television, music videos and rap music, romance novels and slasher films, and pornography.

complete non-attention or even active *non-attention* (e.g., using the remote to change television channels). And yet, culture is not only read in ads, but the ongoing work of cultural construction takes place there as it does in more "serious" media forms, such as textbooks and museums, and in other institutions, such as schools and churches; cultural construction suggests a thick and sticky web of meaning that defines how we perceive, think about, speak about, and act in reality. And media along with other social institutions and practices contribute to how we are able to perceive the world.

A media specialist, then, would constantly, though not always consciously, refer to cultural myths when designing effective messages, including ads, and in so doing help cement into place a status quo version of reality. Stuart Ewen (1976) contends that advertising is linked to the world of "real" power through an antithetical relationship: advertising, in celebrating style and co-opting real moments of resistance, directs attention away from the substance of our own interests.

Using Frith's (1997) levels of meaning, we will analyze a particularly rich text, a piece of direct mail advertising for the Nissan Pathfinder, a video, and the accompanying print collateral materials that were obtained only by having already responded to first-tier print (magazine) advertising. We will move from surface meaning to preferred or intended (advertiser's) meaning to cultural (or ideological) meaning. Then we will link that cultural meaning to long–standing political–economic relations which have and continue to structure grave inequalities in access to political, economic, and natural resources. It is that final step that gives this kind of analysis its importance since it shows how essentially throw away cultural forms can contribute to an incomplete understanding of the effects of real relations of experience. The plethora of "unimportant" cultural forms add up to a formidable wall of meaning that reflects the interests of the powerful at the expense of those on the periphery of power.

TWO LEVELS OF MEANING

The surface meaning of this text is described by examining it from the outside in. As a piece of advertising, it has the advantage of relying on several different media to heighten audience awareness and participation, thereby increasing effectiveness.

The Nissan Pathfinder is a sport utility vehicle which has been promoted through a print and television "safari" campaign. Both print and television advertising highlight an African safari theme to promote features such as rugged durability complemented by an equally high level of comfort and luxury. Print advertising invites response: call a toll–free telephone number and receive further information including a video.

Campaign consistency is maintained in our text, the mailing, by several design characteristics. The outside of the package is a canvas and "leather" pouch, with the address inserted into a leatherbound see-through nametag. The top of the pouch unzips to reveal the promised video, a personally addressed letter, a four-color brochure, and a "field assignment: test drive the all new 1996 Nissan Pathfinder" (unattributed quotes refer to the Nissan Pathfinder direct mail package). The letter is printed on paper that has the rougher appearance of handmade or recycled paper; the letterhead is a dark olive-green type, also suggesting the khaki favored by explorers and the military. It begins with puffery: "Thank you for requesting..." and concludes with a call to action "Right now is a great time for you to take the all new Nissan Pathfinder on an adventure of your own..."

The brochure is overlaid by tracing paper, on which is inked an outline of a rhino (Figure 2.1), but through which the Pathfinder product is visible. Words on the overlay ostensibly describe the rhino ("rugged disposition" or "sure footed") but clearly refer to the car. The brochure's theme is announced on the first color page and is clearly visible though the overlay: "The Lure of Adventure" and that theme is maintained throughout, including through the last words on the page where the exterior colors are named:

Rugged Disposition

Solid Body

Highly Territorial

Powerful Stance

Sure Footed

Figure 2.1

Mediterranean Blue, Rain Forest Green, Pearl, and Sahara Beige.

The *field assignment* is a folded paper with African motif print design (olive green with brown contrast) on the left-hand side, and with a further offer on the inside. The 10-minute video is in a sleeve that also looks rough (not the more common slick video cover) and again the dark olive-green print is on the identifying labels.

The video is produced as if it were a "mini-film" with a title screen, full production, and followed by credits, which include some information such as "no animals were harmed in this filming." In sum, this is a superlative example of a direct mailing: one that maintains campaign consistency, provides information in an entertaining way, uses a personalized letter, makes another offer to further involve the recipient, and provides something useful and lasting (the canvas pouch imprinted with the word Pathfinder) that will always remind the recipient of the product.

This description of our text provides a sense of the surface meaning of the ad. The secondary sense also is revealed: to link this product's benefits with the values and lifestyles of the target audience. But how does an African safari setting help do that? What does Africa mean?

Thus, we come to questions that engage our third level of analysis: why place this vehicle in unfamiliar surroundings? Juxtaposition helps fix this product clearly in its proper place, that is, civilization. Africa is a prime signifier of the wild, the uncivilized, and this advertising campaign capitalizes on that by evoking images of the actual "wild" (i.e., nature as exemplified by wide-open terrain and animals indigenous to the region) and the wildly exotic peoples (i.e., cultures that differ from "ours").

Contrast and juxtaposition, metaphor and simile, and analogy are all literary techniques that creatives in advertising learn how to exploit to make their work entertaining, informative, and meaningful for their defined target audience. These techniques, along with a strong theme and consistent tone, help communicate the benefits and features of the product effectively. But a semiotic analysis

suggests that something more is happening within ads. Specific signs suggest discursive strategies that we participate in to help us make sense, not only of the ads, but of our world. This engages the third level of meaning.

RACE AND CLASS, GENDER AND SEXUALITY
Clearly we must already have some concept of civilized and wild, one that we share with the text to make the text intelligible. The target audience is not one of safari-going adventurers, nor of Africans who might live in one of the many locations shown in the video, but Americans who want to drive a sport utility vehicle and have the means to buy one. Since we already have come to a point in the discussion where we've used the word "our," we must now confront how this advertising defines "us."

It is not enough to assume that as a national advertising campaign this ad includes all Americans or even all Americans whose income could support this purchase (an already considerably smaller group). Nor is it particularly enlightening to think only in terms of the advertiser's intended demographics and psychographics, although those provide a starting point for analysis. Demographically the audience is educated, married couples with combined incomes of over $75,000 their psychographics might be the equivalent of the value and lifestyle (VALS) category Actualizers (full nest III).[4]

But what else defines "us"? The ad suggests race in a particularly pernicious way: the wildly exotic people featured in the video are black Africans. "We" are not black, nor are "we" African; black Africans are objectified by being idealized as authentic tribesmen. From the point of view of this advertising, all Africans are black and black is portrayed as "other" than the "norm." Thus although we know that Africa is a multiracial continent, we are positioned against an exotic other—beautiful, evocative with bright

[4] For a brief discussion of advertising research, particularly consumer research, see *Kleppner's Advertising Research*, 11th ed. by J. Thomas Russell, et al. (Prentice Hall, 1990).

clothing, gorgeous jewelry, and handcrafted implements—and definitely not "civilized." This is an example of the incomplete understanding of real relations of experience.

One of the experiences within the video shows the protagonists, two American travelers (a man and a woman), encountering a group of Masai tribesmen in Tanzania; there is an exchange of gifts and greetings. The encounter takes place in the Ngorogoro Crater, referred to by the male protagonist as "the eighth wonder of the world—believed to be the fatal Garden of Eden ... the descent into the crater was far from Paradise" (steering remained precise and controlled, however). According to the narrator, it took over an hour to cross the crater and the viewer watches about 1.5 minutes of videoed rough terrain replete with leopards and elephants, zebras, and giraffes. It is the woman who notes when a Masai village appears near at hand (the male voice has been describing the rough terrain and the vehicle's advantages). The woman notes, "The Masai have their own idea of luxury ..." while the video shows Masai handling the car, stroking it, poking through the sun roof and being "fascinated" by the automatic windows. The male voice finally comments, "We were equally impressed with their craftsmanship and exchanged goods as a gesture of friendship" (he hands over a mass-produced pocket knife; the Masai offer hand-tooled spears).

The protagonists on safari are white and the man speaks with a British-English accent, which endows him with the authority that Americans tend to assign the English as well as suggesting his roots in the nineteenth century colonial enterprise. The woman, his companion, speaks with an identifiably American-English voice; she is denoted as secondary by her voice—responding to the first words which are spoken by the male, and driving only when the couple "returns" to civilization. The man and woman, although not romantic in terms of their actions (since most of the action of the video involves driving the car), evoke the notion of couple rather than, for example, colleagues; this is a heterosexual demographic. The text

closes off the possibility of other sorts of relationships be-
tween men and women.

The accents of the actors are suggestive of the coalition
of forces brought to bear in Africa from the 1890s onwards.
British colonialism was a central political–economic system
within sub-Saharan Africa; since the 1960s the World Bank
and International Monetary Fund has dictated policy within
many "independent" countries. Why are these white people
"here?" The video suggests that it is natural and that the
adventuresome explorers are both knowledgeable and fa-
miliar with African terrain.

The reference to the Garden of Eden positions our pro-
tagonists as informed historically by Western, specifically
Judeo-Christian traditions, and geographically by investing
mythology with location. The Garden was "fatal," therefore
a flawed Paradise. The reference also suggests the story of
the Fall commonly attributed to Eve's temptation of
Adam—woman leading man into temptation, man, who
without woman might still exist in a state of grace. The
product, in comparison, is dependable.

COLONIALISM AND NEOCOLONIALISTS

Europe's colonial past may be far removed from Americans'
daily consciousness and the "scramble for Africa" simply a
phrase from eleventh grade world history. Yet, historical
knowledge of the colonization of the African continent is
central to the workings of this ad campaign. Colonialism as
a political–economic system dominated Africa until the
1960s, a period well within the lifetime and even memory of
our "target audience." It has more recently been romanti-
cized in films like Out of Africa (starring Meryl Streep and
Robert Redford) and The Lion King, the Disney cartoon
blockbuster. Elsewhere I have described how the Banana
Republic mail order catalog also turned what is a dreadful
history of ruthless conquest into a theme for selling prod-
ucts such as T-shirts, women's jewelry, and clothing
(Lester, 1992).

The Pathfinder direct mail piece harkens back to an
authentically pristine time, when rugged terrain was left to

the animals and subsistence tribesmen wandered the desert in small kinship groups. Signifiers of the pristine past are wide-open spaces with rugged terrain and unpaved paths; wide shots of the sky at midday or at dusk; large, unpeopled areas and then unexpectedly a small group of tall, very slender black "tribesmen" (the Masai) in their bright, draped (non-Western) clothing. The protagonists have penetrated the apparently untraveled landscape in much the same way as perhaps the first "white men" penetrated Africa—as explorers bringing time itself, i.e., civilization. Time is signified by an itinerary, which the video specifies by naming each (real) location. This naming of real places heightens the verisimilitude of the ad. Time is also signified by luggage. Strangely the luggage is one of the more noticeable "actors" in the video. After the car and the protagonists, it is the luggage that makes the most frequent appearances, used to demonstrate some features of the car, but also used to remind the viewer that the protagonists are passengers on an exotic voyage, and that they have access to other luxury products. At the end of the video, back in "civilization" (i.e., a first-class hotel) the luggage is unloaded by black attendants for the white protagonists.

The video begins with a shot that is echoed in *The Lion King* which begins with a long shot (albeit a cartoon rendering) of a spreading tree against an African sunrise, supported by the score of African-sounding music and followed by animals, big and small, rushing by—the signifiers of Africa:

[Opening shot: a shaded tree, hills in the background, sunrise coloring the sky gold, dissolve to a top shot of an antelope running free across a green watery fresh looking marsh, dissolving again to show the Pathfinder peeling across a dusty rugged landscape; music African instruments and drums].

Narrator (voice of male protagonist): "It is the world's second largest continent; home to thousands of species of mammals, reptiles, birds and insects. This is *Africa*, land of extremes, and the perfect place to test the limits of the all new Pathfinder."
[Then the title of this short film appears, *Pathfinder on Sa-*

fari, printed in gold letters against the brown and rust patterned background that is replicated in olive green on the stationary].

What the narrator tells us is that this space is freely available for "us" to travel through for our own purposes; it is a no-man's land, a continent without reference to particular history, to nationality, even to people. What the narrator describes is a kind of nature preserve, yet he is talking about a continent with over 30 countries, national borders, different political systems, and all the features of any social formation. But his and our position is defined against the absence of African people.

The reference to a "land of extremes" also suggests the absence of the mundane, of the details of daily life. The video shows extremes as well: the harsh terrain, the contemporary highways; the Masai village (no visible structures) and the fabulous hotel. This is Africa as theme park: sites are presented without their context—the entire Eastern half of the continent is roamed at the will of the protagonists, with seeming irrelevance of each place to the other. It is never clear that each location is anything more than a kind of backdrop; and yet, these spots are presented as real—the video is purporting to show not a trip to an architecturally designed park, but a real trek through a number of independent nations.

The four-color brochure also reminds us that we are colonizers of the adventuresome sort: "A clear day, an empty road, and miles to go. Wanderlust strikes without warning. An aching urge to head off with a fat novel." The copy only makes sense to one who occupies a position of power—to satisfy wanderlust requires a freedom that is purchased through wealth and usually but not always is the prerogative of men. Africa is a good choice of location since unlike the English colonization of India, which did not provide opportunity to women, Africa is known for white women adventurers, settlers such as Isak Dinesan (Meryl Streep) and naturalists such as Jane Goodall (Sigourney Weaver).

32

SIGNIFYING SYSTEMS

After exploring our text, both from its surface and intended meanings, and its deeper meanings it is now important to return to the larger question: why is it important to undress this ad? The ubiquity of ads and other forms of popular culture endows them with power; the inanity of ads masks their cultural leverage. But, as we have noted, discourses of gender, race, nationality, and class structure this particular text, positioning not only the intended target audience, but other viewers as well. And it is here that the advertiser's intended meaning is not in contradiction to its broader and deeper one; advertisers learn to target only one specific audience, both in terms of creative work and media buys. But as we know, others view and interact with the ads (the ongoing struggle over children's and teens' responses to tobacco and alcohol advertising is a case in point).

The contention here is that we learn and have reinforced certain attitudes, beliefs, and knowledge about gender roles and relations, racial roles and relations, class, history, politics, and economics by viewing this among other cultural products. For example, African issues are rarely covered in our mainstream media unless there is a devastating war or famine; colonialism and the effects of post-colonialism are only briefly covered in our school textbooks; "we" often assume that African nations are poor and that all Africans are poor; "we" often assume that all couples are male-female. This advertising defines not only its target audience, but a much broader audience that is inscribed in discourses of not only heterosexuality, but heterosexism; not only race, but racism; not only male and female, but sexism; not only U.S.A.-citizens, but nationalism. Without the secure knowledge and understanding of heterosexism, racism, and so forth, this advertising would appear to be a parody of the real, but in fact it appears, as mentioned before, as an excellent example of an effective ad campaign. Through its use of verisimilitude, that is, through its evocation of familiar common-sense roles, we enter into these discourses unthinkingly, enfolding both

the product and ourselves within a structure of power relations.

When we encounter the Nissan Pathfinder in our own communities we may now pay more attention to who it is that drives and occupies the vehicle; the last one I saw was being driven through downtown Athens, Georgia, (color, Sahara Beige) by a blond woman wearing sun glasses and clearly chauffeuring several kids who occupied the passenger seats to school. I wondered if she knew that "[o]ne of the main benefits of driving a Pathfinder is driving on something other than a main road." I wondered if she is a "restless soul" who responds to Nissan's "rugged sophistication." I expect that like me she has to ensure that her children get to school on time, that she hopes they will learn something while there, that perhaps, in her children's lifetime (if not her own), there will be something resembling peace, prosperity, and enough resources to go around. I wonder if she, or her children (in junior high, in high school, in college?), think they are co-opted by the powerful when they cry at a movie—say *The Killing Fields*—but don't have time to even wonder if the U. S. military should invade other nations—say, Iraq with missiles. I wonder if she understands that in a 10-minute video and the few pieces of a direct mail ad campaign are inscribed over 100 years of European colonialism and U.S. neo-colonialism, over 400 years of racism, and over 1000 years of patriarchy. Or perhaps she's too busy driving her younger children, hoping the college kids are studying more and partying less, going to her job, picking up the younger ones, calling the older ones, cooking, cleaning, tutoring, loving, relaxing, and so forth, to even notice an ad.

34

REFERENCES

Barthes, Roland (1973). *Mythologies*. St. Albans, UK: Paladin.

Ewen, Stuart (1976). *Captains of Consciousness*. New York: McGraw-Hill.

Fiske, John (1989). *Reading the Popular*. Boston: Unwin Hyman.

Frith, Katherine (1997). "Undressing the Ad: Reading Culture in Advertising," in *Undressing the Ad: Reading Culture in Advertising*, Katherine T. Frith, ed., New York: Peter Lang, pp. 1-18.

Giroux, Henry (1988). "Border Pedagogy in the Age of Postmodernism," *Journal of Education*, Vol. 170, No. 3, pp. 162-81.

Hebdige, Dick (1979). *Subculture: The Meaning of Style*. London: Metheun.

Jhally, Sut (1995). "Introduction," in *Gender, Race and Class in Media*, Gail Dines and Jean M. Humez, eds., Newbury Park, CA: Sage.

Leiss, William, Stephen Klein and Sut Jhally (1988). *Social Communication in Advertising*. Ontario, Canada: Nelson.

Lester, Elli (1992). "Buying the Exotic 'Other': Reading the Banana Republic Mail Order Catalog," *Journal of Communication Inquiry*, Vol. 16, No. 2, pp. 74-85.

Lester, Elli. (1994) "The 'I' of the Storm: U.S. Reporting on Democratic Kakmpuchea," *Journal of Communication Inquiry*, Vol. 18, No. 1, pp. 5-26 .

Lester Elizabeth Pauline and Usha Raman, (1996). "News for Kids: Presenting the World to Atlanta's *Kids*," in *Multiculturalism and Global Understanding*, eds., K.S. Sitaram and Michael Prosser, New York: Ablex.

O'Barr, William M. (1994*). Culture and the Ad: Exploring Otherness in the World of Advertising*. Boulder, CO: Westview Press.

Williamson, Judith (1978) *Decoding Advertisements: Ideology and Meaning in Advertising*. London: Marion Boyers.

Chapter 3

Sponsorship, Globalization, and the Summer Olympics

Matthew P. McAllister

INTRODUCTION

Commercial network television in the United States is decidedly American. Despite the hundreds of hours of weekly entertainment programming shown on the Big Three networks (NBC, CBS, and ABC) and the three "weblets" (Fox, The WB, and UPN), other cultures are rarely shown and the great majority of characters and settings are American. *Seinfeld* stays in New York, *Roseanne* stays in Lanford, and *Cybill* stays in Los Angeles.

Yet for two weeks in July/August 1996, viewers in the United States were exposed to a variety of international images. These images were the result of NBC's Summer Olympic broadcast from Atlanta. Certainly the Games themselves showed athletes from other countries (although, perhaps, not as much as they could have), including occasional "inspirational profiles" of non-U.S. athletes with accompanying images from their home countries. But the broadcast of the Olympics itself may not have been the most significant source of other peoples and cultures. What was even more international in nature than the competition was the advertising that surrounded the competition. Commercials broadcast during the Olympics may have exposed American viewers to more global images and more foreign languages than had been displayed on NBC, especially in non-news programming, over the previous 12

months. TV commercials for Coca-Cola, IBM, AT&T, and a variety of other advertisers featured images of several countries, including South Africa, Italy, France, Australia, China, Russia, Japan, and Brazil.

This chapter explores the significance of these international ads, looking at the motivations behind this sudden wave of international portrayals, the characteristics of these portrayals, and the implications such corporate strategies may have. The chapter argues that these ads are part of a larger movement toward globalized advertising, both reflecting global corporations' motivations behind this movement and their attempt to blunt criticism of these motivations.

THE MOVEMENT TOWARD GLOBAL MARKETING
Large corporations, especially large American corporations, have always had their eye on international markets in the modern era. In this century, for example, companies like General Motors and Standard Oil started to significantly expand their international marketing efforts after World War I, perhaps taking advantage of European competitors who had been ravaged by a war on their home soil. Advertising agencies soon opened branch offices in different countries to help the international marketing efforts of these multinational corporations, making it easier to promotionally reach outside the United States with international advertising placement and media buys (O'Barr, 1994, 12). However, there were barriers and problems to international marketing. Early efforts were often uncoordinated and scattered. Some countries, especially socialist countries, were impenetrable to advertisers and many other countries often charged significant tariffs and demanded independently created advertising campaigns to match the cultural specificity of the country and its mass media system. As one advertising executive describes IBM's international efforts even into the early 1990s, "By early 1993, there were over 50 marketing communications firms working worldwide on IBM's behalf. The net effect was that often there were distinct and inconsistent messages delivered by

IBM around the world" (McCullough, 1996, 12). Although corporations such as GM and Coca-Cola have been very influential abroad for much of the century, in a multi-national world international marketing often was expensive (a different campaign for each different country), partially successful, and fragmented.

In the 1980s, however, the world began to change to fit the needs of global marketers. In fact, these changes were often the result of global marketers' effort and influence. New markets opened as the Cold War ended. Russia, Poland, Romania, and other former Soviet Bloc countries found marketers peeking through the Iron Curtain even before it collapsed. In the economic chaos that followed, such countries were often willing to strike very lucrative deals with international corporations, offering to privatize manufacturing facilities or eliminate restrictions to bring in revenue. Focusing on another Cold War player, marketers are willing to overlook the antidemocratic tendencies of the Chinese government as long as that country increases access to its one-billion-plus citizens. By 1991, retail sales in China had reached $173 billion, a five-fold increase from 1978 (Barnet and Cavanagh, 1994, 167).

Even in countries targeted by marketers before the Cold War, international corporate selling is easier in the 1990s. Recent deregulatory policies have meant fewer restrictions on non-local corporations. Policies like the Uruguay Round of the General Agreement on Tariffs and Trade (GATT) and the North American Free Trade Agreement (NAFTA) have liberalized trade policies, often because of the lobbying efforts and political–economic clout of Fortune 500 corporations (Anderson et al., 1996; Khor, 1996).

The creation of large, boundary-crossing media systems has also made selling on a global level much easier. Global cable and satellite systems allow marketers to reach hundreds of millions, if not billions, of people while only having to negotiate the purchase of advertising time with one or two media organizations. In 1991, CNN began offering global media buys (Lipman, 1991) and by 1995 was found in 130 countries (Barber, 1995, 105). By 1993, MTV was in

cable systems in over 71 different countries, reaching more than 500 million people (Barber, 1995, 104). ESPN by 1995 was offering programming to 150 countries in 18 different languages (Mandese, 1995, 4). Cable is not the only global offering. Global satellite television also makes ad placement easier. Rupert Murdoch's Star Television reaches 38 Eastern countries such as Hong Kong (where it is based), Thailand, Israel, India, and China (Schiller, 1996, 112). The growth of large media conglomerates, such as Disney/ABC and Time-Warner/Turner, can offer an expansive "media mix" to reach global markets through a variety of media. Time Warner, for example, could offer the advertising services of Warner Television, DC Comics, *People Magazine*, and CNN to reach people in different ways in different countries.

Advertising agencies, those who create the campaigns for marketers, have followed suit. The year 1986 is known as "The Big Bang" in the advertising industry. During this year, a series of major agencies merged, largely to facilitate global advertising efforts (Gleason, 1996, 3). These mega-agencies, like Omnicom, have become specialists in global advertising. Of the forty largest ad agencies in the U.S. and Great Britain, only about one-third had departments specializing in global advertising in 1987; by 1992 only one agency of the forty did not have such a department (Barnet and Cavanagh, 1994, 170). The largest agencies are continuing to increase the percentage of non-U.S. billings in their total revenue stream (Gleason, 1996, 54).

Marketers have exploited such trends to expand into every (lucrative) corner of the globe. McDonald's largest restaurant is not found in New York City or Los Angeles, but in Beijing, and the second largest is in Moscow (Schiller, 1996, 119). By 1991, McDonald's had 760 restaurants just in Japan, and by 1995 served 20 million customers each day worldwide (Barber, 1995, 29; Barnet and Cavanagh, 1994, 235). In total McDonald's has 17,000 franchise restaurants in 90 different countries (Official 1996 Olympic Web Site—McDonald's, 1996). Coca-Cola is even more globalized. As Barnet and Cavanagh describe

Coke's reach in 1994, "What was once advertised across America as ' The Pause that Refreshes' now takes place 560 million times a day every day in 160 countries" (169). Two-thirds of Coca-Cola's 1992 revenue came from outside the United States (Barber, 1995, 68). Coca Cola, in fact, understands that future growth is based on global markets. The president of the company once described this in religious terms: "When I think of Indonesia—a country on the Equator with 180 million people, a median age of 18, and a Moslem ban on alcohol—I feel I know what heaven looks like" (quoted in Barnet and Cavanagh, 1994, 181).

The development of global markets, global media, global advertising agencies, and global marketers has led to a push toward globalization in marketing: the treatment of the entire planet as one market. Unlike "multinational" advertising, where the marketer shapes individual campaigns for individual cultures, "global" advertising attempts to create one "universal" ad that would work in all cultures. Such efforts benefit the marketer in several ways. The creation of global campaigns is more cost efficient. The advertising agency only needs to create one campaign for 100 cultures versus 100 campaigns for 100 cultures. Advertisers can also strengthen the identity of a particular product brand by a global advertising blitz. When Tony the Tiger can be recognized everywhere, Kellogg's Frosted Flakes can be sold everywhere.

On the other hand, critics have also pointed to the significant dangers of using universal global advertising techniques (Barber, 1995; Barnet and Cavanagh, 1994; Englis, 1994; Farhi, 1992; Frith and Frith, 1990). One danger is the change in material habits that aggressive marketing may bring. Local peoples may switch from purchasing local foods and products to global products, perhaps altering for the worse their diets and the local economy. This is a danger with both multinational and global marketing. Global advertising strategies, though, create other problems for local cultures. A global strategy is designed to be *universal*, which often translates to image-oriented advertising rather than more heavily verbal-oriented ads. This undermines

the consumer usefulness of advertising, as ads concentrate on the "look" of a product (or the look of consuming a product), rather than concentrating on the consumer benefits of a product. Thus, the factual usefulness of advertising messages to make consumer purchasing decisions decreases when campaigns are globalized. Worse, *universal* images often mean copying images of *American* popular culture, given the international pervasiveness of such images. Even international companies not based in America use American-style images and modalities in their global advertising. As is discussed later in this chapter, there are serious concerns about global advertising in light of cultural imperialism and the erasure of international diversity and indigenous perspectives. Would the use of one campaign for the globe, a campaign from a decidedly American perspective, eventually erode the multiplicity of cultural perspectives?

GLOBAL MARKETING: SPORTS ADS AND SPONSORSHIP

Despite the existence of global media and global advertising agencies, one problem for global marketers is finding universal media content to which they can attach their sales messages. Increasingly, televised sports is becoming an important vehicle for global advertising. Corporations find that the sponsoring of sporting events helps to advance their global goals, especially when the sporting events have global appeal, such as World Cup soccer and, of course, the Olympics. Marketers can use sports telecasts to promote their products globally in one of two basic ways. First, they could become a sponsor of the event. A corporation sponsors an event when it gives money to the event organizations in exchange for promotional benefits (McAllister, 1996, chap. 6). So when Frito-Lay gave $15 million for the three-year sponsorship rights to the college football game The Fiesta Bowl, they are able to use the bowl game to promote their product, Tostitos (*New York Times*, 1995). Thus, Tostitos becomes the name of the event (The Tostitos Fiesta Bowl), appears in background "signage" in the stadium of the event, and appears on players' uniforms and in

the event program. In this sense, the event itself becomes an ad for Tostitos. Another way that advertisers can use sporting events is not necessarily to sponsor the event, but to advertise during the broadcast of the event. In this case, obviously, spot advertising becomes the main promotional vehicle.

Both strategies are useful in reaching global markets, if the sporting event is big enough. Viewers' passion for their sports teams and athletes can run very deep. In addition, sports is seen as having *universal* appeal and, at least with its focus on individual achievement, is apolitical and safe in that it does not raise controversial issues of social power and inequity (Jacobson and Mazur, 1995, 111). Countries importing sports images may find these images less objectionable and culturally imperialistic than American movies or TV situation comedies. One U.S. media executive concluded about global sports that "If you are a foreign country worried about importing American ideology, the safest thing you can buy is sports programming and Disney" (Hofmeister and Hall, 1995, A12).

The Olympics have become an especially powerful form of global sponsorship and advertising. Despite the amateur connotation of the Games, the modern Olympics have literally always been accepting of advertisers' advances. The program for the 1896 Games featured an ad for Kodak and Coca-Cola began its association with the Games in 1928 (Stotlar, 1993, 35). The commercialism of the Olympics took a geometric leap forward with the 1984 Los Angeles Games, however. That year the Games turned a $1 billion deficit that the 1976 Montreal Games experienced into a $215 million profit (Gelman, 1984; Manning, 1987). The change in fortunes was not achieved by decreasing the expensive spectacle of the Games, but by bringing in more sponsorship revenue. But there was a promotional price to be paid for that additional money. The depth and breadth of involvement by sponsors in the Games significantly increased in Los Angeles in 1984 and this involvement was even more visible in Barcelona in 1992. Corporations could choose to sponsor various elements of the Olympics, from

the International Olympic Committee to the national teams to the broadcast of the Games to the individual athletes. One *Adweek* columnist noted that the biggest story of the Barcelona Games was "how the Olympics have transformed themselves from a nationalist sports festival to an international marketing event in just eight years" (Buchanan, 1992, 20).

A major reason for this transformation was the appeal the Olympics have as a global marketing showcase. Advertisers know that worldwide viewership will be in the billions and that nearly 200 countries will send their citizens to participate. One Olympic sponsor, Visa, admits that "Visa's affiliation with the Olympic Games, begun in 1986, has helped Visa become a truly international brand. The Olympic spirit reflects Visa's own corporate mission to be global, competitive, and always striving for excellence" (*Special Events*, 1996). Notice, though, that the primary goal, the one listed first, is the global goal.

THE 1996 ATLANTA GAMES
Atlanta continued the sponsor and advertiser presence of earlier Games. The total cost of the Olympics, $1.7 billion, ensured that the event needed as much sponsorship money as it could get (*Fortune,* 1996). In addition, this particular Olympics added certain elements that made it especially desirable for global sellers. It was the first Olympics in popular memory where all invited countries chose to compete. The record number of countries participating (197), as well as the large number of gold medal events (239), meant that many countries would be interested in following the Games. Indeed, the final audience size confirmed the large audience prediction: an estimated 3.5 billion people throughout the world watched some part of the Olympics (Boswell, 1996, G9). Also increasing the global desirability of advertising during these Olympics was the first systematic use of Internet Web pages as an Olympic promotional tool. The Internet, theoretically accessible from any location on the planet, offered an official Olympic Web site, with links to different sponsors' homepages. Similarly,

computerized AT&T ads appeared on more than 25 Olympic and sports Web sites during the Games (Cleland, 1996).

All told, nearly 180 different companies and brands had some promotional ties to the Olympics, either by sponsoring the Games themselves, sponsoring a part of the Games, advertising during the Games, or being a key business partner of a company that sponsored the Games (Grimm, 1996, 26). The ten major "Global Sponsors," like Coca-Cola and IBM, spend a total of $2.1 billion to maximize their Olympic exposure (Jensen and Ross, 1996, 1). It should not be a surprise, then, that the NBC broadcast reflected the high degree of commercialism for these Olympics. NBC sold $675 million worth of advertising time to 50 advertisers (Jensen and Ross, 1996, 1). A study conducted by the *Washington Post* found that more airtime was devoted to the commercials than to the actual sports action (Farhi and Shapiro, 1996, A1).

Coca-Cola, especially, strongly linked itself to the Olympics through sponsorship and advertising. The soft-drink company was probably the most visible marketer with the Games. Although one incentive for this corporation's involvement was the location for the Games (Atlanta is Coca-Cola's corporate headquarters), the potential global reach may have been an even bigger reason. Coca-Cola is marketed to 137 of the 197 competing countries (*Fortune*, 1996, 59). The level of money it spent, and the amount of promotional activity it devised, illustrate how important the Olympics was to the company. The company invested over $60 million for NBC advertising slots to promote its different brands, including Coca-Cola Classic (Ross, 1996, 3). It spent another $40 million to be a Worldwide Partner of the Games (Jensen and Ross, 1996, 27), $20 million to sponsor the Olympic Torch Relay leading up to the Games (Heckman and Fitzgerald, 1996, 20), and $20 million on Coca-Cola Olympic City in Atlanta (*Fortune*, 1996, 59). Also, during the NBC broadcast it aired up to 100 different commercial spots, some of which cost $1 million to produce and were only shown during the Games broadcast (*Advertising Age*, 1996; Tyrer, 1996).

For this kind of money, Coca-Cola expected a lot of return: return on a planet-wide scale. The other Olympic sponsors did as well, which may explain the large number of Olympic ads that featured global and international images. The trend toward globalization was reflected in many of the ads shown during the 1996 Olympic broadcast on NBC. The following sections of this chapter detail these globalized ads, their characteristics, and their significance.

GLOBALIZED OLYMPIC ADS DURING THE 1996 GAMES

For this study, 30 hours of Olympics-related broadcasts were videotaped. Most of this taping was of NBC's broadcast of the event itself. However, some tapes were made of other networks' Olympic-related programming (such as CNN's coverage) or of related NBC events such as the qualifying matches for the Women's Gymnastics Olympic team, broadcast in early June. From these tapes, thirty-three different ads featuring global and international images for fifteen different products were found. As noted at the beginning of this chapter, this increase in the number of multicultural images on American TV seems on the surface to be a positive benefit of globalization. Here are American viewers exposed to other nations' culture and language. In these commercials we saw Italians, Russians, Chinese, and Jamaicans, many of them portrayed in their native lands. But a closer look at these ads shows certain shared characteristics that are not so beneficial. These globalized ads are very much influenced by the marketers' promotional goals, by the influence of ethnocentrism, and by the nature of the commercialized Olympics themselves. As will be argued, the final message of these ads, taken in totality, is one of U.S., and U.S. corporation, superiority.

U.S. PRODUCTS AS JOYFULLY UBIQUITOUS

In a *New York Times* article, media critic Neil Postman noted about the wave of globalized ads during the Olympics that "no matter how alien the tongue, the people in these ads are discussing American products and they are enthralled by them" (Lohr, 1996, D6). And he's right. Adver-

tisers supplied these international images: advertisers who are first and foremost interested in selling their products and justifying this selling. The different cultures were not celebrated in these ads, but the role of the product in these different cultures was. This is a characteristic of many globalized ads (Juluri, 1996), but it is especially descriptive of ads during the Olympics. These ads often bragged that the products can be found everywhere on the planet and are welcomed with open arms by all people. Thus, commercials for Visa, Coca-Cola, Kodak, IBM, Panasonic, Hanes, and Budweiser all had the same message: our products make everyone happy and solve everyone's problems, regardless of where on the planet they live.

An Olympic-themed Visa ad was especially illustrative, celebrating both the product and the value of industrialization generally. The ad was titled, "Thomas Goes to the Olympic Games," and featured a young man being sent off to the Olympics by the small, preindustrial Italian village that he is from. Various women in the town give him gifts to help him on his journey: one woman drapes him in links of home-made sausage ("For you, Thomas, to make you strong"), another in a hand-woven scarf ("To keep you warm"), and a third with a seductive kiss ("For inspiration"). However, the wise old man of the village, disgusted with this nonsense, raps his cane to gain everyone's attention. As the Olympian reverently walks up to the elder, the wise man says, "There is only one thing you need." Then the elder whips out his Visa card. As the crowd gasps, the old man orders, "And bring me back a T-shirt," and everyone cheers. Not only is Visa "everywhere you want to be," it is everywhere *it* wants to be, including an out-of-the-way Italian village.

The selective use of gender in this ad is telling. O'Barr, in his analysis of how U.S. ads portray foreigners, notes that one tendency of advertising is a "feminizing" of certain non-American characters. He argues that advertising attempts to symbolize the inferiority and submissiveness of certain "backwards" cultures by overwhelmingly portraying them as stereotypically female or even childlike (O'Barr,

1994, chap. 4). Elements of the Visa ad reflect this characteristic. In this ad, the women in the village represent the old, ignorant, outmoded ways: preindustrial food, clothing, and sex. However, the wise old man of the village knows better. He knows that Visa can supply the young Italian male athlete with better, modern versions of food, strength, clothing, warmth (sex?), and whatever he needs. The village elder is the wisest and most respected of the villagers, but also the most accepting of industrialization and commodification. No handmade scarves for him, he wants Olympic merchandise!

Other ads had similar messages. A Coke ad showed Jamaicans laughing, dancing, drinking Coke, and playing musical instruments made out of Coke containers. Italians, Australians, and Russians cheerfully chatted with each other about the advantages of IBM's products ("...the Olympic judges are relying on IBM Thinkpads," noted one Aussie in the Outback). The Budweiser Blimp awed people as it flew over Tibet, China, Africa, and Venice. Another Budweiser ad told us that "the beer run" to the local liquor store is more of a global happening than the Olympics, as long as everyone drinks Budweiser. UPS informed viewers that "Every day we serve over 200 countries and territories, speak 43 languages, and deliver overnight to a world that still measures 250,000 miles around" as it showed pictures of UPS trucks delivering packages in a Middle East desert, the French Alps, and a Chinese celebration.

Some ads visually pounded home the pervasiveness of the products' global presence. In another Coke ad, entitled "Passion Has A Colour," groups of Indian children were shown playing cricket. In the ad, the apparent "colour" of passion is red, Coca-Cola red. Practically every shot (92 edits in a 60-second spot) featured the same color red as the Coke logo; the Coke logo itself appeared in many of these shots. The Indian children in this ad drink Coke, wear Coke, play with Coke products, and play in front of Coke billboards. Coke supplies the refreshment, the athletic equipment (Coke cartons are used as Cricket markers), and perhaps, the ad implies, the "passion" for life it-

self. As yet another Coke ad told us, the product is "Always There, Always Coca-Cola." They meant it.

U.S. CORPORATIONS AS GLOBAL PHILANTHROPISTS

Another message of many of the global ads was that not only are these companies everywhere, but they are also nice. They contribute to the social good. Despite the logical fallacy of this message, often the ads stated that they did not just want to sell to us, they also want to help people. Sometimes this message was said explicitly, sometimes it was implied.

The most obvious way that global corporations were portrayed as nice corporations was through the promotion of their role as Olympic sponsors. Most of the globalized ads touted their participation as a funder of all or part of the Olympic Games. Visa commercials told us the company is a "Worldwide Sponsor." York Air Conditioning informed viewers it was an "Official Supplier," and Kodak was the "Official Imaging Sponsor" of the Games. Panasonic was more than a sponsor, "we're part of the team." In this last case, Panasonic is not an American brand, rather it is owned by Matsushita of Japan, but it is marketed like an American corporation. In 1992, it used U.S. Olympiad Carl Lewis to pitch its products in TV commercials that were shown in 30 countries (Farhi, 1992, H5).

Two commercials with global themes particularly focused on the sponsorship activities of the corporation. An AT&T ad, featuring a Japanese-Kabuki pole vaulter and a Southeast Asian archer in full ceremonial dress, informed us what a charitable corporation it was: "This summer the world will be connected to the Olympic Games like never before, at a special place called the AT&T Global Olympic Village. A place where athletes can join those who could come to the Games and reach out to those who could not." Similarly, a McDonald's ad said the company "was proud to help feed the athletes in the Olympic Village" as it showed Olympians of different ethnicities munching on Quarter Pounders and fries. That sponsors blew their own horns about their Olympic participation did not go unrewarded: it

is a great public relations move. One summer 1996 survey found that over two-thirds of respondents "thought that Olympic sponsors are doing a good thing for the country" (Emmons, 1996, 26).

Other ads were more subtle, even absurdly so, in their philanthropic claims. An ad for a Panasonic camcorder showed a tourist using the camcorder in a rain forest. Is the tourist nervous about the strange environment, or nervous about the resentment caused by the destruction of native lands by industrial exploitation? Of course not. The commercial suggested that the tourist is using Panasonic not only to ensure that the locals are friendly and nice, but also to erase any guilt about exploiting an endangered environment. In an example of what O'Barr (1994, 41) calls, "photographic colonialism," the native rainforest dwellers become subservient to the American's camera technology. They willingly pose for the American tourist and look in amazement at the videos the camcorder makes. In fact, the ad implies that the tourist is doing the locals a favor by using Panasonic. "I'll save the forest and preserve endangered species. I'll keep friends forever. I'll have the world in the palm of my hand," the tourist says in the ads' voice-over. The ad was saying (rather explicitly) that the product gives the consumer/tourist a form of imperialistic power: the power to "save the forest" and the power to domesticate the indigenous inhabitants. Western consumption and technology (such as a camcorder), in actuality a *cause* of deforestation, becomes its savior. At least, the product becomes a savior in the only terms that apparently matter to Panasonic: preserving the locals, animals, and forest on video.

Taken as a whole, one could argue that these ads highlighted philanthropic intentions in one other way. It was noted at the beginning of this chapter that international images are rarely found on television, especially non-news television. But there is at least one venue where international images are found. In public service advertisements for charitable funds like "Save the Children" and "Childreach," children from the developing nations appear

fairly frequently. In these ads, children are portrayed as horribly destitute, hungry, often homeless, alone, and very despondent (O'Barr, 1994, 96–101).

Yet the ads during the Olympics presented a very different picture of "Third World" and other non-American children. At least ten of the globalized ads portrayed foreign children in their home country. However, these children looked very different from those in "the needy foreign child" ads. In the Olympic commercials, children were surrounded by other children and adults. They were laughing, active, and healthy. They were also accompanied by the advertisers' products. However, the ads went a step further than just philanthropy by association. Many ads implied that not only do corporate products surround the happy children, the products are often the reason for the happiness. The children have nice clothes (brought to you by Hanes), communicate with their fathers via AT&T technology, use Budget rent-a-cars to ride around in, and have plenty of Coke to drink. In these ads, no one is poor, no one does without.

The reality of many children's lives in economically oppressed countries is different of course. Around 36 percent of preschool children in developing countries are severely or moderately malnourished, a condition due mostly to chronic poverty (*Journal of the American Dietetic Association*, 1995, 1160). But in Olympic ads, there is neither hunger, nor poverty. Everyone is happy. Given the traditionally bleak context of how foreign children are usually portrayed in "Save the Children" announcements, one wonders if a moral learned from Olympics commercials was, "Don't worry about Third-World poverty and inequality. We, the corporations, present a much better picture. Our products help solve these world problems." The ads did not explicitly say this, of course, but visually and collectively the "heroic" presence of the product was implied.

THE UNITED STATES IS BEST: EVERYONE ELSE ISN'T
In addition to the pro-corporation message of the ads, the commercials slanted the international picture in other

ways. Despite all of the new international symbolism in these ads, the commercials still had characteristics of old-fashioned jingoism. A message that framed much of the global iconography was that the United States, as a country and a people, is still Number One. Several ads mixed pro-U.S. images with the international images. What especially emphasizes the impact of these Americanized images was that they often were the final, most enduring, images shown in the ads.

The Olympic Games was the most common vehicle to show American superiority. Despite the montage of Italy, Turkey, and Africa in a Nation's Bank commercial, for example, the most sentimental shot was the last one, of a laughing little girl waving an American flag during an Olympic event.

Other ads showed why the little American girl is so happy. The United States always wins. A McDonald's commercial about the Olympic Village presented athletes of different nationalities eating french fries, but was also peppered with images of emotional American athletes during triumphant moments, including one waving a U.S. flag in slow motion. In a Panasonic commercial, a track sprint was simulated, with an American winning at the end. We know the American won because a simulated Panasonic scoreboard in the background listed the winner's country as U.S.A. An American woman sprinter in a UPS ad was also an apparent winner during her race (she's in the lead, at least). A commercial for the Dream Team told us that the U.S. Basketball Team planned to "Eat these guys [meaning every team on the planet] for lunch." Recall, too, that these examples were just the ads that were part of this study. Other Olympic ads, those without accompanying global images, were even more celebratory of the U.S., featuring mythologizing portrayals of such American athletes as Jackie Joyner-Kersey (in ads for Avon and McDonald's) and Janet Evans (Cadillac).

Such occasional pro-U.S. images perhaps had more effect given the ultimately negative and stereotypical images of non-Americans in many of the ads. While Americans

were portrayed as winners and as individual achievers, foreigners were often characterized in ways that distanced them from the American viewer, even while the ads showed the foreigners happily using the American products. Three IBM ads fell into this category. In one ad, laid-back (perhaps even lazy?) Crocodile Dundee-type Aussies shuffled their feet and picked their teeth as they hung out on a dusty porch in the middle of the day. Their "strangeness" was emphasized by the use of subtitles at the bottom of the TV screen, despite the fact that they were speaking English in the commercial. An Italian male, portrayed as a "Latin-lover" type, is caught lying to his girlfriend about what he was really thinking (perhaps philandering thoughts?) and covers his tracks with platitudes about IBM. A third IBM ad featured a French fencer (naturally) admitting to a rival that his father owns a poodle-grooming business (French poodles, of course). Everyone in a Visa ad was smiling ... except the two grim Russians, suffering through a Russian winter. The savage, distant rainforest dweller, his face painted, his hand holding a spear(!), only can be humbled by the magic of Panasonic. Finally, in at least five different ads, one icon of foreign inferiority was the foreigner's dental status. Americans had perfect teeth in these ads, while non-Americans, had comically flawed teeth. These ads told us, through various portrayals, that missing and rotten teeth are characteristic of Africans, Jamaicans, old-world Italians, and Chinese. How do we know who is missing teeth? Because, remember, everyone in these ads (except the Russians) was always smiling.

CONTEXTUALIZING THE OLYMPIC COMMERCIALS
When TV advertising critics analyze the possible meanings in ads, they often assume that the ads are isolated from the programs. They tape an ad, or a series of ads, and ask, "What is this ad saying?" They rarely look at the specific programs the ads were aired in, at what point during that program the ads appeared, or how the meaning of the ad was reinforced or altered by the meaning of the program. Likewise, when TV-program critics analyze programs, they

rarely consider what ads were shown during the program and how the ads may affect the possible meanings of the programs. Often this is a legitimate attitude: the ads are very separate and distinct from the programs. But sometimes the ads are not that separate from the programs. Sometimes ads can be very program-like (infomercials, for example), or programs can be very ad-like (such as a news story about the latest Hollywood blockbuster). When this is the case, the meanings in the commercials and the shows may reinforce each other.

If the globalized Olympics ads just described, were interpreted apart from the NBC broadcast in which they were shown, they would lose much of their original potential meaning and impact. The broadcast was very much related to the ads. In this particular case, the ads and the commercials had common themes. The contextual cocoon that the NBC Olympics broadcast provided the commercials reinforced at least two of the themes of these ads. These themes were the ubiquity of the corporate presence and the superiority of the United States.

Not only did advertising show that corporations touch every part of the globe, but so did the Games themselves. Corporate names and logos appeared quite frequently on the TV screen during the Games. However, these logos did not appear in a place many would expect to find them. Corporate signage was not found on the walls of the arenas because Olympic rules prohibit advertising at official Olympic athletic venues (Jacobson and Mazur, 1995, 113). Rather, the ubiquity was signified on another place during the Games, a place that strengthened the *global* ubiquity of corporations, just as the ads did. Corporate symbols were found on the athletes themselves.

During events, we saw the names or logos of Nike, Adidas, Champion, Reebok, and others on the uniforms of the athletes, often quite prominently. This was not new with the Atlanta Games. Previous Olympics have turned athletes into human billboards. But what marked the 1996 Olympics as commercially special was the equal opportunity shown by marketers. At this Olympics, the former enemies

of capitalism, countries like Russia and China, were as likely to be emblazoned with The Nike Swoosh (or the equivalent) as the U.S.'s Michael Johnson. In fact, both Reebok and the music-club chain the House of Blue were sponsors of the Russian Olympic Team (Drozdiak, 1996; Jensen, 1996). By sponsoring teams and athletes, corporations were insuring that they would touch, if not the world, then at least the world's athletes.

The global visibility of corporate sponsorship was signaled on the very first day of the Atlanta Summer Olympics, during the Opening Ceremonies. On the same night that viewers saw the Coke-in-India ad, the UPS-in-the-Middle-East ad, and the IBM-in-Australia ad, they saw the Argentinean team, one of the first countries to appear in the Parade of Nations, march into Olympic Stadium, each one of them dressed in a prominently labeled Adidas warm-up suit. This was a early sign of the logoization of the Olympic athletes.

Throughout the Games, corporate logos appeared on just about every athlete from just about every country. Corporate logos were especially obvious in the high-profile sports of women's swimming/diving, men and women's gymnastics, and track and field. During the Women's 100 meter freestyle finals, for example, we saw Adidas on the two German athletes and Speedo on two American, the Australian, and the Chinese athletes. The logo on the Chinese athlete was especially eye-catching, composed of huge, white letters across the front of her black swimsuit. During that same Olympic night viewers also saw ads featuring the globe-trotting Budweiser blimp and the utility of a Panasonic camcorder in the rainforest.

Elsewhere I have argued that event sponsorship, combined with traditional product advertising, offers a one-two punch for corporate image management (McAllister, 1996, 220). While commercials explain how good products are for us, sponsorship—and its accompanying message of philanthropy—show us how corporations provide us with good things. In the case of the Olympics, the one-two punch was on a planet-wide scale. While the commercials showed us

how happily widespread products are, the labeled outfits of sponsored athletes showed us how globally generous sponsors are. Both the program and ads said, "Corporations are everywhere and people/athletes are glad to have us."

The corporate logos on athletes were not the only way that the Olympics broadcast reinforced the meanings of the global ads. Another level of concordance between program and commercial was in the pro-U.S.A. messages of the NBC broadcast. Modern Olympics broadcasts in the U.S. have a history of jingoism and over-the-top patriotism (Riggs et al., 1993). The 1996 broadcast was no exception. Several critics noted the pro-U.S. slant, and the anti-foreign digs, during the NBC Games coverage (Kornheiser, 1996, C4; Sandomir, 1996, B14; Shapiro, 1996, C6; Shales, 1996, B1). One critic even argued that it took the bombing at Centennial Park to tone down the broadcast's blatant nationalism (Schwarzbaum, 1996).

Like the obviousness of corporate sponsorship, the pro-U.S. message was established during the Opening Ceremonies, when NBC only interviewed U.S. athletes and when John Tesh's preview of the women's gymnastics competition portrayed smiling Americans versus grim, arms-crossed Russians and Romanians. The pro-U.S. angle carried through most of the Games by focusing heavily on the U.S. athletes, whether they medaled or not, and by sometimes even rooting for the U.S. Kornheiser (1996) summarized the media coverage as follows:

> "My sense of the Olympics so far is:
> We win! We win!
> *They* win?
> Oh, they must be on drugs."
>
> (Kornheiser, 1996, C4)

The nationalism of the broadcast reinforced the "U.S. Is Best" message of the globalized commercials. Just as simulated athletes were winning Gold in Panasonic commercials, so we saw (over and over) U.S. athletes winning Gold in real events. We not only have the best athletes in the world, but we have the best corporations.

CONCLUSION: KATHIE LEE, HANES AND MONOCULTURE
Given all of the above—the ubiquity of global products, the philanthropic messages, the pro-U.S. orientation—what could we conclude about these ads?

First of all, one question to be asked is, who is the intended audience for the ads? This chapter began with a discussion of globalization and advertising and how corporations are exploiting the cost efficiency and brand effectiveness of global ads. Global advertisers want one planet, one ad. Certainly some of the globalized ads discussed earlier will be shown to other countries. IBM's "subtitles" campaign (like the Australians with a Thinkpad) was designed to be aired globally, using the same visuals in each country, but translating the subtitles to the language of the country in which the ad airs (McCullough, 1996, 14). In this case, then, American viewers become part of the globalized process. Americans saw the same ads as everyone. However, those in the U.S. may not notice this trend, because the *universal* ads were based upon American styles and consumption practices. To American viewers, the global ads blended in with American programming. The only difference might have been the occasional foreign-looking person in a foreign-looking land. But these commercialized foreigners were still acting American.

Other ads that featured globalized images, though, were designed only to be aired in the United States. The Delta "Marathon" ads, featuring actor Nigel Havers as he country-hopped around the world on Delta Airlines, did not run in Europe, for example (Wilke, 1996, 3). So what is the motivation behind these ads that have globalized images but not globalized distribution? And was there another motivation besides cost efficiency behind all of the ads, even those that were being aired internationally?

One could argue that there was another motivation. Globalization, as an economic practice and legislative policy, had taken some severe public relations hits in the U.S. during the months leading up to the Olympics. The North American Free Trade Agreement (NAFTA), once a grand

achievement of the Clinton Administration, had become a politically taboo topic. This is because many Americans began to perceive that corporations use the policy to shut down U.S.-based factories to move them to labor-cheap countries. Or, if corporations do not actually move the factories, they may threaten to do so during labor negotiations, a tactic called "whipsaw bargaining." After Xerox had moved two Illinois and Massachusetts plants to Mexico, labor representatives for a New York facility agreed to concessions to prevent that plant from moving (Anderson et al., 1996, 27). The term "free trade" has become such a devil term that President Clinton did not even mention NAFTA during his 1996 State of the Union address (Korten, 1996, 14).

Bad publicity for globalization was also caused by the Kathie Lee Gifford scandal in May 1996. Gifford was accused of supporting, through her endorsement of a Wal-Mart fashion line bearing her name, a Honduras clothing factory that exploited child labor. Publicity over the issue went through the roof when Gifford used her highly rated daytime talk show to launch into, as *Time* described it, "a teary, it's not-my-fault, TV hissy fit" (Thigpen, 1996, 101). Shoved onto the social agenda, then, was the role of global corporations in the establishment of poor working conditions in developing countries. Although this publicity mostly translated into jokes by Jay Leno and David Letterman, nevertheless the ugly nature of globalization was visible to Americans.

But advertising and sponsorship during the Olympics helped to turn that around. The globalized portrayals in Olympic ads served as propaganda for globalization. Globalization does not mean losing U.S. jobs to Mexico, it does not mean child exploitation, it means fun in foreign countries! It means the superiority of the U.S. abroad. It means that corporations, both in the U.S. and in India (or wherever), are nice. Whether intended by corporations or not, in the midst of negative American public opinion about corporate activity came the saving grace of Olympics advertising.

The preceding discussion analyzed how the Olympic portrayals have responded to the immediate past (anti-globalization sentiment). Another question to be asked about all this Olympic ad activity is, what can we learn about the future, given the portrayals of globalization in these advertisements?

Despite the portrayals of happy people in these ads, it is not a happy picture of the future. On the surface, the globalized ads seemed to celebrate cultural diversity. The ads showed South Africans smiling in their native garb; Indian children playing cricket against unique architecture; Australians talking in colorful slang; Euro-hip Italian lovers on the beach; the biological diversity of the rain forest; the distinctive style of Chinese celebrations. What the corporations that made these ads want, though, is the ultimate elimination of this diversity. They want cultural uniformity, specifically the uniformity of everyone drinking Coke, or using IBMs, or riding in Budget rent-a-cars. The values and symbols they were saluting in the ads—the distinct international iconography—are the very values and symbols they are trying to eradicate.

A commercial for Hanes clothing spelled out this motive. The first half of the Hanes commercial presented various images of different cultures as the narrator says, "To some, people are either Brazilian, or Norwegian. Indian or Chinese. South African or Dutch." The visuals showed each of these cultures represented by natives in their culturally specific attire, each smiling at the camera. This is great; it is a celebration of unique differences and styles. Except then the narrator informed us, "To us, it's much simpler than that. People are just small, medium, or large." And as the narrator says this sentence, we see the people at the beginning of the ad covering their national dress with the same, bland, Hanes clothing. All the different nationalities have Hanes T-shirts as they smile even wider. Thus, the South African at the end of the commercial looks like the Chinese who looks like the Norwegian. They all look the same, they all wear Hanes. The distinct styles at the beginning of the ad are gone. In fact, the only person who has

any sort of cultural identity at all at the end of the ad is the American model, who is wearing a "USA"-labeled Hanes sweatshirt.

The final images of the Hanes commercial is the image of the world that many global corporations want. They want one big market, with everyone using their products. Cultural diversity gets in the way: it messes up advertising strategies and consumer predictability. To what extent does the global marketers' desire for market uniformity reflect the reality? We may be moving toward the world of the Hanes ad faster than we think. One critic argues that globalization—the global strategies of marketing and advertising that large corporations use—is shaping the planet to be a "monoculture." In this monoculture,

> people everywhere eat the same food, wear the same clothing and live in houses built from the same materials. It is a world in which every society employs the same technologies, depends on the same centrally managed economy, offers the same Western education for its children, speaks the same language, consumes the same media images, holds the same values and even thinks the same thoughts. (Norberg-Hodge, 1996, 20)

In this light, social observers point to how diets worldwide are becoming more Americanized via fast-food and junk food marketers (leading to an increase in cancer rates in some countries), or how local drinks and juices are the real casualties of the Pepsi and Coke cola wars (Barnet and Cavanagh, 1994, 246). Mattelart notes about the irony of juice in Brazil, for instance, that this country is "at the same time the major world exporter of orange juice, the smallest consumer of orange juice, and one of the major consumers of Fanta Orange, which contains not the slightest trace of this fruit—and all this while vast sectors of the population suffer a high deficiency of vitamin C!" (1991, 67). Televisions, radios, and movie theaters all over the country are carrying the same, American content (Barber, 1995; Barnet and Cavanagh, 1994).

It is a scary loss of global difference. One last corporate message about globalization drives this home. McDonald's on their Olympic World Wide Web site bragged about their

supplying food to all athletes in the Olympic Village, no matter what country these athletes were from. McDonald's noted that their restaurants "serve the athletes' demanding schedules and provide them with a familiar taste of home" (Official 1996 Olympic Web site—McDonald's, 1996). The fast-food company was not being ironic. In countries all over the world, home cooking is now defined as a McDonald's Big Mac.

REFERENCES

Advertising Age (1996). "Hot Spot: Coca-Cola Co.," July 22, p. 3.

Anderson, S., J. Cavanagh, and D. Ranney (1996). "NAFTA: Trinational Fiasco," *The Nation*, Vol. 263, No. 3, pp. 26-29.

Barber, B. R. (1995). *Jihad vs. McWorld*. New York: Times Books.

Barnet, R. J., and J. Cavanagh (1994). *Global Dreams: Imperial Corporations And The New World Order*. New York: Simon & Schuster.

Boswell, T. (1996). "Between The Commercials, Waiting For The Real Show," *The Washington Post*, July 20, p.G9.

Buchanan, R. (1992). "Higher, Faster, Farther," *Adweek*, August 10, pp. 20-21.

Cleland, K. (1996). "AT&T, Modem Ring Up A Big Olympics Web Buy," *Advertising Age*, July 15, p. 16.

Drozdiak, W. (1996). "Shoe Firm Foots Russia's Bill," *The Washington Post*, July 26, p. A1, A16.

Emmons, S. (1996). "Sponsors of Games Show Boost to Image," *Advertising Age*, July 15, p. 26.

Englis, B. G. ed., (1994). *Global and Multinational Advertising*. Hillsdale, NJ: Lawrence Erlbaum Associates.

Farhi, P. (1992). "Pitching The Global Village," *The Washington Post*, June 14, pp. H1, H5.

Farhi, P., and L. Shapiro (1996). "Sports As an Afterthought on NBC," *The Washington Post*, July 27, pp. A1, A14.

Fortune (1996). "Fortune's Olympic Fact Sheet," July 22, pp. 58-59.

Frith, K. T. and M. Frith (1990). "Western Advertising and Eastern Culture: The Confrontation in Southeast Asia," *Current Issues and Research in Advertising*, Vol. 12, pp. 63-73.

Gelman, M. (1984). "Fewer Sponsors—But Greater Impact," *Advertising Age*, May 7, p. M6.

Gleason, M. (1996). "Big Bang of 86 Is Still Shaping the Ad World," *Advertising Age*, April 22, pp. 3, 54.

Grimm, M. (1996). "Olympic Grab Bag," *Brandweek*, June 10, pp. 26-28, 30, 32, 34.

Heckman, A., and K. Fitzgerald (1996). "Fired Up Over Torch," *Advertising Age*, July 1, pp. 20.

Hofmeister, S., and J. Hall (1995). "Disney To Buy Cap Cities/ABC For $19 Billion, Vault To No. 1," *The Los Angeles Times*, August 1, pp. A1, A11, A12.

Jacobson, M. F. and L. Mazur (1995). *Marketing Madness: A Survival Guide For a Consumer Society.* Boulder, Colo.: Westview Press.

Jensen, J. (1996). "House of Blues Brings Musical Fair to Games," *Advertising Age*, July 1, p. 8.

Jensen, J. and C. Ross (1996). "Centennial Olympics Open As $5 Bil Event of the Century," *Advertising Age*, July 15, pp. 1, 27.

Journal of the American Dietetic Association (1995). "Position of the American Dietetic Association: World Hunger," Vol. 95, pp. 1160-1162.

Juluri, V. (1996). "Us and Them: Advertising and the New World Other," Paper presented at the meeting of the International Communication Association, Chicago, IL.

Khor, M. (1996). "Colonialism Redux," *The Nation*, Vol. 263, No. 3, pp. 18-20.

Kornheiser, T. (1996). "In Its Gold Rush, U.S.'s Attitude Makes For Bad Sports." *The Washington Post*, July 24, p. C4.

Korten, D. C. (1996). "The Limits of the Earth," *The Nation*, Vol. 263, No. 3, pp. 14-16, 18.

Lipman, J. (1991). "CNN To Offer a World-Wide Ad Package," *The Wall Street Journal*, May 23, p. B6.

Lohr, S. (1996). "Commercials at the Olympics Took a Decidedly Global Flair," *The New York Times*, August 5, p. D6.

Mandese, J. (1995). "Is It Magic Kingdom or an Evil Empire?" *Advertising Age*, August 7, pp. 1, 4.

Manning, R. (1987). "The Selling of the Olympics," *Newsweek*, December 28, pp. 40-41.

62

Mattelart, A. (1991). *Advertising International: The Privatisation of Public Space*, New York: Routledge.
McAllister, M. P. (1996). *The Commercialization of American Culture: New Advertising, Control and Democracy*. Thousand Oaks, CA: Sage.
McCullough, W. R. (1996). "Global Advertising Which Acts Locally: The IBM Subtitles Campaign," *Journal of Advertising Research*, Vol. 36, pp. 11-15.
Norberg-Hodge, H. (1996). "Break Up The Monoculture," *The Nation*, Vol. 263, No. 3, pp. 20-23.
Official 1996 Olympic Web Site—McDonald's—Olympic Games Partner (1996). Http://www.atlanta.olympic.org/acog/sponsors/d-mcdonalds.html
O'Barr, W. M. (1994). *Culture and the Ad: Exploring Otherness in the World of Advertising*. Boulder, CO: Westview Press.
Riggs, K. E., S. T. Eastman and T. S. Golobic (1993). "Manufactured Conflict in the 1992 Olympics: The Discourse of Television and Politics," *Critical Studies in Mass Communication*, Vol. 10, pp. 253-272.
Ross, C. (1996). "Coke Readies Team of 70 TV Ads For Games," *Advertising Age*, April 29, pp. 3, 50.
Sandomir, R. (1996). "Live Coverage from Atlanta, but only in Atlanta," *The New York Times*, July 23, p. B14.
Schiller, H. I. (1996). *Information Inequality: The Deepening Social Crisis in America*. New York: Routledge.
Schwarzbaum, L. (1996). "American Airwaves." *Entertainment Weekly*, August 9, No. 339, pp. 46-47.
Shales, T. (1996). "Let The Commercials Begin!" *The Washington Post*, July 23, pp. B1, B2.
Shapiro, L. (1996). "NBC Doesn't Let Too Many Facts Get in the Way of a Good Story," *The Washington Post*, July 26, p. C6.
Special Events—Visa. (1996). http://www.visa.com/cgi-bin/vee/se/olympics/main.html?2+0, July.
Stotlar, D. K. (1993). "Sponsorship and the Olympic Winter Games," *Sport Marketing Quarterly*, Vol. 2, pp. 35-43.

The New York Times (1995). "A New Sponsor Adds Spicy Flavor to Game," December 29, p. B12.

Thigpen, D. E. (1996). "If You Could Hear Her Now," *Time*, May 13, p. 101.

Tyrer, K. (1996). "Coke Salutes the Fans," *Adweek*, Feb. 12, p. 4.

Wilke, M. (1996). "Delta Suits Up For Marathon During Atlanta Olympic Games," *Advertising Age*, July 1, pp. 3, 28.

Chapter 4

The Paco Man and What Is Remembered: New Readings of a Hybrid Language

Morris B. Holbrook and Barbara B. Stern

The authors gratefully acknowledge the support of the Columbia Business School's Faculty Research Fund and the Rutgers Graduate School (Newark) Research Fund.

INTRODUCTION

In recent years, interpretive approaches to the study of consumer behavior, marketing in general, and advertising in particular have arisen to challenge the positivist "hard science" perspective. These approaches represent a paradigm shift in consumer research, traditionally dominated by the positivist belief system fundamental to modern science. This system centers on the cardinal tenets of universal truth, objective reality, knowledge independent of its context, and separation of researcher from the research subject. In contrast, the interpretivist paradigm, also called "postpositivism" or "postmodernism" (Firat and Venkátesh, 1995), centers on opposing beliefs such as socially constructed truth, subjective reality, knowledge that is context-dependent, and the presence of the researcher in the phenomenon being studied (Hudson and Ozanne, 1988).

Unlike positivist research that relies on quantitative techniques and empirical methods, postpositivist research

draws from a wide variety of humanistic approaches to understanding, including literary criticism, semiotics, structuralism, hermeneutics, cultural studies, and philosophical inquiry. Interpretive researchers accept multiple meanings, consider the goal of research to be understanding rather than prediction, and do not expect to find a single "right" explanation.

This paradigm changed the face of consumer research in the late 1980s, when the *Journal of Consumer Research* began publishing articles using ethnographic and phenomenological techniques to elicit information about consumption. At about the same time, literary criticism (Stern, 1989) and semiotics (Mick, 1986) followed Levy's early and pioneering use of structuralist analysis (1981). Since that time, the interpretive perspective has been disseminated in Hirschman's edited volume (1989) and Sherry's chapter in the *Handbook of Consumer Behavior* (1991). It was advanced by Hirschman and Holbrook's book (1992), and now includes a sizable body of research on consumers that borrows methods from numerous disciplines.

Despite the acceptance of interpretivism in consumer research, much advertising research is still conducted from the positivist perspective, relying on information-processing and decision-oriented choice models to study consumers' responses to ads. These models presume that all consumers read ads in the same way, and, if they comprehend the message properly, arrive at the same "correct" meaning. The processing assumptions take for granted a stable text, a single meaning, and a correct response on the part of a collective audience of readers.

Our purpose is to challenge these assumptions by demonstrating a postmodern alternative in which the dichotomy of gender (Stern, 1993) is revealed as a key influence on interpretation. Feminist critics have paved the way for discovering the influence of gender—being a man or being a woman—on reading (Culler, 1982). They emphasize the role that gender plays in the interpretive work of making sense out of a text (Schweickart, 1988). In accordance with the view of perceived meaning as something co-created by the

reader rather than "put in" the text by the author, gender influences the reader's response. Literary experiments have shown male readings to differ from female readings (see Flynn and Schweickart, 1988), and we can no longer assume that each sex reads the "same" literary text (short story, novel, play). In the following readings, we propose to extend this finding to advertising, using our own gendered readings to illustrate the impact of maleness and femaleness on meaning.

NEW READERS READING: HOLBROOK AND STERN

Holbrook and Stern have come to interpretive research in consumer behavior and advertising from somewhat different backgrounds. Beginning with a neopositivistic approach to the semiotics of communication, Holbrook (1975) moved through a phase devoted primarily to experimental methods in consumer esthetics (1987a,b) toward an increasing emphasis on the semiology of consumption symbolism (Holbrook and Grayson, 1986; Holbrook and Zirlin, 1985). In that research domain, Holbrook has focused special attention on the role that symbolic consumer behavior plays in our semiological interpretation of films, plays, novels, operas, and other forms of entertainment and works of art (Holbrook and Hirschman, 1993; Stern, 1994). Stern's training was originally in literary criticism (1965), and she began analyzing advertising text by adapting formalist methods developed by the New Critics (1988, 1991). She broadened her focus to study various aspects of marketing strategy and consumer behavior (1989), and has extended the literary perspective to include feminist and deconstructive critiques of the communicative role of gender (1993) and genre (1990).

In sum, both Holbrook and Stern are "new" readers of advertising in that they come to it from different kinds of training and research interests. Even more salient, they accept concepts such as the interactive nature of reading advertisements, the hybrid verbal/visual language in which the text is encoded, and the permeability of linguistic boundaries between advertising and art. For new readers,

the meaning of art or advertising emerges via a process of communication in which the gender of the reader plays a central role. That is, they accept reader affect as integral to meaning (Fish, 1980; Iser, 1978; Jauss, 1982) and gender-based cultural distinctions (Carey, 1988; Hobsbawm and Ranger, 1983) as significant determinants of ways that different readers construct different meanings.

Insofar as the reader and the cultural context both play important roles in shaping the meaning of communication in the culture of consumption, Holbrook's and Stern's readings focus on the synergistic relationships among various elements in the communicative gestalt. All of the elements work together to determine the meaning of any text via a mutually interdependent network of reciprocal relationships. Looked at this way, understanding a work of art or an advertisement implies taking all such factors into account without privileging one over another or forcing a single right reading. Rather, understanding evolves out of respect for the complexity, fluidity, and multivocal nature of reading. Ambiguity and divergence are accepted as the norm, not errors that must be resolved if meaning is to be agreed upon. From this perspective, there is no all embracing universal "meaning," but, instead, numerous local and personal meanings.

READING AN ADVERTISEMENT: PACO RABANNE

To demonstrate multiplicity of meaning, the authors engaged in an interpretive dialog directed toward an in-depth understanding of the role that gender plays in an interpretation of the consumption symbolism and literary style of one advertising exemplar. It is a print advertisement for Paco Rabanne men's cologne ("Man on a Boat"), Figure 4.1, that features a young man in the cabin of a sailboat talking to an unseen woman on the ship-to-shore telephone (Stern and Holbrook, 1994). Our semiological and literary exegesis works through multiple phases of interpersonal dialog in which Stern and Holbrook debate the visual/verbal language and encoded meanings, circle around various inter-

pretations, and ultimately agree to disagree on a bundle of meanings found in the Paco ad.

The method used is comparison of the *initial interpretations* constructed by Holbrook and Stern based on their *first exposures* to the Paco ad (prior to the changes wrought in their readings by the ensuing dialogs). The full set of dialogs includes three "rounds" of independent readings (see Stern and Holbrook, 1994), with the latter two representing reactions of one to the other. However, the following readings were the first, and thus were written before any dialogue between the two authors occurred. Given the orientations of the two authors—Holbrook toward semiology, Stern toward literary criticism—we believe that these initial interpretations illustrate interesting and important ways in which their perspectives diverge and converge. Accordingly, we shall first present each independent interpretation, which was written and mailed to the other author without any discussion of what the diskette contained. We will then present our current impression of the ways that differences and similarities between the conceptual orientations of Holbrook and Stern colored their individual interpretations.

70

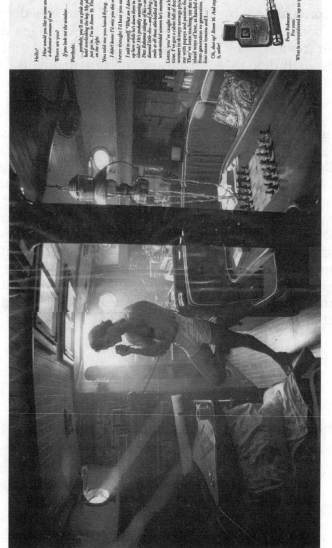

Figure 4.1

The advertising copy reads:

Hello?

*How would you like to come and make
a dishonest woman of me?*

Where are you?

If you look out the window...

Porthole.

*...porthole, you'll see a pink stucco
hotel overlooking the bay. My plane
just got in. I'm in Room 16. First bed
on the right.*

You told me you hated flying.

I didn't know I'd miss you this much.

I never thought I'd hear you say that.

*I said to myself, "What am I doing
up here while he's down there in the
islands? He's probably wearing that
Paco Rabanne cologne of his—and
damned little else—and flashing that
smile at all those able-bodied and
weak-minded women he's meeting."*

Listen, you've caught me at a bad
time. I've got a cabin full of doe-eyed
women in skimpy sarongs plying
me with papaya and passion fruit.
They've been teaching me the secret
island ways of love, as handed down
from generation to generation. Only
four more lessons and I...

*Oh, shut up! Room 16. And step on
it, sailor!*

72

HOLBROOK'S READING: GIGOLO GUY AND BIMBO GAL
This ad addresses the burning questions of (1) "What sort
of man uses Paco Rabanne?" and (2) "What sort of effect
does this consumption behavior have on his sex life?" The
answers—to anticipate briefly—are (1) a gigolo who can (2)
attract any sort of bimbo he wants (or, in this case, doesn't
really want all that much). In arriving at this interpretation,
we must *collect* clues gleaned from both the picture and the
verbal script. These combine to create an overall text that
commands our attention by virtue of the ambiguity and
ambivalence that it suggests. We have to start somewhere,
so perhaps the verbal dialog on the right (aimed at the left
brain?) is the best point of entry.

The opening dialog immediately establishes the woman
as a little shady ("dishonest" by her own description), pro-
vincial or at least not too well-traveled (because she hates
flying and doesn't know the difference between a "window"
and a "porthole"), unemployed (since she apparently has no
reason not to leave town on a moment's whim), and horny
as hell (the sort of person who no sooner gets off the plane
than she hops into bed—the "first bed" she can find—and
starts making sex-starved phone calls). She does have one
slightly endearing quality—namely, her emotionally direct
openness and ability to tell our hero that she has missed
him. Besides this, her main qualification as a love object is
that she is apparently one of those "able-bodied and weak-
minded women" at whom he likes to flash that gigolo smile
of his.

Meanwhile (turning to the pictorial evidence), our hero
appears to be just arising for the day. He has not yet had
time to drink much of his morning coffee, which is evident
from the still nearly full mug. But the sun has already
risen to about the eleven o'clock position—as can be in-
ferred from the angle of the light streaming through the
window (Oops, I mean "the porthole"). He is too lazy to
make his bed (usually the first thing a true sailor would do
to keep things ship-shape) and too casual to bother putting
on anything more than swimming trunks (barely distin-
guished from white boxer shorts by the fact that they have

pockets). He does appear to have some intelligence (unlike his "weak-minded" sex objects) in that he apparently knows how to read a navigational map (spread out on the desk in front of him as if he has been looking at it), likes to play chess (though the case would be more persuasive if the pieces had been moved to positions suggesting that a game is in progress), and has been reading a very thick book (though, on closer examination, it turns out to be *Shogun* and he has only gotten as far as about page 127). The magazines under the book cannot be identified, but the tiny television indicates that this fellow is plugged into pop culture while the bookshelf suggests that his reading tastes may range more widely (though, because the titles are obscured, one cannot rule out the possibility of such subjects as *Sailing Made Simple* and *Girl Watching on the Islands*). The kerosene lamp (by which, perhaps, he has been reading late into the night or pondering esoteric chess moves— though I doubt it) features a macrame holder into which he could place a hanging plant. But, that would distract him from such chores as making his bed (which is already too much trouble) and keeping himself immaculately exercised, coifed, groomed, and perfumed (which is, after all, the main point of the ad).

Now the careless reader might feel tempted to leap to the conclusion that this hero of ours is some sort of wealthy playboy tycoon enjoying his winter vacation aboard his yacht. But nothing could be farther from the truth. If he were such a successful businessman, he would be reading *In Search of Excellence* instead of *Shogun*. His worktable would contain a laptop computer with a copy of the *Lotus Manual* close at hand instead of a chess set. And, instead of talking to his intrusive girlfriend, he would be calling his stockbroker for the latest quotations from Tokyo.

No, upon careful reflection, we soon realize that this fellow is actually the cabin boy left in charge of the boat while the owners do whatever boat owners do during the week (live on the island, run savings and loan associations, and/or deal drugs, for example). A boat this size would have a forward cabin with a big double bed. Obviously, he

doesn't sleep there. Equally obviously, somebody else—
namely the boat's owners—does or do sleep there (probably
on weekends, when our hero puts on his white pants and
white hat, serves as a member of the crew, and scurries
around making the owners and their guests feel welcome
by serving them tantalizing tropical drinks that he makes
in the blender located in the galley, but obscured from our
view by the mast).

One might think that this sort of itinerant domestic ser-
vant would be delighted to get a call from the passionate,
adoring, available woman in Room 16 who wants to see
him right this minute ("step on it, sailor"). But he treats her
with cruel indifference. He begins by correcting her use of
the English language, making her feel ignorant and poorly
schooled in the ways of the world. Next, he compounds the
offense by saying that he never thought he would hear her
say something nice. Then, clearly on a sadistic roll and un-
able to stop himself, he glides into a little self-indulgent
fantasy about the kind of females with whom he would os-
tensibly like to be spending his time ("a cabin full of doe-
eyed women in skimpy sarongs plying me with papaya and
passion fruit"). Admittedly, he parades this dream sequence
as a piece of joking banter. But we know from reading
Freud that such manifest content is only a thin disguise for
all sorts of illicit wishes desperately seeking fulfillment and
lurking ominously as latent meanings hidden beneath the
surface of the dream work.

Speaking of Freud, of course, we must not forget to look
for the phallic symbol featured prominently in this carefully
constructed commercial text. And there it is, leaping to our
attention at the bottom of the right-hand column—right
next to the bottle of Paco Rabanne, with which it becomes
intimately associated by virtue of its contiguity. Behold, it
is a telescope (penis analog) in the collapsed (flaccid) and
horizontal (impotent) rather than the extended (erect) posi-
tion. But notice also what a tiny telescope it is. This spy-
glass is literally dwarfed in size by the bottle of eau de toi-
lette next to which it lies.

So now—at last—we know the secrets of our tormented hero: a slovenly personal existence, the failure to find a decent self-respecting job, a sexually insecure indifference to heterosexual love, and (one infers) genitalia whose stature pales in comparison to the true object of the woman's attention and the advertiser's gaze—namely, the bottle of Paco Rabanne. In relative terms, the ratio in sizes of this bottle of eau de toilette versus this telescope as compared with that for a normal bottle versus a normal telescope is about 637-to-1. Thus, "what is remembered" about our hero—as emphasized by the last line of the ad—is not the power of his male sexuality. Rather, it is the sweet and slightly effeminate smell of his Paco Rabanne cologne. This aroma of our somewhat androgynous stud exerts a force so strong that, obsessed by the recollection of his odoriferous Paco, women follow him to the ends of the earth, even though he tends to treat them with callous disinterest once they arrive. In this connection, the last line invites scanning as the purest poetry. "What is remembered is up to you" places a strong accent on the word "up." The message is clear: If your little telescope just lies there in a collapsed heap, then "get it up" with Paco Rabanne—a gigantically effective magnet for dishonest, ignorant, able-bodied, weak-minded, and unquenchably horny women who will flatter your otherwise shaky and vulnerable male ego by chasing you around the globe even though you are a lazy, shiftless, vain, and self-satisfied but fundamentally insecure loser who does not deserve their amorous attention. Friends, you cannot and should not resist buying a big bottle of Paco Rabanne. And don't forget to flash that smile.

STERN'S READING: GENDER AND GENRE

The ad is a "telephone" drama with two characters: a man (first speaker, visible, whose part of the dialog is non-italicized) and a woman (second speaker, not visible, whose part of the dialog is italicized). The opening greeting sets the action in motion via a question—"hello?" is punctuated with a question mark, which is unusual in several respects. To begin, an opening salutation is often delivered as a de-

clarative or exclamatory statement and punctuated that way with either a period or exclamation point. Then, the "tag-question" (rising inflection at the end of a word or phrase) is more characteristic of women's language than of men's. The opening suggests that some gender-bending will occur, and prepares the reader for shifting sex roles and possible sexual ambiguity.

The (woman's) response clearly identifies the relationship as heterosexual, but one in which she has the dominant role. Perhaps the ambiguity will consist of dominator/dominatrix sexuality. This is hinted at in the first six words she says: "How would you like to come ..." The words could stand alone (a complete clause), and are sexually explicit if we recall the meaning of "come." She asks him, in effect, to "come and make" her—an open invitation to sex in the morning (note the sunlight streaming through the skylights and portholes). That is, the relationship is from the outset defined by sex, and the woman is portrayed as the aggressor—she sets the tone and delivers the seduction speech.

The woman says that if the man materializes, he will make a "dishonest woman" of her. This is an ambiguous comment. There are several possibilities here. If she were married, an illicit sexual affair would literally make her dishonest. Alternatively, if he were married, an illicit affair would make him literally dishonest and her at least morally dishonest. Of course, if they both were married, they would both be rather dishonest. Perhaps what is most intriguing is that she only mentions her own dishonesty and not her partner's—no matter the circumstance, apparently, she is going to end up paying both parties' wages of sin.

He follows her come-on with a question. By asking her where she is, the man indicates that he would indeed like to come on over. Her reply is elliptical because he interrupts her—she says "window" and he corrects her by saying, "Porthole." The interruption and correction are typical of male speech communication patterns—studies show that men tend to interrupt and correct women speakers far more often than the reverse. That is, to a male speaker, it is

normal to interrupt a seduction speech ... if a correction must be made. Perhaps he is a stickler for accuracy when yachting is at stake—even the neatly rumpled bed suggests a man who is fussy about his seagoing space.

The woman, on the other hand, seems more casual about time and space. She tells him that her plane just got in. If we assume that it is morning at sea, she had to be flying for at least some part of the night. Could they be in the South Seas? I think it's possible—Tahiti perhaps. In any case, she accepts the correction to "porthole"—note the sexual allusions in her conversation—"hole," "pink," "stucco" (pun for "stuck-Oh!"?). Finally, the overt reference to what she wants: "I'm in Room 16. First bed on the right." She makes no pretense to coyness in stating her sexual desires. His comment—that she told him she hated flying— indicates surprise that she made the trip. It also suggests that she traveled a long way, interesting since he is the one who stays put, and she commutes. This is another role reversal of sorts—she'll go to the ends of the earth for hot sex, but he won't budge.

She explains how to get over fear of flying—perhaps the discussion of flying is an allusion to Erica Jong. This makes some sense, since if the drama celebrates sexual awakening, Jong would be a reasonable antecedent. His surprise deepens—not only did she fly off to see him, but also, he says that he "never thought" he'd hear her say she missed him. This seems to be some more reversal—he indicates that she (unlike women in general) is not communicative about her feelings: she is not likely to articulate her sense of loss when they are apart. However, while she is not typically feminine in lack of emotional expression, he too is not typically masculine in indicating that he has been waiting for some expression of emotion from her. Apparently, she is better at expressing sexual needs than emotional ones.

She now in a long (7 line) speech reveals what is on her mind. This is done by the device of "I said to myself."... What she asks herself is why she is "up here" (civilization, a city, work?) while he is in the islands. This is a good

question—we never find out the answer. We can surmise that she has obligations requiring her to be somewhere other than a tropical island—another facet of the role reversal: she has a job perhaps (or a husband and family), and he is more of a free spirit.

In any case, she answers her question about what he is doing in the islands. One word in her answer is extremely revelatory—"damned." Women simply do not have the freedom men have to use expletives, obscenities, or slang—she uses about the strongest curse a woman can use without going beyond the pale of "polite" conversation. Again, she flouts the canons of normal female communication by using an expletive—BUT it is a mild one. The word suggests that she is quite unrepressed, but not whorelike.

Her comment that he is flashing his smile at "able-bodied and weak-minded women" is again sexual: "flashers" are men who expose themselves to women (often little girls). Her labeling of other women as sound of body/weak of mind suggests that while unrepressed, she is no feminist—the other women she imagines are not liberated adults, but rather, childlike sex objects. She does not demonstrate a positive view of either sex, for women are viewed as weak and men as seducers. So far, she seems to be the only functional adult—she has responsibilities elsewhere, but organizes them well enough to get on a plane, make hotel reservations, call ship-to-shore, and make a date.

He delivers his long speech (8 lines) now. The opening—"you've caught me at a bad time"—is chilling. It is a coded way of saying, "I am with someone else with whom I am sexually involved ..." The comment is a barely polite brushoff—the current version of "don't call me; I'll call you." That he would say this seems to indicate a fairly sadistic sense of humor—she flew a long distance and is waiting in bed for him, and he tells her that she's caught him at a bad time. I don't like him at all.

His next sentence continues his nasty humor—and also locates the drama in a tropical setting—doe-eyed women, sarongs, papaya, passion fruit. However, no matter the set-

ting, his view of women is rather unenlightened. His fantasy women are "plying" him with fruit and have "been teaching [him] the secret island ways of love." This delineates women's "place" in his mind: they provide food and sex. Barefoot and bikinied is best. Not only are their roles rather severely restricted—they never even get to be individuals—he has a "cabin full" of women (not one special one). This sounds like a male fantasy—lots of nubile willing women who want to give everything and get [him] as a reward—the ultimate stud.

She tells him to "shut up" but reminds him of her room number and orders him to "step on it, sailor." Interestingly, she takes command in this final speech in several ways: she is the one giving orders in a quasi-military mode (be quiet, remember to go to the right place, and hurry up). She apparently tolerates his kidding—as one would tolerate a child's joke?—long enough to jolly him into doing what she really wants him to do: get to her bed, fast.

In sum, the man and the woman seem to reverse stereotypical masculine and feminine traits—he is the dreamer, she the doer; he the seduced, she the seducer. If we were to give this ad a feminist role-reversed reading, that could be very interesting: imagine *him* saying her lines and vice versa. What you would get, I think, is a reasonable reading of male/female roles. The ad as it stands seems more counter-stereotype—hot-to-trot women and fussbudgety passive men are not as culturally acceptable.

COMPARATIVE ANALYSIS

The two interpretations just presented differ markedly in tone: for example, the titles given to their readings position Holbrook as whimsical or satiric ("Gigolo Guy and Bimbo Gal") and Stern as serious or scholarly ("Gender and Genre"). Further, they pursue divergent orientations: based on his background in marketing, Holbrook views the Paco ad as an ordinary print advertisement, whereas Stern's training in literary criticism leads her to read it as a telephone drama. As such, they draw on contrasting interpretive approaches: Holbrook focuses on the semiological

interpretation of consumption symbolism and scrutinizes various details of the picture with relatively less attention to the words, while Stern draws on the conventions of literary analysis and emphasizes the verbal dialog with less importance attributed to the ad's visual content.

Given their rather different interpretive styles, Holbrook and Stern construct surprisingly congruent readings of the central character. Based on numerous visual clues (coffee, sunlight, unmade bed, swim trunks, map, chess set, book, TV, coiffure, galley) and a few verbal hints (correction, insult, joking banter), Holbrook finds the Paco man to be lazy, casual, intelligent but lowbrow, servant-like, cruel, callous, indifferent, self-indulgent, slovenly, sexually insecure, effeminate, or even androgynous. Similarly, drawing primarily on aspects of the dialog ("hello?" with its gender-bending interrogative inflection, the interruption and correction concerning "porthole," the long speech about "doe-eyed women") with less mention of the pictorial details (the sunlight, the decor, the unmade bed), Stern regards the man as sexually ambiguous, heterosexual but dominated, typically male in his tendency to interrupt, a stickler for accuracy, chilling, barely polite, sadistic, unenlightened, and the "ultimate stud." Thus, even though the two interpreters start from different vantage points, they arrive at similar conclusions about the visible subject of the advertisement—the man in the photograph.

Where divergence occurs, it seems to result from focusing on what is *not* shown in the advertisement. Thus, when Holbrook and Stern delve into the aspects of what they "find" to be *missing* from the manifest content of the print ad, they differ in their interpretive approaches. For Holbrook, these missing ingredients concern (1) parts of the boat that cannot be seen (obscured behind the mast or behind the photographer in the forward cabin) but that imply a lowly cabin-boy status for the Paco man, and (2) latent meanings of visual clues provided by the telescope (collapsed, flaccid, tiny) as an apparent phallic symbol signifying Gigolo Guy's confused or insecure sexuality— that is, the aspects that Holbrook regards as missing tend

to hinge on the potential pictorial content. However, for Stern, the most important missing ingredients are verbal and concern the absent woman—known only through her verbal dialog—whom Stern reads as dominant, aggressive, ambiguously "dishonest," casual about time and space, reticent in communicating her feelings, bound by obligations and responsibilities elsewhere, unrepressed but not whorelike, and "no feminist." To some extent, this difference in focus may reflect the contrasting preoccupations of a man (Holbrook) and woman (Stern) looking for congenial material in the advertisement. However, in connection with the construction of advertising meaning out of hybrid language, we suggest that it mirrors the contrast between a semiological approach (focused on the visual consumption symbolism) and a literary approach (focused on the verbal dialog).

Finally, and somewhat surprisingly, given the sharp contrasts just identified—the two interpretations converge strongly in their views of the "bottom line" conveyed by the Paco Rabanne advertisement. Thus, Holbrook sees the print ad as aimed at a sexually insecure, androgynous, or potentially impotent but vain and self-satisfied "loser" who can gain self-esteem only by dousing himself in something that smells sickeningly sweet—a point that he illustrated as vividly as he could by mailing his analysis to Stern in an envelope *drenched* in Paco Rabanne (a gesture that aroused the fascinated curiosity of the mailman, the superintendent, and several other tenants in her apartment building). Meanwhile, Stern also singles out the sexually ambiguous orientation of the Paco Guy and concludes her initial interpretation with the following marketing-oriented postscript:

> He just isn't all-man to me. This makes sense, I think, in view of [the] target market and customer. I think the ad is aimed at a consumer whose sexuality is ambivalent, and that the ambivalence in the characters may be designed to inspire empathy with those of indeterminate sexuality.

82

REFERENCES

Carey, James W. (1988). *Communication as Culture: Essays on Media and Society.* NY: Routledge.
Culler, Jonathon (1982). *On Deconstruction: Theory and Criticism after Structuralism.* Ithaca, NY: Cornell University Press.
Firat, A. Fuat and Alladi Venkatesh (1995). "Liberatory Postmodernism and the Reenchantment of Consumption," *Journal of Consumer Research,* Vol. 22, pp. 239-267.
Fish, Stanley (1980). *Is There a Text in This Class? The Authority of Interpretive Communities.* Cambridge, MA: Harvard University Press.
Flynn, Elizabeth A. and Patrocinio P. Schweickart, eds., (1988). *Gender and Reading: Essays on Readers, Texts, and Contexts.* Baltimore: The Johns Hopkins University Press.
Hirschman, Elizabeth C., ed. (1989). *Interpretive Consumer Research.* Provo, UT: Association for Consumer Research.
Hirschman, Elizabeth C., and Morris B. Holbrook (1992). *Postmodern Consumer Research: The Study of Consumption As Text.* Newbury Park, CA: Sage.
Hobsbawm, Eric, and Terence Ranger, eds. (1983). *The Invention of Tradition.* Cambridge, UK: Cambridge University Press.
Holbrook, Morris B. (1975). *A Study of Communication in Advertising.* Ann Arbor, MI: University Microfilms International.
Holbrook, Morris B. (1987a). "Progress and Problems in Research on Consumer Esthetics," in *Artists and Cultural Consumers,* Douglas V. Shaw, William S. Hendon, and C. Richard Waits, eds., Akron: Association for Cultural Economics, 133-146. Also published as "Perception et Représentation Esthétiques du Consommateur: Progrés et Problèmes de la Recherche," in *Économie et Culture,* Vol. 1, Xavier Dupuis and François Rouet, eds. Paris: La Documentation Française, pp. 147-155.

Holbrook, Morris B. (1987b). "The Study of Signs in Consumer Esthetics: An Egocentric Review," in *Marketing and Semiotics: New Directions in the Study of Signs for Sale*. Jean Umiker-Sebeok, ed., Berlin: Mouton de Gruyter, pp. 73-121.

Holbrook, Morris B., and Mark W. Grayson (1986). "The Semiology of Cinematic Consumption: Symbolic Consumer Behavior in *Out of Africa*," *Journal of Consumer Research*, Vol.13, pp. 374-381.

Holbrook, Morris B., and Elizabeth C. Hirschman (1993). *The Semiotics of Consumption: Interpreting Symbolic Consumer Behavior in Popular Culture and Works of Art*. Berlin: Mouton De Gruyter.

Holbrook, Morris B., and Robert B. Zirlin (1985). "Artistic Creation, Artworks, and Aesthetic Appreciation: Some Philosophical Contributions to Nonprofit Marketing," *Advances in Nonprofit Marketing*, Vol. 1, pp. 1-54.

Hudson, Laurel A., and Julie L. Ozanne (1988). "Alternative Ways of Seeking Knowledge in Consumer Research," *Journal of Consumer Research*, Vol. 14, pp. 508-521.

Iser, Wolfgang (1978). *The Act of Reading: A Theory of Aesthetic Response*. Baltimore: The Johns Hopkins University Press.

Jauss, Hans Robert (1982). *Toward an Aesthetic of Reception* (translated by Timothy Bahti) Minneapolis: University of Minnesota Press.

Levy, Sydney J. (1981). "Interpreting Consumer Mythology: A Structural Approach to Consumer Behavior," *Journal of Marketing*, Vol. 45, pp. 49-61.

Mick, David Glen (1986). "Consumer Research and Semiotics: Exploring the Morphology of Signs, Symbols, and Significance," *Journal of Consumer Research*, Vol. 13, pp. 196-213.

Schweickart, Patrocinio P. (1988). "Reading Ourselves: Toward a Feminist Theory of Reading," in *Gender and Reading: Essays on Readers, Texts, and Contexts*. Elizabeth A. Flynn and Patrocinio P. Schweickart, eds., Baltimore: The Johns Hopkins University Press, pp. 31-62.

Sherry, John F., Jr. (1991). "Postmodern Alternatives: The Interpretive Turn in Consumer Research," in *Handbook of Consumer Behavior*, Thomas S. Robertson and Harold H. Kassarjian, eds., Englewood Cliffs, NJ: Prentice Hall, pp. 548-591.

Stern, Barbara B. (1965). *Entrapment and Liberation in James Joyce's Dedalus Fiction.* Ann Arbor, MI: University Microfilms International.

Stern, Barbara B. (1988). "Medieval Allegory: Roots of Advertising Strategy for the Mass Market," *Journal of Marketing*, Vol. 52, pp. 84-94.

Stern, Barbara B. (1989). "Literary Criticism and Consumer Research: Overview and Illustrative Analysis," *Journal of Consumer Research*, Vol. 16, pp. 322-334.

Stern, Barbara B. (1990). "*Other-Speak*: Classical Allegory and Contemporary Advertising," *Journal of Advertising*, Vol. 19, pp. 14-26.

Stern, Barbara B. (1991). "Who Talks Advertising? Literary Theory and Narrative 'Point of View'," *Journal of Advertising*, Vol. 20, pp. 9-22.

Stern, Barbara B. (1993). "Feminist Literary Criticism and the Deconstruction of Advertisements: A Postmodern View of Advertising and Consumer Responses," *Journal of Consumer Research*, Vol. 18, pp. 556-566.

Stern, Barbara B. (1994). "Interpretive Semiology and the Literature of Consumption: A New Reading of Advertisements and Consumer Produced Text." Review of *The Semiotics of Consumption,* by Morris B. Holbrook and Elizabeth C. Hirschman. *Semiotica*, pp. 35-67.

Stern, Barbara B. and Morris B. Holbrook (1994). "Gender and Genre in the Interpretation of Advertising Text," in *Gender Issues and Consumer Behavior*, Janeen Arnold Costa, ed., Thousand Oaks, CA: Sage, pp. 11-41.

Chapter 5

As Soft as Straight Gets: African American Women and Mainstream Beauty Standards in Haircare Advertising

INTRODUCTION

The portrayal of African Americans in advertising, as a whole, has gone through many changes over the last few decades. While in decades past African Americans were depicted stereotypically in servitude as porters, cooks, and maids, a contemporary advertisement might feature an African American in the role of a business executive. A black woman is even currently featured as the television spokesperson for AT&T telephones and long distance services. Moreover, one may also notice that there are now more beauty and cosmetic ads targeted at black women than in the past.

Laurie Freeman (1995) discusses the political economics of the $600 million ethnic health and beauty industry in an *Advertising Age* article entitled "Blending into the Mainstream." Freeman states that white manufactures of beauty aids are "mainstreaming" the ethnic haircare and cosmetics industry by creating separate product lines for African American women or by extending their regular lines to include ethnic items. She also notes that many minority-owned haircare and cosmetics companies are being purchased by larger white-owned companies eager to extend their product lines to this burgeoning market segment. At

one point, minority-owned companies were the primary source for ethnic health and beauty products. However, nonethnic health and beauty companies are marketing to blacks now more than ever. Freeman attributes this to the fact that African Americans and Hispanics are increasing in the United States population at a faster rate than whites. It has been projected that by the year 2050, Hispanics will comprise 21 percent of the U.S. population and African Americans will make up 16 percent (Arrarte and Barciela, 1993). Thus, advertisers are making a concerted effort to reach minority women as a potentially lucrative consumer market.

Some media critics (Joseph and Lewis, 1981; Brown, 1993; hooks, 1995a) contend that advertising perpetuates a false need for African American women to emulate white beauty standards and therefore should be critically analyzed. Advertising for haircare products marketed toward black women proliferates in magazines. But rather than embracing the natural beauty of black hair, the majority of the ads promote the alteration of black hair texture from its natural state into a "relaxed" or straightened state in order to attain social acceptance (hooks, 1992; Russell et al., 1992).

Very often, the black women that are featured in advertisements are those whose appearances conform to traditional Eurocentric ideals (Strutton and Lumpkin, 1993). Many current ads feature black models who look almost white, due to their light skin complexions. Strutton and Lumpkin (1993) point out in their article "Stereotypes of Black In-Group Attractiveness in Advertising," that empirical evidence dating back to the 1950s shows stereotyping in the selection of black models by advertisers. Moreover, they note that a disproportionately large percentage of black models used in ads possess light skin and Caucasian features.

The acceptance of ethnic notions of African American female beauty in advertising has been marginal. Moreover, it also appears that the images of black beauty that abound in current advertising are still defined by dominant white

societal discourses. In the essay "Eating the Other" featured in *Black Looks* (1992), bell hooks, discusses this issue in relation to multiculturalism:

> When the dominant culture demands that the Other be offered as a sign that progressive political change is taking place, that the American Dream can indeed be inclusive of difference, it invites a resurgence of essentialist cultural nationalism. The acknowledged Other must assume recognizable forms. (p. 26)

Pre-Civil Rights advertisements often portrayed blacks negatively in subservient roles as maids, butlers, or cooks like Aunt Jemima (Pieterse, 1992; Dates, 1993; O'Barr, 1994). However, the Aunt Jemima character still exists and is considered to be a part of the cultural history of America. Patricia Morton (1991) discusses the long history of the misrepresentation of black female images in American scholarship and media industries like advertising. She notes that the Aunt Jemima character is a continuation of the "mammy" stereotype and has been updated to reflect modernization. Keeping with the times, the Aunt Jemima character of today is illustrated on pancake boxes without her trademark bandanna and with relaxed hair (Moog, 1990; Edwards, 1993; Kern-Foxworth, 1994).

In this chapter, dominant cultural beauty standards mediated in print advertisements in relation to depictions of black haircare products for black women are examined. The aim of this chapter is not to measure the influence of advertising on African American women, but to examine the ideological and cultural messages that are disseminated through advertising in relation to black female beauty. Also, the usage of "Afrocentric" appeals as a marketing strategy in advertising is also taken into account. By studying advertisements targeted at specific groups, the communications researcher can uncover the cultural ideologies within them (Frith, 1990). As Sinclair (1987) notes:

> The study of advertising tells us that what the dominant commercial forces do is to construct these groups into 'markets' of 'consumers' who are addressed according to their 'demographic' characteristics. This is done in a way which selectively incorporates their actual cultural characteristics into messages so as to

invite them to identify with a commercialised image of themselves. (p. 38)

ADVERTISING AND BLACK BEAUTY STANDARDS

According to Joseph and Lewis (1981) and other more political researchers, advertising seems to advocate the emulation of whiteness and white beauty standards. Joseph and Lewis (1981) conducted a study in which they examined popular magazines read by both black and white women. The magazines with primarily white female readership were *Cosmopolitan, Seventeen, Harper's Bazaar, Glamour, Mademoiselle,* and *Viva.* The magazines that were used which had primarily black female readership were *Essence, Ebony, Jet, Black*Tress, Right On,* and *Black Star.*

Their content analyses revealed that the majority of advertisements in all of the magazines were for beauty products like hair dyes, clothes, jewelry, tampons, cosmetics, and perfume. They note that the media produces messages that suggest that a "cosmetically unenhanced" woman is unacceptable by society (Joseph and Lewis, 1981, 157). They mainly used *Essence* and *Cosmopolitan* to illustrate their argument, because they are two of the leading magazines for black and white women respectively. In an issue of *Essence* used in their analysis, they note that 56 ads (44.7 percent) out of 123 were for various beauty aids. In an issue of *Cosmopolitan,* they found that 181 ads (68 percent) out of 270 were for various beauty aids. They note that the reason for buying these beauty products was to attract a man. As a consequence, women envision themselves through the male gaze:

> For the vast majority of women, the motivation for buying this image comes from several sources: a conspicuous consumption culture; a conditioned mentality that says women must look a certain way; a socially constructed competitive urge to be equal to or better than other women in appearance; the desire to be appealing to and approved by men, by achieving and emulating "essences" of "natural" (?) femininity. The women thus become male-identified, in the sense that they dress and behave on the basis of male definitions and expectations of what it is to be a woman. (p. 158)

Joseph and Lewis concluded that the image of being a woman was constructed almost entirely through sexuality. They note that the concept of female beauty for both black and white women is based on standards set by white males, whom they feel are empowered in this society. They also discuss the problem of African American women being compared to the Eurocentric beauty standards, which surface in the media:

> White males created the values; White women strive for the image; and Black women run the spectrum in skin color, facial features, and hair textures. Those women having "White" or European features certainly have nothing to apologize for. It is the adulation, glorification, and exploitation of those features that is demeaning. (p. 159)

In their reading of the ads they surveyed, Joseph and Lewis feel that black women are encouraged to emulate white women by changing their appearance in order to be considered attractive:

> The Black women featured poses and clothing and styles and makeup similar to the White women, the major difference being that Black women must "become White" before they can do all the things the White women do (i.e., be the image). By altering their psychical state to appear with lightened skin and silky hair, Black women, too, can compete and thereby gain status and security by being with (having) a man. (p. 159)

Many black women often use relaxers to alter the natural texture of their hair by straightening it. It has been argued that the chemical straightening of black hair is done to replicate white hair texture (Sheperd, 1980; Joseph and Lewis, 1981; Russell et al., 1992). During the 1960s and 1970s, unprocessed black hair emerged as a political statement against Eurocentric beauty standards. One of the most popular hairstyles at the time was the Afro. As Russell et al., put it:

> When the Afro became fashionable during the sixties, it was radical in more ways than one. It not only associated the wearer with the politics of the Black Power movement, but, for women, it also signaled the abandonment of the hair-straightening products they had been conditioned to use since childhood. The Afro

eventually went the way of all trendy hairstyles, and by the mid-seventies most blacks returned to processing their hair. (p. 47)

Mercer (1994) notes that the Afro hairstyle as well as dreadlocks are not "natural" and their creation arose out of political protest by blacks in the United States and in the Caribbean, respectfully:

> With varying degrees of emphasis, both invoked "nature" to inscribe Africa as the symbol of personal and political opposition to the hegemony of the West "over the rest." Both championed an aesthetic of nature that opposed itself to any artifice as a sign of corrupting Eurocentric influence. But nature had nothing to do with it! Both these hairstyles were never just natural, waiting to be found: they were stylistically cultivated and politically constructed in a particular historical moment as part of a strategic contestation of white dominance and the cultural power of whiteness. (p. 108)

Afrocentric hairstlyes can have direct ties to the continent of Africa. Beaded braids and cornrows are two styles that have been said to have ties to Africa (Long, 1970; Russell et al., 1992; Mercer, 1994). However, this connection to Africa does not make beaded braids and cornrows any more "natural" than the Afro and dreadlocks, because they are nevertheless headdress creations (Mercer, 1994).

The beauty practice of hair straightening existed even during slavery. According to one source, female slaves usually had their heads covered with bandannas, but sometimes straightened their hair with hog lard, margarine or even axle grease (Russell et al., 1992, 43). These authors note that during and after slavery, many black women, in an effort to "enhance" their appearance, often attempted to emulate the straight hair that white women and many mulatto black women possessed.

Advertisers have come under fire recently by media critics and scholars alike for their promotion of Eurocentric beauty standards and the preferential usage of lighter-complexioned models in their ads (Brown, 1993; Keenan and Woodson, 1994). Clinton Brown (1993) points out that the diversity of black beauty is rarely shown in advertising, while diverse images of white women abound. He points

out that the controversy surrounding skin color and black features, as presented in the various incarnations of the media, still persists. Brown says that cultural institutions such as the film and advertising industries often use lighter-complexioned black women as paradigms of African American beauty. Brown notes that advertisers adhere to a strict standard in which lighter-complexioned black models appear more frequently in ads and are favored by advertisers, who are predominantly white.

hooks (1995b) discusses the preferential usage of lighter-complexioned black female models by the media over darker-complexioned black female models. In *Killing Rage: Ending Racism,* she discusses the issue of color-caste hierarchies in society at great length. She notes that these hierarchies embrace the issues of both skin color and hair texture (hooks, 1995b, 126). Moreover, she radically states that this phenomenon affects black women more than it does black men:

> The exploitive and/or oppressive nature of color-caste systems in white supremacist society has always had a gendered component. A mixture of racist and sexist thinking informs the way color-caste hierarchies detrimentally affect the lives of black females differently than they do black males. Light skin and long straight hair continue to be traits that define a female as beautiful and desirable in the racist white imagination and in the colonized black mindset. Darker-skinned black females must work to develop positive self-esteem in a society that continually devalues their image. (p. 127)

According to hooks, dark skin is stereotyped as being indicative of masculinity. Thus, the darker a black female is, the more masculine she will be perceived as being. In contrast, hooks states that black males are empowered in media representation by their dark skin (hooks, 1995b, 129). Thus, the lighter and more Caucasian appearing a black female is, the more appealing and feminine she will be considered. As a consequence, hooks states that bi-racial looking black women have a prominent place within the hierarchy of black beauty in the media and society at large. However, this group does not represent the majority

of black women. Thus, this look sets a standard for beauty that is unattainable by most black women.

ANALYSIS OF HAIRCARE ADS FOR BLACK WOMEN

Numerous black magazines such as *Ebony, Today's Black Woman, Upscale,* and *Essence* are filled with ads for relaxers and other products that change the hair texture of black women from its natural curly texture into a straighter form. These magazines thus provide black female consumers with a barrage of media messages that suggest the inferiority of their natural traits and characteristics. McCracken (1993) notes that black magazines like *Essence* often feature ads for haircare products which come into conflict with its messages of black liberation, education, and politicization:

> These ads include hair dyes, relaxers, permanents, activators, shampoos, wigs, and gels, often encouraging readers to pursue white ideals of beauty. Although the Black community purchases these products, such ads often conflict with *Essence's* progressive editorial material which encourages Black liberation and self-confidence. (p. 227)

Several themes appear quite often in haircare beauty ads featured in black women's magazines that suggest the "inferiority" of black female hair texture:

Theme 1. Black hair is naturally, constantly dry, brittle, damaged, and untouchable

Theme 2. The natural texture of black hair is unmanageable, wild, and out of control

Theme 3. Unprocessed black hair is not as attractive as relaxed or naturally straight hair

In this section, I deconstruct some of the themes and symbols that are used in beauty ads aimed at African American women. The ads are typical examples of this genre and were chosen from magazines aimed at African American women, such as *Essence, Today's Black Woman, Class,* and *Upscale.*

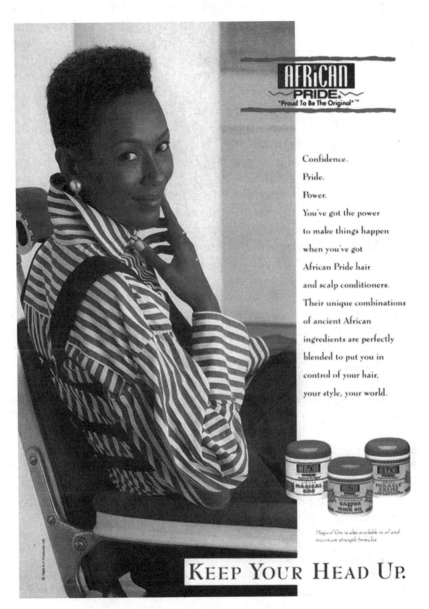

Figure 5.1

The first ad, shown in Figure 5.1, is for African Pride haircare products and appeared in the April 1996 issue of *Today's Black Woman.* As noted earlier, advertising campaigns are often made to appeal to specific target markets. The manufacturers of African Pride have created a promotional image for a product line that is imbued with cultural codes. In this ad, there are many signifiers that link the product to Africa including the phrase in the copy claiming that the product is made of "ancient African ingredients." The color scheme of the packaging was tropical with bright greens and reds, referring to the many African national flags that use these colors. The name of this product, African Pride, has an almost mythic meaning. Its name alludes to the continent of Africa, the place in which ancestors of many African Americans originated. It also links the product to the rich history of a deracinated race of people in America, due to chattel slavery.

This ad features a brown-complexioned black model, facing the reader with a slight smile. She is shown with curly, short hair that appears slightly processed and has a reddish tint. She appears to be seated in a hair stylist's chair, which conveys the idea that she is a haircare professional. She is shown wearing a pants suit outfit with an array of suspenders that look like they belong on a straitjacket!

At a deeper level of analysis, this ad presents a clear example of the liberated woman or "superwoman" stereotype (Kilbourne, 1995). The copy in the ad mainly focuses on the concept of taking control by using words like "confidence," "pride," and "power" in the body copy. The ad notes that a black woman can "control the world" after she gets her hair under control:

> "You've got the power to make things happen when you've got African Pride hair and scalp conditioners. Their unique combinations of ancient African ingredients are perfectly blended to put you in control of your hair, your style, your world."

The message of the ad metaphorically ties the black model's control over her bodily appearance with control

over her socio-economic environment (Goldman, 1992, 111). Goldman notes that advertisers often appropriate and commodify the ideology of feminism for their own purposes:

> Advertisements frequently represent women taking control and power over their lives and relationships through their commodified articulation of feminine appearance. This model of social power proposes that autonomy and control can be obtained through voluntary self-fetishization. (p. 108)

Also, the product name "African Pride" becomes synonymous with the phrase "black pride." To African Americans, to have "black pride" is to be proud of one's race and heritage. The last line of copy is a patronizing advertising ploy designed to tie into the notion of fostering black pride in black women. It states: "Keep your head up."

African Pride can be considered as a product line and as a symbolized commodity with cultural and psychological significance. As Wernick (1991) notes:

> Naming a product both facilitates the pinning of a borrowed meaning to it, and fixes its association as a sign. It also connects the product to its manufacturer. Indeed the first function has followed from the second. Brand-names developed out of patents as a way to lay title, against stealers and forgers, to the personal ownership of the formula, invention or design embodied in a product. (p. 33)

The African Pride logo is fashioned in a manner that recalls tribal markings. Beneath the name is the statement: "Proud to be the original." This statement makes it seem as if this brand were the first to relate its image to Africanness. It also suggests that the manufacturers of the brand are of African descent. However, the company that manufactures African Pride, Shark Products, is largely owned and operated by whites.

In fact, Shark Products, has tried to "lay title" to the personal ownership of all African motifs and imagery in advertising by suing other companies that use the word "African" or the African colors of red, black, and green in their ads. It seems that the name of the company is very appropriate.

In response to the lawsuit, a one page advertisement appeared in the August 1994 issue of *Class* magazine (Figure 5.2). It was printed by a consortium of black owners of haircare companies in protest of the legal actions of Shark Products. These companies have taken the position that they have as much right to use African imagery in advertising as Shark does.

Author and frequent *Village Voice* columnist Lisa Jones (1994) comments on the absurdity of the situation in her book *Bulletproof Diva: Tales of Race, Sex, and Hair*. She states that it is ridiculous for any person or company, black or white, to try and declare ownership of "African," just as one might own brand names like Subaru or Pepsi. She contends that it is absurd for a white-owned company to try and obtain legal sanction to prevent black-owned companies from using their continent of heritage as a means of drawing black consumers (Jones, 1994, 300). Moreover, she notes that a long list of products with African heritage inspired marketing concepts existed before African Pride's debut in 1991:

> Do a federal trademark search and you'll find scores of products that use "African" as a prefix (like African Queen cologne) or a derivative (Afroshave shaving products or Afro Sheen, hair dress, circa 1971). These include nearly a dozen hair tonics, some registered long before African Pride. (p. 300)

At the bottom of the ad in *Class*, the logos of various black-owned haircare companies are shown. Each of these companies belongs to AHBAI (American Health and Beauty Aids Institute), an organization that represents black manufacturers. AHBAI is not in favor of larger white haircare companies using Afrocentric appeals to attract black consumers:

WHO'S THAT LADY

AHBAI
THE PROUD LADY

Our symbol of economic strength, unity and pride.
Purchase Black hair care and beauty products that
feature the Proud Lady Symbol and recycle your
Black dollars in the community!
It's good for Black America!

Did you know . . .

That since Shark Products, makers of African Pride, a majority white-owned company
initiated lawsuits against two Black-owned companies for the use of the word "African"
and use of African colors red, black and green, consumers are more concerned about which
products they buy. The best way to be sure the products you buy are manufactured by a
Black company is to look for the Proud Lady.

Support Black-Owned Businesses Featuring the Proud Lady Symbol

For a complete list of all majority white-owned and black-owned products, contact AHBAI headquarters
401 N. Michigan Ave., Chicago, IL 60611; phone 312/644-6610

Figure 5.2

98

AHBAI calls white companies' use of Afrocentric marketing
"deceptive" to black consumers, who often assume these com-
panies are owned by blacks and that their revenue goes back to
African Americans in the form of jobs or community programs
(Jones, 1994, 301)

Each of the black companies listed in the ad place the
"proud lady" symbol, a silhouette of a black woman with
wavy hair, and the AHBAI logo on their products to let the
consumer know that they are black-owned.

Another ad (Figure 5.3) that is typical of this genre, ap-
peared in the May 1996 issue of *Essence,* and is for PCJ
Pretty-N-Silky hair relaxer for black girls. This type of ad is
not uncommon in black magazines targeting black women.
Other relaxers for young black girls are Dream Kids from
African Pride and Beautiful Beginnings from Dark and
Lovely. At the surface level, the Pretty-N-Silky ad shows a
black mother with her two young daughters, aged about 6
and 7. All of the models are smiling and appear to be hav-
ing a good time. In the lower right-hand corner of the ad is
the box for the product. The box has lots of confetti and
colorful balloons on it, which give the impression of a
party-like atmosphere. Another smiling little black girl, who
has relaxed hair styled in loose curls, is pictured on the
box.

Upon closer examination, one can see the emphasis
upon a mother's love and concern for the care of her chil-
dren. The body copy illustrates the gratitude the mother
appears to feel for the invention of a chemical relaxer for
her children that is fairly safe to use: "I only use PCJ
Pretty-N-Silky Children's No-Lye Relaxer. It's improved
conditioning formula has less harsh chemicals than most
other relaxers. So it's virtually irritation free!" Above the
image of the product box the copy also reads: "Mother's
trust PCJ Pretty-N-Silky."

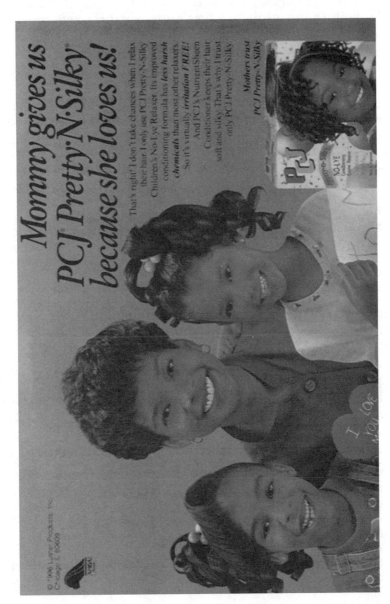

Figure 5.3

At the ideological level, it is apparent that this ad is really selling an adult product that can be used on young children. A young black girl would probably experience severe scalp burns, eye injury or even have all of her hair fall off if she used this chemical treatment unsupervised by an adult. Thus, the ad targets black mothers who would buy this product to apply it on their female children. In the article, "Straightening Our Hair," noted author, bell hooks, mentions that the act of having one's hair straightened for the first time can be interpreted as a rite of passage into womanhood for black girls (hooks, 1995a, 199). However, she notes that this beauty ritual is concerned with the racial dynamics of cultural ideology:

> The reality is: straightened hair is linked historically and currently to a system of racial domination that impresses upon black people, and especially black women, that we are not acceptable as we are, that we are not beautiful. (p. 297)

The Pretty-N-Silky ad emphasizes the idea that black hair in its natural state is unmanageable and untouchable. The copy notes that this product will make it easy for the mother to take care of her daughters' hair: "And PCJ's Nutrient Sheen Conditioner keeps their hair feeling soft and silky. Styles easy too!" Hopson and Hopson (1990) emphasize that black children should be taught about cultural differences and racial prejudice at an early age. They also note the importance of fostering positive self-esteem in black girls, especially concerning cultural differences like skin color and hair texture:

> For example, if you continually tell your daughter that her curly hair is attractive and makes her look good, she will develop pride in her appearance. If you complain about her "nappy" hair and how difficult it is to comb, however, she will probably come to resent her hair and think that it is inferior to other types of hair. So, by pointing out their attributes in positive ways, we can help our children to form healthy mental pictures of themselves. (p. 26)

The headline of this ad is also an example of how parental guilt can be positioned as a selling device: "Mommy gives us PCJ Pretty-N-Silky because she loves us!" The

headline ties into the visual image beneath it. The two little girls are holding handmade signs that express their affection toward their mother, a paper heart and a hand-drawn poster. Obviously, the advertisers have staged this scene to make it appear that the girls are extremely elated to have their hair straightened. However, what message does this ad really communicate to black mothers and black women in general? Perhaps, it is suggesting that a black mother who does not relax her daughter's hair is not a good mother. Also, it suggests that a black girl whose hair is unprocessed is not "pretty." There are no products marketed directly to little white girls that chemically alter their hair texture from its natural state. However, the ad implies that black girls should alter their hair as soon as possible in order to become more attractive. Ultimately, black females in this culture often feel that they must relax their hair in order to be accepted in society.

WHITE WOMEN AS ABSENT REFERENTS IN ADS

In her book *Decoding Advertisements: Ideology and Meaning in Advertising*, Judith Williamson (1978) discusses the systems of meaning or "referent systems" being used in ads. Simply put, advertisements often refer to pre-existing historical, social and ideological systems, which are "drawn into the work of the ad" (Williamson, 1978, 99). She notes that the usage of nature in ads is illustrative of this notion. For example, cars and trucks are often depicted in ads defying natural phenomena, such as rain and snow. She also notes that the intended audience of an advertisement functions as an active receiver by taking part in the creation of meaning in an advertisement (Williamson, 1978, 41). Drawing upon his or her pre-existing familiarity with the potential hazards of changing weather conditions, a spectator of a truck commercial may want to buy the vehicle advertised over another, because it handles better in the rain.

Ads are created with intended meanings or "preferred readings" (Goldman, 1992, 40). However, they sometimes carry additional ideological messages that may not have

been intended for interpretation by the audience as in the next ad for Revlon Realistic Extra Conditioning Creme Relaxer (Figure 5.4). The ad appeared in the November 1994 issue of *Upscale* magazine. It features two black models, a woman and a man. They appear to be in an amorous embrace, and both have their eyes closed. The headline reads: "If you don't believe how hair this straight could possibly feel so soft, ask a friend." The advertising message emphasizes that this product will straighten black women's hair and also make it soft to the touch. The female model in the ad is shown leaning over the man with her relaxed hair draped on his chest, making her appear as if she is fawning for his attention. This positioning tied with the text communicates to the reader that black women will be considered more attractive to men if they use this product to straighten their hair.

In our society, dominant cultural standards of beauty are often perpetuated in ads (Joseph and Lewis, 1981; Wolf, 1991). This ad suggests that the primary reason for black women to straighten their hair is to attract a man and that the curly, natural texture of black female hair is devoid of softness, and therefore, is not attractive to men. Thus, a black woman can increase her desirability by using this product to alter her black hair texture into "realistic" soft, straight hair as noted in the body copy: "And with the aid of Realistic's new Extra Conditioning Maintenance Line with Restora, this softness exists all the way through to your finishing touches." The last lines of copy in the ad seem to equate "soft hair" only with white women. It reads: "Revlon Realistic. As soft as straight gets." The word "straight" in the copy seems to refer to white female hair texture, because white women are characterized as usually having straight hair, and thus to suggest that white females are the archetype of beauty to all men. Dominant cultural beauty standards can be implicit in ads even when white women are not present. As a consequence, white women and their inherent characteristics can appear as "absent referents" in advertisements (Adams, 1991, 44).

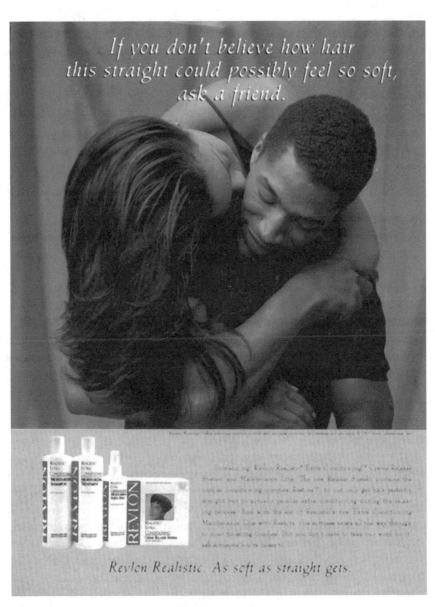

Figure 5.4

CONCLUSIONS

There is a definite need for a critical pedagogy that is con-
cerned with advertising and its relation to culture (Frith,
1995). Advertising has emerged as a social indicator of
contemporary social values and trends and it plays an im-
portant role in society (Kellner, 1991). Kellner (1991) states
that media images, such as print advertisements, should
be a primary concern of critical pedagogy:

> Furthermore, the significance of advertising for education is
> many-sided. Advertising constitutes one of the most advanced
> spheres of image production with more money, talent, and en-
> ergy invested in this form of culture than practically any other in
> our hypercapitalist society. Advertising is itself a pedagogy which
> teaches individuals what they need and should desire, think,
> and do to be happy, successful, and genuinely American. Adver-
> tising teaches a worldview, values, and socially acceptable and
> unacceptable behavior. (p. 66)

Thus, the study of advertisements aimed toward mi-
norities is very important. African Americans as a whole
have struggled to attain equality in the educational system,
the workplace, and other environments. As a result of the
civil rights movement, many of the current advertisements
reflect these socio-economic changes (Dates, 1993; O'Barr,
1994).

In this chapter, I have explored beauty standards con-
cerning African American women in print advertising for
haircare products. Critics such as bell hooks (1992), Rus-
sell et al. (1992), and Clinton Brown (1993) note that ad-
vertising images proliferate which perpetuate the false need
for African American women to emulate mainstream beauty
standards. Taking into account what these critics have dis-
cussed, the notion of beauty in relation to the representa-
tion of African American women was examined.

Lastly, advertisers should carefully consider both the
apparent and underlying advertising messages that are
disseminated through their marketing efforts. Advertise-
ments that are created in an attempt to appeal to target
audiences should not intentionally or unintentionally de-
mean the inherent cultural characteristics of the intended

audience. A certain amount of cultural sensitivity needs to be taken into account when marketing to African American women and minorities as a whole.

REFERENCES

Adams, Carol J. (1991). *The Sexual Politics of Meat.* New York: Continuum.

Arrate, Anne Moncreiff, and Susana Barciela (1993). "A Snapshot of the New America," *The Miami Herald,* February 22, 1993.

Brown, Clinton (1993). "Which Black is Beautiful?" *Advertising Age,* February 1, p. 16.

Dates, Jannette L. (1993). *Split Image: African Americans in the Mass Media.* Washington, D.C.: Howard University Press.

Dyer, Gillian (1982). *Advertising as Communication.* London: Methuen.

Edwards, Audrey (1993). "From Aunt Jemima to Anita Hill: Media's Split Image of Black Women," *Media Studies Journal.* Vol. 7, No.1/2, pp. 214-22.

Freeman, Laurie (1995). "Blending into the Mainstream," *Advertising Age.* July 17, pp. S2-S3.

Frith, Katherine T. (1990). "Undressing Advertisements: A Technique for Analyzing Social and Cultural Messages," paper presented at the 1990 Association of Education in Journalism and Mass Communication Conference, Minneapolis, MN.

Frith, Katherine T. (1995). "Advertising and Mother Nature," *Feminism, Multiculturalism and the Media,* in Angharad N. Valdivia, ed., Newbury Park, CA: Sage.

Goldman, Robert (1992). *Reading Ads Socially.* London: Routledge.

hooks, bell (1981). *Ain't I a Woman: Black Women and Feminism.* Boston: South End Press.

hooks, bell (1992). *Black Looks: Race and Representation.* Boston: South End Press.

hooks, bell (1995a). "Straightening Our Hair," in *Reading Culture: Contexts for Critical Reading and Writing,* Diana George and John Trimbur, eds., New York: Harper Collins.

hooks, bell (1995b). *Killing Rage: Ending Racism.* New York: Henry Holt.

Hopson, Darlene, and Derek S. Hopson (1990). *Different and Wonderful: Raising Black Children in a Race Conscious Society.* New York: Prentice Hall Press.

Jones, Lisa (1994). *Bulletproof Diva: Tales of Race, Sex, and Hair.* New York: Anchor.

Joseph, Gloria, and Jill Lewis (1981). *Common Differences: Conflicts in Black and White Feminist Perspectives.* New York: South End Press.

Keenan, Kevin, and Laureece A. Woodson (1994). "Colorism in Advertising: Issues Related to Race and Gender in Mainstream and African American Women's Magazines," paper presented to the AEJMC Advertising Division, Atlanta, GA.

Kellner, Douglas (1990). "Advertising and Consumer Culture," in *Questioning the Media: A Critical Introduction,* John Downing, Ali Mohammadi and Annabelle Sreberny-Mohammadi, eds., Newbury Park, CA: Sage.

Kellner, Douglas (1991). "Reading Images Critically: Toward a Postmodern Pedagogy," *Postmodernism, Feminism, and Cultural Politics,* Henry A. Giroux, ed., New York: State University of New York Press.

Kern-Foxworth, Marilyn (1994). *Aunt Jemima, Uncle Ben, and Rastus.* New York: Greenwood Press.

Kilbourne, Jean (1995). "Beauty and the Beast of Advertising," in *Reading Culture: Contexts for Critical Reading and Writing,* Diana George and John Trimbur, eds., New York: Harper Collins.

Long, Ted (1970). *Hair Styles for the Black Woman.* New York: Cornerstone Library Publications.

Mayes, Ernest M. (1996). "Images of Black Women in Print Advertisements in Relation to Dominant Cultural Standards of Beauty," M.A. thesis, The Pennsylvania State University.

McCracken, Ellen (1993). *Decoding Women's Magazines: From Mademoiselle to Ms.* New York: St. Martin's Press.

Mercer, Kobena (1994). *Welcome to the Jungle: New Positions in Black Cultural Studies.* New York: Routledge.

Moog, Carol (1990). *"Are They Selling Her Lips?": Advertising and Identity.* New York: William Morrow.

Morton, Patricia (1991). *Disfigured Images: The Historical Assault on Afro-American Women.* New York: Greenwood Press.

O'Barr, William (1994). *Culture and the Ad: Exploring Otherness in the World of Advertising.* Boulder, CO: Westview Press.

Pieterse, Jan N. (1992). *White on Black: Images of Africa and Blacks in Western Popular Culture.* New Haven, CT: Yale University Press.

Russell, Kathy, Midge Wilson and Ronald Hall (1992). *The Color Complex: The Politics of Skin Color Among African American.* New York: Harcourt Brace Jovanovich.

Sheperd, Juanita M. (1980). "The Portrayal of Black Women in the Ads of Popular Magazines," *Western Journal of Black Studies,* Vol. 4, pp. 179-182.

Sinclair, John (1987). *Images Incorporated: Advertisng as Industry and Ideology.* New York: Croom Helm.

Strutton, David, and James R. Lumpkin (1993). "Stereotypes of Black In-Group Attractiveness in Advertising: On Possible Psychological Effects," *Psychological Report,* Vol. 73, 507-511.

Wernick, Andrew (1991). *Promotional Culture: Advertising, Ideology and Symbolic Expression.* Newbury Park, CA: Sage.

Wolf, Naomi (1991). *The Beauty Myth: How Images of Beauty Are Used against Women.* New York: Doubleday.

Williamson, Judith (1978). *Decoding Advertisements: Ideology and Meaning in Advertising.* London: Marion Boyers.

Chapter 6

We Can't Duck the Issue: Imbedded Advertising in the Motion Pictures

Linda K. Fuller

"Product placement"—advertising brand-name goods by showing them in films or TV shows—is increasingly common, but few viewers are aware that it exists. Because corporations take great pains to ensure that their products are shown in a favorable context, they encourage the viewer to associate their product with pleasant scenes, likable characters, romance, glamour, and fun.

Michael F. Jacobson and Laurie Mazur

INTRODUCTION

As corporate sponsors and advertisers alike increasingly turn to the medium of film for their target markets, it behooves us as both consumers and students of media communication to be educated on this growing phenomenon. While the debate has long raged regarding how much of film is aesthetic and how much is cultural artifact, this chapter doesn't pretend to answer that question definitively; rather, what it proposes to do is attempt to deconstruct, by means of a popular Disney movie and its sequels—*The Mighty Ducks* (1992), then *D2* (1994) and *D3* (1996), case studies in terms of imbedded advertising. Im-

plications and suggestions for future research, particularly relative to younger viewers, are drawn.

Parents, we know, have long been concerned about how many commercials their children are exposed to on television. What they should be wary of, you will learn here, is a more insidious form of advertising: products and ideas that are more subtlely introduced at a subconscious level. While both audiences and advertisers were intrigued with James M. Vicary's 1957 experiments on subliminal messages that flashed dictums to "Drink Coca-Cola" during a screening of *Picnic*, that seemingly couched or "hidden" approach is no longer necessary, as overt examples abound. Today, all the major motion picture studio bureaucracies have product-placement agencies that figure in the initial process of determining even whether a motion picture should be made— that is, what is its potential for including profit-spurring imbedded commercials.

As Jacobson and Mazur (1995) note, "Imagine the impact of your customers seeing their favorite star using your product in a feature film. Both YOUR COMPANY'S NAME AND PRODUCT thereby become an integral part of the show, conveying both subliminal messages and implied endorsements" (p. 67). What follows are some considerations about that product placement vis-à-vis merchandising tie-ins, cross promotions, and the wider issue of imbedded advertising in film.

TIE-INS, PROMOS AND IMBEDDED ADS
Historical/aesthetic considerations

Although Disney was the first studio to introduce the concept of film merchandising—with its 1937 *Snow White and the Seven Dwarfs*, only recently has this practice become de rigeur in the advertising industry for films. "Indeed, only within the last decade have studios initiated in-housing merchandising units within their marketing departments," states Justin Wyatt (1994, 149). In 1982 when *E.T.* gobbled up his famous Reese's pieces and their sales increased 300 percent the trend took off. Sterritt (1995)

notes that M&Ms had turned down director Steven Spielberg's offer to feature their product. That same year, Coca-Cola bought 49 percent of Columbia pictures and Tom Cruise downed a Coke and also increased sales of Ray-Ban aviator sunglasses by 40 percent in *Top Gun*. Four years later, in 1986, it would seem that every motion picture studio had taken note.

"Whether a filmgoer is absorbing a story, a news event, or visual poetry," Stromgren and Norden (1984, 14) remind us, "the film experience is a marvelously varied and complex process and is determined by a combination of technological processes and human traits, both psychological and physiological." Image and ideology, then, are inherent factors in the equation.

While some scholars of film aesthetics (e.g., Wollen, 1972; Silverman, 1983; Gianetti, 1993; Bordwell and Thompson, 1990) focus on the directorial techniques used to convey meaning, others (e.g., Marsden et al., 1982; Rollins, 1983; Wood, 1989; Fuller, 1992a) concentrate on the particular objects and/or stereotypes being employed in that process, seeking to understand them within a sociocultural critical nexus. "Cinema has been studied as an apparatus of representation, an image machine developed to construct images or visions of social reality and the spectators' place in it," argues DeLauretis (1984, 37).

Interpretation of those images and ideologies, then, depends on varying aspects of selective exposure, perception, and retention—combined with our own unique demographic and psychographic composition. "The relationship between the film and the viewer is affected as much by what he brings to the film experience as it is by the film itself," claims Roy Paul Madsen (1973, 12). Yet, as Nathaniel West said long ago, the business of films is the business of dreams. Arthur M. Schlesinger, Jr. (in O'Connor and Jackson, 1988) has noted:

> Ostensibly American movies have been dedicated to the reinforcement of middle-class morality. Certainly they have done their share to strengthen capitalism, chauvinism, racism, sexism, and so on ... Thus, the American movie has provided a

common dream life, a common fund of reference and fantasy, to a society divided by ethnic distinctions and economic disparities. (p. xiv)

Concern for the "power of movies," particularly in terms of what he labels Hollywood International, is the theme of Noel Carroll's (1988, 208) attempts to demystify them. He traces how, "Contemporary film theorists have attempted to explain the ideological effect of film by means of their analyses of the cinematic image, large-scale film narration, and processes of visual narration such as the shot/reverse shot figure, point-of-view editing, and so on." Carroll, however, denies these structures as being inherently ideological, maintaining that, "ideology in film is a matter of the content of specific films and their rhetorical organization, and of the generally antecedent belief systems spectators bring to films" (p. 208).

Socio-Economic Considerations

Film audiences are an easily definable group for advertisers to niche-market, falling as they predominantly do into the 15 to 34 age range and in a medium to medium-high income demographic category—although our particular concern here is for even younger movie-goers. Films themselves, among other things, offer an outlet for a number of products otherwise banned or discouraged from traditional advertising outlets, like cigarettes and alcohol.

The movies offer a particularly appealing means for any number of promotions. For one thing, they can often be tailored to fit multiple viewings, ranging from the theater to home rental/video use and/or in terms of their own promos themselves. "It is not just that products get exposure in a movie with the placement, and the movie companies get monetary compensation or the use of free props," writes Matthew P. McAllister (1996). "The movie company and its cross-promotional partner are strategically using the product placement to maximize the commercial benefits of the activity" (p. 164). Be it a trailer, a teaser, a billboard, a video jacket, or any other means of promotion, products can easily be inserted in print as well as broadcast media.

Placement companies, lucrative growth industries, receive scripts weeks or months before filming starts—giving them a chance for scene-by-scene analysis of opportunities for "plugging." As Wasko et al. (1993) argue, motion pictures stressing economic predictability and symbolic safety are the most promotionally attractive ones.

When Huggies is willing to pay $100,000 to be the diaper of choice in *Baby Boom* (1987), as was the case, consider the impact when advertisers have control over motion picture plot and dialog. In *It Could Happen To You* (1994), for example, a sandwich-making character is asked by her friend if she has Miracle Whip. "Of course I have Miracle Whip," comes the retort. "Miracle Whip is like one of the basic necessities of life that everyone has to have no matter how broke they are." Considering that the basic theme of that movie involved winning the lottery, the overall message unwittingly appeals to our fantasies. *Other People's Money* (1991) has star Danny DeVito making no fewer than nine references to Dunkin' Donuts. Or take *Reality Bites* (1994), a virtual paean to advertising. Pushing its catchy soundtrack throughout, the film features Generation Xers going to The Gap, slurping Seven Eleven's Big Gulp, Rolling Rock, and Minute Maid orange soda, using and talking about Continental Airlines, BMWs, Snickers, Pringles, Pizza Hut, Eastman Corporation, Camels, and much, much more. While some might argue that an emphasis on consumption is the bottom line point of this pic, the imbedded advertising actually is distracting.

Appealing to yet another demographic movie-goer is *Menace II Society* (1993), an inner-city film featuring these products in these frequencies: drinks (19 Old English, 800 40 oz. malt liquors, 20 Coors 40 oz. malt liquors, 11 Cokes, 3 Coors regular 10 oz. beers, 2 Coke signs, 2 Budweiser neon and one Beefeater signs, and at least one image and/or conversation over St. Ides 40 oz. malt liquor, Gatorade, and a Dr. Pepper soda machine); cars (7 Ford Mustang convertibles, 4 Nissan Maximas, 3 Ford hardtop Mustangs, 2 BMWs, and one each Pontiac, Chevy, Nissan Sentra, and

Honda Civic); tobacco/drugs (10 instances of marijuana, 5 cigarettes, and of course Marlboro); firearms (18 9mm Berrettas, 15 Uzi full-automatics, 14 9mm Glocks, 5 12-gauge Mossberg shotguns, 3 9mm Techs, 2 44 Desert Eagles, and a 9mm nickel-plated Berretta); an emphasis on Cross Colours shirts (14), but Guess Jeans and Chicago White Sox clothing and Nike also figured in, and random other products like Trojan condoms, Bicycle playing cards, cellular phones, Tic Tacs, Motorola beepers, *Playboy*, and a Jack in the Box fast-food restaurant.

A competitor, McDonald's leads all other comers as both a locus and a philosophical statement about American values. Long a trendsetter in the fierce advertising world, introducing such previously ignored groups as the handicapped, the elderly, and the divorced in its commercials, its heavily marketed *Mac and Me* (1988) stands as one of the most obnoxious cases of self-promotion; from the title on down, the film unabashedly incorporates Ronald McDonald, McKids clothing, and numerous references to its cross-promotional partners, Coca-Cola and Sears. McDonald's burgers are the topic of choice between the John Travolta and Samuel L. Jackson characters (Vincent and Jules, respectively) in *Pulp Fiction* (1994); then, the next year, the Golden Arches are the locus for couples exchanging buddy talk and children in *Bye, Bye, Love* (1995). Stressing its symbolization for Happy Meals and good times, the chain surely must be compensated for whatever it spends to be so positively enshrined.

Some movies deal unabashedly with the power of advertising. *Crazy People* (1990) stars Dudley Moore and Paul Reiser as ad execs who will do anything to win the interest of prospective clients. Even when the former goes over the deep end, and is sent to a rehab retreat of sorts, actual products and actual campaigns remain foremost in his mind—like Esprit, Bonjour jeans, cars (Pontiac, Chrysler, Porsche, Volvo, Jaguar, Corvette, Saab, Lincoln Continental), the Bahamas, New York, United Airlines, Continental Express, UPS, Paramount Pictures, the U.S. Postal Service,

Pizza Hut, Nabisco crackers, Quaker Oats, Coke, Ban Roll-On deodorant, Metamucil, Camel and Marlboro cigarettes, Magna, Fosters Beer and Dunkin' Donuts (Dunkin' Donuts make up practically the entire theme of Norman Jewison's *Other People's Money* (1991) in which the Danny DeVito character eats them constantly, talks about them, and carries around a box of them throughout the film).

In a lighter mood, *Wayne's World* (1992) has fun satirizing the world of imbedded advertising—such as having its clownish characters hold up a Domino's Pizza box and declare they would never sink so low as to allow themselves to be dominated by commercialism. And then the movie zeros in on, in addition to numerous Pepsi shots, the Chia Pet, Light Clapper, Chicago Joes, White Castle restaurant, Budweiser, Guess, Yamaha drums, Mountain Dew, Cooper sportswear, and of course, the famous Grey Poupon mustard re-enactment scenario.

Yet another form of crossover comes within the creative industries themselves. It may have begun when a number of British ad people migrated to Hollywood in the early 1980s and, at nearly the same time, a number of U.S. filmmakers began directing ads. Mark Crispin Miller (1990) cites the following as examples of ad people who turned their talents to the film medium: Ridley Scott *(Alien, Blade Runner, Someone To Watch Over Me, Black Rain*—then, ads for Chanel, W. R. Grace, and Apple Computer), Hugh Hudson *(Chariots of Fire, Greystoke)*, Adrian Lyne *(Flashdance, 9 1/2 Weeks, Fatal Attraction)*, and Alan Park *(Fame, Mississippi Burning)*. Reciprocally, admakers turned filmmakers include Stan Dragoti, who went from the "I Love New York" campaign to *Mr. Mom*, Howard Zieff from Alka Seltzer's "Spicy Meatball" ad to *Private Benjamin*, and Joe Pytka from Pepsi to *Let It Ride*.

Whatever the twist, it certainly helps explain why motion pictures increasingly look like ads and, by default, why viewers might either not realize advertising has been imbedded in films or might not mind if it is, in fact, pointed out to them. Ditto for designers, whose pieces not only ap-

pear in films like Oscar de la Renta's outfits in *Bright Lights, Big City* (1988) or Armani's in *American Gigolo* (1980) and *The Untouchables* (1987), but the reverse happens when designer wear takes on star quality by being featured in films like *Pretty Woman* (1990) or Robert Altman's "Pret-a-Porter" (*Ready to Wear*, 1994). And just to come full circle, consider the number of celebrity filmmakers who have become product endorsers for ads, such as Spike Lee for Nike and The Gap, Danny DeVito for the American Milk Association, Martin Scorsese for Infinity, or George Lucas for Panasonic. The symbiotic combinations between film and its sponsors seem nearly endless.

Sponsors themselves are increasingly calling the shots—literally. Consider, for example, the movie *Days of Thunder* (1990) which, according to Carder (1993):

> Might have confused viewers as to whether the star of the show was Tom Cruise or his jazzed-up race car (Chevy Lumina) which was painted like a Mello Yello can (a Coca-Cola product). Coke enhanced the movie with a $3 million promotion and ad campaign featuring a Lumina giveaway, T-shirts, racing jackets, and a commercial starring one of the movie's characters. (p. 13)

Alphabetically, here are some of the products I found embedded in the movie: AC spark plugs, All-Pro auto parts, Budweiser, Buick, Busch, Chevrolet, Citgo, Coca-Cola, Crane cams, Crisco, Diehard batteries, Dinner Bell meats, ESPN, Exxon, Folger's coffee, Ford, Gatorade, Goodyear, Goodwrench, Goody's headache relief, Hardee's, Havoline, Heinz ketchup, Hertz, Hilton Hotel, Kellogg's, Kodiak tobacco, Mac tools, Mello Yello, Miller Genuine Draft beer, Motorcraft, Nascar Winston Cup series, Pepsi, Pontiac, Purolator, Quaker State, Ryder, 76 gasoline, Skoal tobacco, Simpson, Snickers, STP, Superflo motor oil, Sweet-N-Low, Texaco, Tide, U-Haul, and Winston.

While sponsors obviously want their products shown in the best light, there are a few instances where lawsuits are considered or have actually occurred. For example, rumors surfaced that Philip Morris wanted its name deleted from the scruffy film *Harley Davidson & The Marlboro Man*

(1991), and that Orkin's legal team was so upset that a fictional pest control employee used obscenities in *Pacific Heights* (1990) it forced changes in the video version.

There is also the famous story floating around of how Black & Decker, who had paid to have its cordless drill featured in the $50 million production of *Die Hard* 11 (1990), tendered the first-ever film product placement lawsuit when the scene featuring Bruce Willis wielding the B&D product was edited down. According to Carder (1993), an entertainment marketing firm, was hired by 20th Century Fox to negotiate product placements. They offered B&D the opportunity for prominent brand identification and partnership with Fox—quoting "research that indicates positive film exposure results in brand recall 2 1/2 times greater than that of a television commercial advertisement." (Carder, 1993, 21-22). B&D, holders of a 90 percent unaided brand awareness among power tools, asked for "guaranteed strong exposure, a line of dialog, and incorporation of their advertising slogans" and supposedly were offered several other opportunities, such as incorporating a clip of a current B&D TV commercial on a set playing on the airplane's movie screen, etc. B&D argued that they had not received all that they were promised and apparently 20th Century Fox settled the $150,000 claim out of court.

Recently, films aimed at children have become an increasingly popular venue for product placement. A *New York Times* article (April 10, 1996) noted that the 28.2 million American children between the ages of 2 and 11 have some $7.3 billion in spending money. Often, these films are little more than disturbingly blatant advertising vehicles. Consider, for example, the merchandising-inspired *Teenage Mutant Ninja Turtles* (1990+) and *Ghostbusters* (1984+) series, the Nintendo-selling film *The Wizard* (1989), or those cute, cuddly little pets dating from 1984 known as Mogwais, or *Gremlins* (Fuller, 1992b). The thing about those Gremlins was that if certain rules weren't followed, they duplicated themselves—a classic symbol for how business is done in Hollywood: when something works, make a serial

118

out of it. In their case, $78.5 million at the box office for the
first film, which had been aimed at the preteen and
teen/"bubble-gummer" generation, automatically spawned
a sequel. George Ritzer, author of *The McDonaldization of
Society* (1996), states:

> The studios like sequels because the same characters, actors,
> and basic plot lines can be used again and again. Furthermore,
> there seems to be a greater likelihood that sequels will succeed
> at the box office than completely original movies; profits are
> therefore more predictable. (p. 91)

I saw *Gremlins II: The New Batch* (1990) when my middle
son and I found ourselves with a free afternoon in Zagreb,
Yugoslavia, in the summer of 1990. Deciding to go to a
movie, we found this film best fit our schedule. Ironically, it
allowed us not only to see this capitalistic-oriented film
subtitled in Serbo-Croatian, but also to consider our differ-
ing reactions in relation to that of the rest of the audience.
Re-viewing it some six times back in the United States, it
became clear that the movie's antimaterialism messages
about the evils of greed undoubtedly had gone over the
heads of the children, who seemingly focused instead on
the glamour of the Big Apple's fancy shops, cars, state-of-
the-art technology, and stylish people. They may have
missed the many examples of imbedded advertising, but let
me review some: Burger King (framed in three different
segments), Maalox, Hertz trucks, people drinking Molson
Golden, Sunkist orange soda, and Jolt cola, eating Hostess
Twinkies, reading *Variety* or the *Village Voice*, and using
Crayola crayons. Balducci's and Raymond James were
featured against the Manhattan backdrop. At the mall,
Mister Donut was prominent (held in the background for at
least 15 seconds), along with the following: Spencer Gifts,
Champions, Penguins, M&Ms, and an entire collection of
Fisher Price toys. There were signs for Busch beer, as well
as Carlsberg beer and Batman. Gremlins were made out of
Legos. They watched television on a Sony monitor, and
drank both regular Budweiser and Bud Light in a bar
scene. And then there is Xerox. For one thing, there was an

actual Xerox room, so labeled. The copier is in operation when we first come upon it—when one of the bad Gremlins has pinned one of the good ones to it, and is producing 100 copies of him on the $85,000 model. The company and its product get a second plug later on in the movie when other Gremlins, with an Ex-Acto knife, go at it in the Xerox room.

Maybe the business of films goes beyond the business of dreams, then, and is just becoming business as usual—literally *xeroxing* our hopes and aspirations as consumers. As James Monaco (1984, 29) has noted, "Film in America has always been better understood as industry rather than as art." Without even discussing other film-related income sources such as prefeatures and previews of coming attractions, trailers, concession stand and fast-food products featuring various movie characters, other media advertising for films and/or stars and series, the home video, television movie channels, and foreign markets, and many other examples, the overwhelming lesson to be learned is this: imbedded advertising is just one more method to help the movies make money. We can't duck the issue.

CASE STUDIES: *THE MIGHTY DUCKS, D2,* AND *D3*
Considering the fact that Disney signed more than one hundred cross-promotional and licensing agreements for 1991 releases of *The Rocketeer, Beauty and the Beast*, and the re-release of *101 Dalmations* (Magiera, 1989), it probably comes as no great surprise that its studios walk away with the penultimate example of advertising posing as entertainment in *The Mighty Ducks* (1992) and, following that financial success, *D2* (1994) and, most recently, *D3* (1996), plus, if you can believe it, a children's television cartoon called *The Mighty Ducks*. In 1993, the movie's title became the moniker for Disney's National Hockey League (NHL) franchise team. *The Mighty Ducks* comes off as a movie and an animated TV show developed with the express purpose of incorporating advertising—as well simultaneously serving as public relations for the expansion team.

The original *Mighty Ducks*, a formulaic, predictable story, stars Emilio Estevez as Gordon Bombay, a former hockey player now smart-ass lawyer whose boss intercedes to contract community service for him to cover a drunken driving offense; needless to say, he whips up a group of diversely politically correctly street-smart kids into a winning team, the Ducks. The president of the law firm sponsoring the team is Mr. Duckworth, the rink is referred to as "the pond," "duck power" conquers all, and the pee-wees sport their ubiquitous duck logo with pride. Class also plays a role. The Ducks' major opponents are the Hawks, an all-white group from the "better" section of town who sport matching jackets and come from intact families. When the ragtag Ducks concede their first match to the Hawks, coach Estevez shares the following conversation with the CEO of his law firm:

> Mr. Duckworth, there are two reasons I stopped by. First of all, I'm learning a lot about team work, fair play and all that junk. Fair play doesn't come cheap. These kids, my team, have no money. They can't afford rink time, safe equipment, proper uniforms—which makes it difficult to compete. Now imagine, sir, being ten years old and stepping out onto the ice with old copies of the *National Enquirer* taped to your shins instead of pads. The point I'm trying to make, sir, is that you wouldn't be taken seriously and neither are these kids.

Duckworth agrees to contribute to the team, after Estevez promises they will name the team after his law practice, adding, "Suddenly we're the good guys, the firm that gives back to the community." Cut, then, to the team members having a field day shopping for hockey equipment. We get the picture: what one wears, and what one uses for brand equipment supply the winning edge.

"Duck power triumphs again," proclaimed *American Movie Classics* with the fast-following *D2* (1994). This time *The Mighty Ducks* were off to defend themselves, if in a new underdog role, in the Junior Goodwill Games as Team USA. With intersecting thematic ideologies of patriotism, the value of team spirit ("We are ducks, and ducks fly together"), how we can learn through communication, and

the corrupting evils of endorsements, true Disneyism per-
meates throughout. As in the original, red, white, and blue
are the constant colors of choice (along with stars and
stripes), and practically every hockey equipment maker is
represented (i.e., Easton gloves, shoulder pads, and sticks,
CCM helmets, skates, and shirts; Koho sticks; Jofa hel-
mets; Champion clothing; Cooper pucks; Itech masks;
Takla pants; Christian sticks; Bauer skates; Vaughn goalie
pads; and Hendricks hockey apparel). It is easy to pick all
these out, as the camera angles were such as to make sure
we noticed—panning, preening, and holding focus. Adver-
tising plastered up around the hockey rink never escapes
our attention, either, and we are bombarded with the likes
of Bubblicious gum, Zubaz, Dove, Greyhound, Gatorade,
General Cinema, Diet Coke, Little Caesar's pizza, Delta,
and even Duck Head clothing. The zenith, however: making
the cover of the Wheaties box!

At one point in *D2*, the sports clothes huckster Mr.
Tibbles (Michael Tucker) spouts to Estavez what are
probably the most prophetic lines in either movie to this
point: "Coaches have images. Images mean dollars. I sell
you, you sell me. We both get rich." That, along with, "Life
can be great when you know the right people," best exem-
plifies the contradictory messages at play here. While on
the one hand we witness the deleterious effects of Coach
Bombay's being swayed by materialism and media interest,
no one hypes better than The Mighty Ducks themselves—
outfits and all. Yet, while ex-Lakers coach Pat Riley is
pointed out as a "bad" coach because he took endorsement
money, Lakers superstar Khareem Abdul Jabbar has a
cameo as a pitchman. Wayne Gretzky, Greg Louganis and
Kristi Yamaguchi also make appearances—"showing" how
important the team was/is.

The aforementioned "class" theme finds itself most
stressed in *D3* (1996), when the Ducks find themselves
with sports scholarships to a private school: fictional Eden
Hall in Minnesota. While most of the action takes place on
campus, so that many of the same hockey-related products
can again be featured, Disney themes of sportsmanship

and scholarship are also underscored. From a promotional point of view, though, it was quite intriguing to compare titles and visuals: *The Mighty Ducks* focused on hockey play and players; *D2* was advertised as Emilio Estevez in Disney's *D2: The Mighty Ducks*; and although *D3* was billed as Emilio Estevez in *D3: The Mighty Ducks*, with no mention of the studio, the actor actually appeared for less than six minutes, according to my calculations (the movie began with something of a vague flashback, we learned he had another opportunity elsewhere that he couldn't resist, and Estevez was briefly on screen to remind the Eden Hall trustees of their responsibilities regarding the scholarship students, plus had a brief profile at the end). The real winner, scoring that last-minute, much-needed hockey goal, was an unlikely kid named Goldberg; go figure.

Not that these various *Mighty Ducks* were the first films to incorporate sponsorship orientations into the field of sport, mind you. We rooted with Tom Hanks for the New York Giants in *Big* (1988)—not only did he wear their sweatshirt and attend one of their games, but the team was talked about often. *The Program*, emphatically televised by ESPN, was notably Wilson-oriented; in every scene, it was quite clear who had made the football. Add also Adidas shirts, Champion socks, Miller Draft, Coors and Bud Light, Gatorade, Diet Coke, Harley Davidson, and a number of mentions of *Sports Illustrated*. Most recently, *Ace Ventura*, a seemingly silly Jim Carrey star vehicle, really revolves around the Miami Dolphins and their many sponsor-related items.

It is always instructive to question our message systems and our messengers. That process is often mandatory for us to do especially for children, whom we consider a particularly vulnerable, or special audience. There can be no doubt that dissecting *The Mighty Ducks* and its sequels *D2* and *D3* have unearthed any number of discrepancies between what appears on the screen both overtly and covertly, including both stories' near-subliminal corporate subtext.

IMPLICATIONS

Advertising in the United States is about a $150 billion business. As its avenues for exposure get restricted, it seems only natural to expand into areas that have proven successful; hence, moving more into the movies is a natural extension. Still, the surprising thing is how few people are even aware of these occurrences. The time has come, it is clear, to expose this increasing encroachment (Seiter, 1995). At a time when parents and educators are advocating fewer advertisements aimed at children on television, it seems incongruous that so few people are even aware of the huge amounts of not-even-subliminal advertising to which they are inadvertently being exposed, even bombarded (Fuller, 1993).

Maybe our whole sense of "reality" is being challenged. While the rationale for imbedded advertising in film is that it makes a scene more realistic, the truth is that scripts are increasingly written not so much around a plot as around a product, or products. From the perspective of the personnel involved in storytelling, ranging from creators to producers, there is serious concern about a dilution of artistic control. When too many sponsors are in a position to make decisions, McAllister (1996) notes:

> Such selective buying could put additional pressure on moviemakers to make movies that have happy endings or scenes receptive to product placement. Product placement as a form of place-based advertising thus limits the diversity of motion picture content. It creates incentives for certain types of movies, but not others. (p. 82)

So much for the American-movie-created happy ending. According to Mark Crispin Miller (1990), that is what movies are all about today; he makes a compelling case for the increasing amount of advertising that is embedded in film:

> Sailing through the movies, the multitudinous labels and logos of our daily lives appear (or so the advertisers hope) renewed, their stale solicitations freshened up by the movie's magical, revivifying light—and by the careful steps taken to glamorize them." (p. 197)

At a time when the Center for the Study of Commercialism (CSC) is asking the Federal Trade Commission (FTC) to probe product placement in the motion pictures as forms of "plugola" and "sleath advertising," and the Center for Science in the Public Interest is petitioning that same federal advisory board to require a visible disclaimer for on-screen disclosure when paid product placement appears (Colford and Magiera, 1991), this clearly is a topic that belongs in the public arena. As so often is said in our communications field, though, lots more research is needed; at this point, the very best data remain privy, locked up in the vaults of movie moguls.

FILMS CITED (In alphabetical order):

Ace Ventura, Pet Detective. 1994. Director: Tom Shadyac
American Gigolo. 1980. Director: Paul Schrader
Baby Boom. 1987. Director: Charles Shyer
Beauty and the Beast. 1991. Directors: Gary Trousdale, Kirk Wise
Big. 1988. Director: Penny Marshall
Bright Lights, Big City. 1988. Director: James Bridges
Bye, Bye, Love. 1995. Director: Sam Weisman
Crazy People. 1990. Director: Tony Bill
D2: The Mighty Ducks. 1994. Director: Sam Weisman
D3: The Mighty Ducks. 1996. Director: Robert Lieberman
Days of Thunder. 1990. Director: Tony Scott
Die Hard II. 1990. Director: Renny Harlin
E.T. 1982. Director: Steven Spielberg
Ghostbusters. 1984. Director: Ivan Reitman
Gremlins. 1984. Director: Joe Dante
Gremlins II: The New Batch. 1984. Director: Joe Dante
Harley Davidson & The Marlboro Man. 1991. Dir: Simon Wincer
It Could Happen To You. 1994. Director: Andrew Bergman
Mac and Me. 1988. Director: Stewart Raffill
Menace II Society. 1993. Directors: Allen and Albert Hughes
The Mighty Ducks. 1992. Director: Stephen Herek
101 Dalmations. 1991. Directors: Wolfgang Reitherman, Hamilton Luske, Clyde Geronimi
Other People's Money. 1991. Director: Norman Jewison
Pacific Heights. 1990. Director: John Schlesinger
Picnic. 1956. Director: Joshua Logan
Pretty Woman. 1990. Director: Garry Marshall
The Program. 1993. Director: David S. Ward
Pulp Fiction. 1994. Director: Quentin Tarantino
Ready to Wear. 1994. Director: Robert Altman
Reality Bites. 1994. Director: Ben Stiller
The Rocketeer. 1991. Director: Joe Johnston

Snow White and the Seven Dwarfs. 1937. Director: David
 Hand
Teenage Mutant Ninja Turtles. 1990. Director: Steve Barron
Top Gun. 1986 Director: Tony Scott
The Untouchables. 1987 Director: Brian DePalma
Wayne's World. 1992 Director: Penelope Spheeris
The Wizard. 1989. Director: Todd Holland

REFERENCES

Bordwell, David, and Kristin Thompson (1990). *Film Art: An Introduction*, 3rd. edition. New York: McGraw-Hill.

Carder, Sheri (1993). "Product Placement in Film: Advertising Via the Box Office: A Comparison of Marketing Techniques Between the United States and the United Kingdom." Paper presented at the combined annual conventions of the Southern Speech Communication Association and the Central States Communication Association, Lexington, Kentucky.

Carroll, Noel (1988). *Mystifying Movies: Fads and Fallacies in Contemporary Film Theory*. New York: Columbia University Press.

Colford, S.W. and Marcy Magiera (1991). "Products in Movies: How Big a Deal?" *Advertising Age*, June 10, p.12.

DeLauretis, Teresa (1984). *Alice Doesn't: Feminism, Semiotics, Cinema*. Bloomington, IN: Indiana University Press.

Fuller, Linda K. (1992a). "Introduction," in *Beyond the Stars III: The Material World in American Popular Film*. Bowling Green, Ohio: Popular Press.

Fuller, Linda K. (1992b). "Gremlins in Yugoslavia: A Cross-Cultural Cinematic Experience." Paper presented to the Northeast Popular Culture Conference, Brookline, MA.

Fuller, Linda K. (1993). "Instructing About Imbedded Advertising in Film," first place winner in faculty competition, National Broadcasting Society/AERho, St. Louis, Missouri.

Gianetti, Louis (1993). *Understanding Movies*. 6th ed. Englewood Cliffs, NJ: Prentice Hall Press.

Jacobson, Michael F., and Laurie Mazur (1995). "Product Placement," in *Marketing Madness: A Survival Guide for a Consumer Society*. Boulder, CO: Westview Press, pp. 67-72.

Loukides, Paul, and Linda K. Fuller, eds. (1993). *Beyond the Stars III: The Material World in American Popular Film*. Bowling Green, OH: Popular Press.

Madsen, Roy Paul (1973). *The Impact of Film: How Ideas are Communicated through Cinema and Television.* NY: Macmillan.

Marsden, Michael T., John G. Nachbar, and Sam L. Grogg, Jr., eds. (1982). *Movies as Artifacts.* Chicago: Nelson-Hall.

McAllister, Matthew P. (1996). *The Commercialization of American Culture: New Advertising, Control and Democracy.* Thousand Oaks, CA: Sage.

Miller, Mark Crispin (1990). "Advertising: End of Story," in *Seeing through Movies,* NY: Pantheon Books.

Monaco, James (1984). *American Film Now: The People, The Power, The Money, The Movies.* New York: New American Library.

O'Connor, John E., and Martin A. Jackson, eds. (1988). *American History/American Film: Interpreting the Hollywood Image.* NY: Continuum/Ungar.

Ritzer, George (1996). *The McDonaldization of Society.* Newbury Park, CA: Pine Forge Press.

Rollins, Peter C., ed. (1983). *Hollywood as Historian: American Film in a Cultural Context.* Lexington: University Press of Kentucky.

Seiter, Ellen (1995). *Sold Separately: Parents and Children in Consumer Culture.* New Brunswick, NJ: Rutgers University Press.

Silverman, Kaja (1983). *The Subject of Semiotics.* New York: Oxford University Press.

Sterrit, David (1995). "Are Movie Marketers Too Mighty?" *Christian Science Monitor,* July 31, pp. 1+.

Stromgren, Richard L., and Martin F. Norden (1984). *Movies: A Language in Light.* Englewood Cliffs, N.J.: Prentice Hall Press.

Wasko, J., M. Phillips, and C. Purdie (1993). "Hollywood meets Madison Avenue: The Commercialization of US films." *Media, Culture and Society,* Vol.15, pp. 271-293.

Wollen, Peter (1972). *Signs and Meaning in the Cinema.* Bloomington: Indiana University Press.

Wood, Michael (1989). *America in the Movies*. New York: Columbia University Press/Morningside Edition.

Wyatt, Justin (1994). *High Concept: Movies and Marketing in Hollywood*. Austin: University of Texas Press.

Chapter 7

Ideology in Public Service Advertisements

INTRODUCTION

Commercial advertisements are one of the products of capitalist economy. Their most obvious goal is the persuasion of possible consumers into the purchase of one product or service over others of similar characteristics. As acts of communication they are manifestations of an ideological discourse that structures social practices. The repetition, reinforcement, and perpetuation of relations within the social grid are guaranteed by the cultural exchange, an exchange that in capitalist societies is one of commodities and the meanings attached to them. Advertisements, then, represent the vehicle through which commodities become signs (Goldman, 1992). This signifying value is borrowed from codes that are initially foreign to the consumption of the product, but that eventually become equivalents to the product, establishing a reciprocal signifying relationship: the commodity becomes a fetish. The reiterated depiction of social practices contributes to their being perceived as "natural" rather than as constructions within the capitalist order (Mattelart, 1978, 13). This naturalization presents capitalist social constructs and values as matters of fact, which discourages any attempt at change.

It seems clear, then, that the role of the commodity is a primordial one: commodities become the currency for the exchange of social meanings. The act of consumption is one

of selection between competing signs, and that act is completed when the meaning is reenacted and attached, through the product, to the consumer. Commodities therefore become signs in an intricate grid of overlapping codes that form the ideology of Western capitalism.

If commodities are the element of exchange, and commercial advertising the process by which their value is publicly stated, one issue that comes into question is whether the absence of the commodity as physical embodiment of this trade results in significant alterations of the processes involved in the construction of the messages and whether or not the ideological constructions are still present. With that in mind, we will proceed to examine public service advertisements as an example of mass media messages that, at least initially, appear not to have any direct connection to economic profit in the way it is understood in the capitalist market.

The analysis of the advertisements will essentially use the tools of semiotics and Marxist-based critique to attempt to bring out possible embedded ideological content. The ads themselves were selected from publications such as *Communication Arts, The Art Directors Annual,* and *Print Magazine* that showcase award winning or critically praised advertisements. This criterion for selection intends to ensure the use of ads that are held as examples of adequate advertising practices by those involved in the very same process of producing ads. In regard to the theoretical framework used in this chapter, semiotic analysis explores the use of signs in the selected ads. One must understand that a sign is the combination of a signified (or concept) and a signifier (verbal or visual representation, which can be a word, a photograph or illustration, etc.). Signs combined together construct codes that make communication possible.

Advertising messages, like all media messages, relate to referent systems. Referents present themselves as the real world, even though, in fact, this reality might already be part of a coding system which operates at a cultural or societal level. Thus, when dealing with an act of communication in whatever medium, it is possible to break down the

meaning of the signs along Barthian lines (Barthes, 1977), identifying the denoted and connoted meaning. In a visual, such as a picture of a house, the most basic understanding of the colors and shapes represented, would be the denoted meaning. A deeper examination of the house might unveil connoted meanings determined by the social and cultural referent systems. For example, if the house appears on a street with other similar houses, we might connote it is a suburban house, or perhaps it appears luxurious therefore connoting an estate. To deconstruct advertising messages we must begin to look at both sets of meanings.

THE IDEOLOGY OF ANTISMOKING ADVERTISEMENTS

The ads selected for this chapter have different goals for each campaign. The first of these advertisements (Figure 7.1), is part of a campaign to stop smoking, and appeared in both print and TV spot adaptations. The visual is composed of twelve separate square pictures of different animals smoking cigarettes accompanied by the sentence "It Looks Just as Stupid When You Do It." Despite the fact that the ad is being put out by the Minnesota Department of Health, there is no specific mention of the harmful effects of tobacco.

The main focus of the message is an appeal to the idea of social acceptance. Smoking becomes an integrative part of an individual's appearance, thus the act of smoking is a decisive factor in the judgment others make of that person. According to this ad smoking will have a negative effect on that judgment. Health is not the issue; social integration is. In the same way that smoking used to be granted social approval, it is now denied on the same principles. Of course, the changes in social attitude are partially due to the knowledge of the effects of the product, but the promotion of this attitude does not divulge that knowledge. The possibility of making an informed decision regarding cigarettes is ruled out and automatically deemed evidence of low intellectual skills. The depiction of animals connotes the reference to the "natural," perhaps implying that the natural behavior of humans would be a nonsmoking one,

134

It Looks Just As Stupid When You Do It.

Minnesota Department of Health

Figure 7.1

as if social behavior was not a construct. This gives us a clue as to the readjustment of the dominant ideology; "the labeling of a social practice as artificial reinforces the perception of the others as natural, [conceals] the fact that the real is no longer real, and thus [saves] the reality principle" (Baudrillard, 1983, 262).

The second ad (Figure 7.2) is possibly less subtle in its use of social acceptability than the previous one, but its strategy manages to bring gender issues into an area that one would think of as nongender specific. The visual of a young model smoking a cigarette contrasts with a verbal message that reads "An Ugly Butt Can Ruin a Great Body." This sentence appears to be "underlined" with a partially consumed cigarette. The double meaning of the sentence is clear: on the one hand there are implications that smoking can have damaging effects on health, while on the other sex appeal becomes an issue. In other words, what is harmful about smoking is clearly not the low aesthetic value of the cigarette butt itself.

The word "butt" double plays as signifier for cigarette both in the health and sexual context. In the latter, however, the contradiction with the image becomes apparent, since the model is presented in a seductive way. She is caressing herself, as if she were "admiring her own body and presenting it to others" (Dyer, 1982, 101). The cigarette she smokes seems to add to the sexual appeal rather than detract from it. The ad makes use of a referent system that consistently depicts women as sexual objects for the voyeuristic enjoyment of the male. This relationship is reenacted, creating an ad that despite its supposedly good intentions, subjects women to patriarchal objectification of the female body. The physical decay that cigarettes cause is only lightly insinuated, and were it not for the fact that the credit at the bottom of the ad mentions a doctors association, the message could be seen to be mostly concerned with the unattractive social character of the habit of smoking. In other words, this ad, while seemingly attempting to discourage smoking naturalizes a view of women as sexual objects that may, in itself, be damaging.

Figure 7.2

In another example (not shown here) a public service advertisement (PSA) by the California Department of Health Services could practically be understood as an exclusively verbal ad. This verbal content, placed over a textural background that represents a piece of burned paper, reads: "The Only Thing That Cigarette Companies Care About Keeping Healthy is Their Balance Sheets." This ad criticizes the corporate attitude instead of directly addressing the tobacco user. The concern with balance sheets is not exclusive to cigarette companies; in fact, it is an attitude that lies at the bottom of capitalist enterprise and that is praised as sound management. Accusing cigarette manufactures of heartless capitalism seems to suggest that capitalism itself is compassionate, and that the tobacco industry is a deplorable exception. In a sense, this attack on the tobacco industry serves as a sacrifice performed in order to guarantee the perpetuation of the rituals of production.

CONSTRUCTING "THE OTHER"
Another common topic of public service campaigns is drug use. In the next case (Figure 7.3), we see a series of three advertisements that were run together as a campaign against the drug crack. All three ads show two identical images of the face of a person, and next to each one of the images, a short text that summarizes very roughly two different stories of the person's life: one, with the person becoming a crack user; in the other, the person stays away from drug use. From the visual point of view, the most apparent aspect of the ads is that of the three people depicted, two are black men and the third one is a woman. The images themselves are rough, and appear in high contrast of black and white. The faces appear removed from any context, even the rest of the person's body. The blank expressions in all three faces give the impression that these are either mug shots or ID pictures; in either case, they remind the reader of a visual representational code that is paradoxically dehumanizing, since the whole purpose of such pictures is to classify and catalog individuals within a

group (criminal population or, for instance, driver's licenses). As mentioned before, one cannot help but notice the fact that two of the people shown are African-Americans. A case could be made for the making of this choice based perhaps on the demographics of drug users. However, even admitting to that possibility, the ad still contributes to the perpetuation of a set of racial stereotypes that sustain the perception of social problems as being racially determined and exclusive. Moreover, for the white reader, the ad reinforces a paradigmatic view of the other that determines behavior expectations.

Issues regarding race are also found in the accompanying text. For example, in the nonuser option one of these ads reads as follows:

> Born June 19, 1962
> Graduate, West Side High
> Bagger, D'Agostino's
> Cashier, D'Agostino's
> Shift Manager, Burger King
> Asst. Manager, Burger King
> Dept. Manager, Alexander's
> Manager, Benetton
> Owner, Benetton Franchise

The other side, describing the same person as a crack user, presents this alternative:

> Born June 19, 1962
> Graduate, West Side High
> User/Dealer, Crack
> Inmate, Rikers Island

By analyzing the progression of this, not coincidentally, nameless person step-by-step it is possible to extract a few underlying ideological messages. The man graduates from high school, but that is the end of his educational career. Considering the first job obtained, bagger, we are to understand that the choice of pursuing a higher education

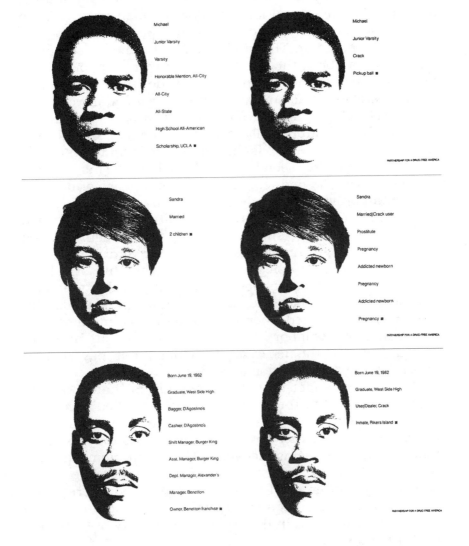

Figure 7.3

was not one of many possibilities open to him, but was predetermined by one of two factors or by the combination of both: his intellectual level was not enough to get him to college, or his family's income did not permit him to continue his education. The implications of either assumption say as much about the social grid and hierarchy of an economically segregated society as they do about an educational system that acts as mechanism for inequality.

The chronology in the step-by-step progression in the character's life supposedly describes a story of success; this success, however, is based on a fulfillment of the capitalist myth of social upward mobility. This upward movement can be deduced not only from a list of occupations that provide a steady increase in income, but also from the increasing level of responsibilities involved in each job: starting with the subservient role of a bagging person and moving on to higher levels of power and status. The culminating step is embodied by the ownership of a franchise. This final stage is open to several possible readings: one, within capitalist logic, would be that personal evolution is only completed when the worker turns into a capitalist. In that sense, labor is devalued as an activity and portrayed simply as the necessary price one must pay in order to ascend the socio-economic ladder.

However, the fact that the ownership is that of a franchise suggests that the story is one of controlled ascension within predetermined channels, and that the relative importance of the business ownership is validated by the existence of an overseeing network. Thus, autonomy is only relative. Ultimately, the evolution from a servant-like role to a relatively higher position in the grid of power relationships could be seen as a metaphor for the macro-evolution of African-Americans in the grid of U.S. society over the last century and a half.

While the gain in socio-economic status related to the supposedly normal life is the reward of a life conducted without the use of drugs, the use of the drug simply states the related punishment. The polarization implied in this division between reward and punishment seems to give the

idea that the two possibilities are equally dependent on personal choice. This appeal to individualism as driving force draws upon the American myth of self-determination and takes away any responsibility from the social structure and from the power institutions. In other words, the message is that drug use is a personal choice, and the institutional role is limited to providing the punishment for what has been agreed upon as the wrong choice.

If this ad operates as a micro-representation of American capitalist mythology, the next one featuring an African-American male represents a good example of the existence of racial stereotypes in public service ads, and in this case, of a rather simplistic and obvious nature. This ad also contrasts a story of success made possible by the absence of drug use with one of failure. In this ad, the person has a name: Michael. The steps that outline his life are:

> Michael
> Junior Varsity
> Varsity
> Honorable Mention, All-City
> All-State
> High School All-American
> Scholarship, UCLA

The story that includes crack use is quite shorter:

> Michael
> Junior Varsity
> Crack
> Pick-up ball

As one can see, Michael also has a steady growth in the importance of his achievements when drugs don't come into the picture. These achievements, however, are all sports related. In fact, for what the reader can tell, his whole life revolves around sports. This reinforcement of the racial stereotype regarding African-Americans and athletic prowess is common practice in advertising. The person in

this ad does achieve higher education (even to a highly re-
puted university such as UCLA), but from the information
presented in the ad he gets there based not on his intellec-
tual abilities, but rather on his physical ones. Of the two
African-Americans portrayed in these two ads, neither one
is clearly attributed with intelligence. One is a hard worker
while the other is a good athlete. Both of the stories culmi-
nate with the integration of the characters into institutions
(industrial capitalism or university education) that are
mostly controlled by white males and that consist of
structured hierarchical relationships. Both the labor in-
tensive jobs of the first person and the sports practices of
the second one serve as learning processes that find their
climax in their incorporation into the highly ritualized
practices that mystify the very process of integration in
these practices. The ideology that acts as foundation of
these rituals, as Mattelart (1978) puts it:

> allows individuals to be inscribed in a natural fashion into the
> practical activities which they fulfill in the interior of the system
> and therefore enables them to participate in the reproduction of
> the apparatus of domination without realizing that they are ac-
> complices in their own exploitation. (p.17)

The other ad in this series portrays a white woman. For the
non-drug user the text reads:

> Sandra
> Married
> 2 Children

For the same person with the use of the drug it reads:

> Sandra
> Married/Crack user
> Prostitute
> Pregnancy
> Addicted newborn
> Pregnancy
> Addicted newborn
> Pregnancy

It is a fairly noticeable fact that while the two men featured in the other two ads reach some sort of professional or educational achievement and, at least according to what we see in the text, they do it on their own, the woman's "success" is limited to getting married and having two children, activities neither one of which can be completed individually. The woman is thus portrayed as dependent and as lacking any interest that does not fulfill, within patriarchal society, the assigned traditional role of housewife. However, just as in the other two cases, her life completes itself when she takes part in a ritualized social practice, in this case, marriage and the creation of a family. Even the consequences of her drug use are not limited to herself: the effects are passed on to her children; when the woman has some effect on or control over others, this is a negative one. Thus, it seems more desirable to maintain a low profile for the woman activities, and the woman is presented once again as an irresponsible, immature being.

DECONSTRUCTING SOCIAL PROBLEMS IN PSAs

Another series of ads, run by a Volunteer Action Center for the homeless in New York City, presents three quite different visuals (Figure 7.4). One, a line engraving representing Jesus Christ; the second one, a photograph of Charles Manson; the last one, a photograph of a black mother feeding her child. The text varies with each image. In the first one, it reads: "How can you worship a homeless man on Sunday and ignore one on Monday?" The ad appeals to Christian values. The logic follows that the announcer presumes either that the immense majority of the audience is comprised of practicing Christians or that only this sector of the audience would possibly be interested in helping to relieve homelessness. The presumption that Christian values are indeed shared by the majority of the population becomes a naturalization of part of the Judeo-Christian ideals that, from a practical point of view, have the potential to alienate part of the audience. But beyond religious beliefs, the ad relies on the political belief that social problems such as homelessness must be solved by the intervention

of charity rather than by an active policy conducted from government institutions. This is a recurrent theme particularly common in conservative American politics. The call for volunteer participation is also a way to create a personalized appeal that provides the possibility of exercising power-over in a way so subtle that it appears to be power-with (Starhawk, 1987).

The second ad in this series carries a photograph of Manson, the cult leader responsible for mass murder, with the following text: "If Society Can Provide Housing for a Man Like This, Can't We Do More for the Homeless?" The ad again calls for volunteer action—the small caption underneath the main text reads: "In the United States we take better care of convicted killers than we do of innocent homeless people. Help us correct this injustice. Call the Mayor's Voluntary Action Center ..." The injustice the ad refers to is but a false analogy that hides the causes of the homelessness problem. It is the instruments of a highly competitive economically driven capitalist system that create homelessness. Penitentiary institutions are just another manifestation of the mechanisms of oppression, and serve to "conceal the fact that it is the social in its entirety which is carceral" (Baudrillard, 1983, 262).

The third ad in the series, shows an image of a black mother feeding her child. The text is written as if the woman was the one speaking, and it reads: "Finish your food. There are thousands of starving people in New York City." The strength of this ad plays on the idea of showing a subject whom we have learned to consider "the Other" (the image reminds us of many images of starving people in areas of developing and Third World countries), then reversing that "otherness" (O'Barr, 1994). The fact that this might cause some embarrassment or shock to the reader brings to light the connotations traditionally attached to the idea of "the Other" that gain new meaning when applied to "us."

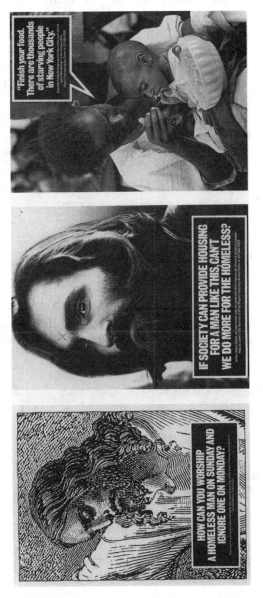

Figure 7.4

The idea of otherness is also the main tool used in the ad that denounces attempts on behalf of conservative forces (such as Jesse Helms and Pat Robertson, the body copy reads) to eliminate the National Endowment for the Arts (Figure 7.5). The ad dates back a few years. While the image shows a painting hanging on the wall that has had the center of its canvas torn out, the headline reads: "Isn't It Ironic That Just As The Soviets are Becoming More Like Us, We are Becoming More Like Them?" Clearly, the use of the pronouns "us" and "them" defines that opposition of roles that creates the view of the Other. The falsity of the notion of a homogeneous group defined as "us" becomes obvious when the text identifies the oppositional forces and places them both within the geographically determined limits used for the definition of us and them. Once again, the criticism does not question the rhetoric used by the ideology it is supposed to be in confrontation with. Rather, it embraces that rhetoric in a self-defeating argument that presumes the existence of us versus them, instead of establishing the plurality and diversity of both, which are the aspects ignored by the intolerant censors the ad tries to criticize.

CONCLUSIONS AND DISCUSSION

It appears, after analysis, that ideology is as present in public service advertisements just as it is in every fiber of the social grid. Issues that have arisen from the study can be outlined briefly: the depiction of "otherness," whether racially, gender, or economically based; the exercising of power and the promise/threat of that power; capitalist values and the myth of social upward mobility; individualism as a central value of the Western world. Despite the absence of an objectified meaning-currency, that is, a physically consumable product or commodity, the possibility and message of consumption are, nevertheless, there to be found in these ads. It is the message, particularly ideology itself, that is to be consumed. This consumption takes place through the observance of the messages. Thus, "If no meaning is taken, there can be no consumption " (Hall,

ISN'T IT IRONIC THAT JUST AS THE SOVIETS ARE BECOMING MORE LIKE US, WE'RE BECOMING MORE LIKE THEM?

For twenty-five years The National Endowment for the Arts has helped Minnesota arts organizations make the arts accessible and affordable for everyone. Everything from the Guthrie Theater and St. Paul Chamber Orchestra to rural school arts programs receive a substantial portion of their support from the Endowment.

But now, because of controversy over only a few grants, some extreme critics like television evangelist Pat Robertson and Senator Jesse Helms are calling for the total elimination of the Endowment. Considering that of the 80,000 grants the NEA has awarded over the years, only 20 have caused any controversy, it's a drastic measure.

Unfortunately, the money will not be replaced from other sources. Admission prices will go up. Museums, dance companies and community arts programs could disappear.

And it will happen if you don't do something right now. Call or write your senators and congressmen today.

Please, don't let our country take a giant step backwards just as the rest of the world is taking such a big step forward.

SAVE THE NATIONAL ENDOWMENT FOR THE ARTS, OR THE ARTS WILL BECOME HISTORY.

Figure 7.5

1980, 129). The discourse must manifest itself in social practices if the process is to be completed. So in the absence of a product, it is ideology itself that becomes commodified and the direct object of consumption. Indeed, when the ideological message arbitrarily defines an icon to be used as currency, the message is more widely extended, since it is immersed in a society accustomed to the consumption of meaningful currency (Williamson, 1978, 97). A good example of this is the pervasive use of the AIDS ribbon. The processes that make the transmission of these ideological messages possible are shared with commercial advertisement and the strategies are also similar. However, while commercial advertising utilizes the commodity as a tool to socialize individuals, and its role as ideological tool seems to be hidden behind profit goals, goals that are subject to critique even from within the capitalist logic, public service advertising passes ideology itself as the common good, and practices of naturalization and exnomination (Barthes in Fiske, 1982, 147) are prevalent.

REFERENCES

Barthes, R. (1977). "The Photographic Message," in *Image, Music, Text*. New York: Noonday Press.

Baudrillard, J. (1983). "The Precession of Simulacra" in Brian Wallis, ed., *Art After Modernism: Rethinking Representation*. NY: The New Museum of Contemporary Art.

Dyer, G. (1982). *Advertising as Communication*, London: Metheun.

Fiske, J. (1982). *Introduction to Communication Studies*. London: Methuen.

Goldman, R. (1992). *Reading Ads Socially*. London: Routledge.

Hall, S. (1980). "Encoding and Decoding," in *Culture, Media, and Language*, S. Hall, D. Hobson, A. Lowe and P. Willis, eds., Cambridge, MA: Unwin Hyman.

Mattellart, A. (1978). "The Nature of Communications Practice in a Dependent Society," *Latin American Perspectives*, Vol.15, No.1, pp. 13-34.

O'Barr, W. M. (1994). *Culture and the Ad. Exploring Otherness in the World of Advertising*. Boulder, Colo.: Westview Press.

Starhawk. (1987). *Truth or Dare: Encounters with Power, Authority and Mystery*. San Francisco: Harper.

Williamson, J. (1978). *Decoding Advertisements: Ideology and Meaning in Advertising*. London: Marion Boyers.

Chapter 8

The Cultural Politics of Prevention: Reading Anti-Drug Public Service Announcements

Michael J. Ludwig

INTRODUCTION

"This is your brain on drugs" reads the caption underneath a picture of a fried egg in a pan. That image was one of the first and perhaps the most well known of the Partnership for a Drug-Free America's many print and broadcast public service announcements (PSAs). The fried-egg PSA was parodied widely: "This is your brain skiing in Aspen" and "This is your brain on Spring Break," among others. These are some examples of the different ways an advertising message may be reinterpreted and used. There is widespread support for the negotiation that goes on between a reader and a text (Ang, 1985, 1989, 1991; Morley, 1980, 1986, 1989), but it is also important to recognize that the text is a function of ideological assumptions and produces hegemonic effects that work to constrain meaning. For example, Cotts (1992) reported that after seeing the fried-egg PSA many children refused to eat eggs. According to their public relations staff, poultry industry officials were angered by the association of one of their products with drugs. Despite these objections the PSA lived on to become part of our culture while it attempted to deliver the simplistic solution to a complex social problem by valorizing individual action as the best way to avert drug use.

Prevention programs are a function of their ideological assumptions and often represent the prevailing hegemony. Drug prevention efforts are no exception. Like all social problems (Gusfield, 1963, 1981; Reinarman and Levine, 1989; Schneider and Kitsuse, 1984), illegal drug use, as a perceived problem is a product of the concern voiced by key social players and institutions, and the degree to which that concern is passed on to the public by the media. The attention paid to illegal drug use in the United States fluctuates between denial and hyperbole. Regarding the legal use of harmful drugs, the situation is ambiguous, at best. For example, the two most popular legal drugs—alcohol and tobacco, both of which are addictive and often detrimental to health—are also heavily promoted through multi-million-dollar advertising campaigns that suggest a variety of benefits accrue to users as a by-product of consumption.

Alcohol and tobacco use are generally acceptable in the United States, and prevention efforts are limited. Typically, alcohol and tobacco prevention efforts form a small part of the school health curriculum and are seldom the subject of PSAs. The few PSAs that do exist are rather narrow in scope. For example, most PSAs relating to alcohol do not suggest abstinence but rather responsible consumption. Two recent alcohol-related PSAs suggest either "drink with your head, not over it" or "don't drink and drive"—both support drinking behavior and only advocate limiting or restricting it in certain contexts.

A growing awareness of the health problems related to tobacco use has led to increasing pressure on tobacco companies: the FDA has issued regulations to limit access by underage persons and limit the use of certain kinds of advertisements. Seventeen states are suing tobacco companies for reimbursement of medical costs paid out by Medicaid programs due to the negative health consequences of smoking, and there are many individual lawsuits against tobacco companies for restitution as a result of smoking-related illnesses. However, the amount of money spent on preventing alcohol and tobacco use pales in comparison to the marketing and advertising budgets of

the industries. Alcohol and tobacco producers, because these products are legal, steadfastly maintain their right to promote their products as they see fit. And while the FDA regulations would limit the type of advertising available for tobacco producers, they have prompted many tobacco manufacturers to go to court to challenge them on First Amendment grounds. The outcomes of these disputes lie years in the future. Meanwhile, advertising continues unabatedly to persuade the American public to consume alcohol and tobacco.

One of the most visible efforts to prevent illegal drug use and abuse has been the anti-drug PSAs. In this chapter I examine how illegal drug use is articulated in the United States, both as general social problem and as the result of a specific widespread campaign by the Partnership for a Drug-Free America (the Partnership)—a campaign that despite its national focus on drugs has never produced an anti-tobacco or anti-alcohol PSA. In addition, I offer a brief rationale for the use of critical methods in understanding media products like PSAs. Last, I analyze two specific segments produced by the Partnership: the introduction to a series of PSAs by Peter Jennings and a PSA entitled "Who Wants." As a result of these analyses, I discuss the concept of illegal drug use as constructed by the Partnership. I contend that drug use and abuse must be seen within the broader context that acknowledges both the positive and negative aspects of all drug use: legal, prescription, over-the-counter, and illegal. Only by adopting this holistic view can one begin to comprehend the variety of forces attempting to influence our drug-taking behavior.

ILLEGAL DRUG USE AND PSAs
Starting in the mid-1980s, the Partnership, a heavily endowed non-profit anti-drug consortium, began to:

> create messages to 'unsell' drugs to preteens, teens and young
> adults for use on television, in magazines, on outdoor posters
> and billboards, and in newspapers and radio. With the assis-
> tance of special creative task forces we craft messages that

'unsell' drugs to minorities, particularly to the African-American and Hispanic communities. (Partnership, 1992, 1)

The Partnership, whose supporters include the major pharmaceutical companies as well as the large alcohol and tobacco companies, solicited the pro bono production and broadcast of hundreds of print and broadcast anti-drug announcements. According to their own estimates, "from March 1987 through the end of 1993, the total amount of broadcast time and print space donated to messages was over $1.7 billion, making this the largest public-service campaign in history" (Partnership, 1994, 1).

Despite the numerous press reports (a Lexis/Nexis search from 1986 through 1996 yielded 1,962 stories in major newspapers) lauding the efforts of the Partnership and brief comments (Drucker, 1992) and critiques (Forbes, 1994) in the anti-drug literature, little has been published attempting to analyze the ads from a representational point of view, exploring the ideological assumptions and hegemonic effects of these PSAs.

Before analyzing the Partnership's PSAs, here is a brief description of how drug use is viewed in the United States. Drug use and abuse are framed most often in medical terms: addiction is a disease that is amenable to a cure. Additionally, this point of view suggests that drug abuse is an individual problem that the individual must work toward curing. In the public health field, there are many who argue that drug abuse is a function of structural determinants such as the lack of adequate educational and economic opportunities. This is an important debate. However, it diverts attention from public recognition that drug abuse is a complex problem that will never be solved by a magic bullet. Regardless of the merits of the many different sides of the debate, it is true that drug abuse is a problem in the United States, particularly if the legal drugs, alcohol and tobacco, over-the-counter drugs, and prescription drugs are included in defining the problem. Legal drugs also need to be framed by the state and corporate capitalist interests they represent: alcohol, tobacco, prescription, and over-the-counter drugs generate substantial revenues not only

for the companies that manufacture them, but also for the government that regulates and taxes them. Manufacturers of these legal products would be the first to object to any suggestion that the consumption of legal drugs is in any way related to the consumption of illegal drugs. However, the use and abuse of legal and over-the-counter drugs are everyday occurrences for many Americans. The amount of money spent on convincing the public that using alcohol and tobacco will result in friendship, love, excitement, and fun is enormous—as is the social cost of the abuse of these two substances. However, most prevention efforts' focus is on illicit drugs (Stein, 1990), leading to a very specific understanding by the general public of drug use and abuse.

The second area where drug use and abuse generate attention is in the development of political capital. While many scholars (Drucker, 1992; Siegel, 1992; Weinstein, 1993) suggest the "war on drugs" is futile, politicians persist in demonizing certain substances, foreign nations, and various U.S. minorities in the hope of getting elected. These and other forces are conflated with the marketing and promotion of the legal drugs, alcohol, and tobacco. While tobacco advertising has been banned from television by Congressional act since 1971, print advertising for tobacco is still ubiquitous. An example of this, and one of the most commonly attacked series of advertisements, was the Joe Camel series. A major study demonstrated that children recognized the Joe Camel character 96 percent of the time (DiFranza, 1991). Alcohol, particularly beer, is advertised on television and in the print media. In an ironic twist not lost on many doing research in this area, alcohol and tobacco advertisements are frequently linked with sporting events. For an example, take Virginia Slims' long-time sponsorship of women's tennis and Budweiser's close association with both baseball and football. Most ironical of all is that sports are often cited as *the* healthful alternatives to illegal drug use.

Both the dominant medical orientation to drug abuse (i.e., as an individually based illness amenable to individual behavior change and medication) and the rise and fall of

certain types of drug abuse as social problems are, to a large extent, the result of common-sense understandings of the issues as presented by various media. The ability to understand and decode media in terms of ideological assumptions and hegemonic effects is an essential skill for all to have so as to be better prepared to analyze critically the many messages and images we all are exposed to on a daily basis.

REPRESENTATION, IDEOLOGY, AND HEGEMONY

Growing up in a media culture means that often we deal with representations of people and the physical world. Much of our knowledge of our culture, our nation, and even ourselves is a result of media images we consume. As representations are produced, common-sense assumptions about those representations are reproduced. Hall (1982) showed the crucial difference that exists in thinking of the media as reflecting society versus representing society, and stated:

> It [representation] implies the active work of selecting and presenting, of structuring and shaping: not merely the transmitting of an already-existing meaning, but the more active labor of *making things mean.* (p. 64)

The common-sense aspect of representations is a result of ideology at work. Hall (1986) defines ideology as:

> The mental frameworks—the languages, the concepts, categories, imagery of thought, and the systems of representation-which different classes and social groups deploy in order to make sense of, define, figure out and render intelligible the way society works. (p. 29)

Media messages are more than what they appear to be, they represent certain values, agendas, and orientations and are never innocent. Hall (1982) elaborated:

> Meaning is a social production, a practice. The world has to be *made to mean.* Language and symbolization is [sic] the means by which meaning is produced. (p. 67)

For example, a recent *New York Times* feature ("Homosexuals Criticize," 1996) reported on a new PSA

produced for the Partnership that "features a young heroin addict describing how, after losing his job, he had to 'have sex with men to support my habit," (p. C7). In response to that PSA, the Partnership was criticized by Alan Klein, news media director at the Gay and Lesbian Alliance in New York, for suggesting that homosexuality "is merely an extreme reaction made by young people in life-threatening situations" and that "if there is one thing worse than being an addict, it's being a homosexual" (p. C7). This is an example of how implicit messages and symbolism can underlie the explicit anti-drug messages in the Partnership's ads.

The ideological elements of media practices are often invisible to most or dismissed as unimportant. Ideology conjures images of domination and coercion for many-why are so many people "duped" by it? Are people really stupid when it comes to the media? How are people fooled so easily? The answer to these questions can be found in the concept of hegemony. Hall (1982), borrowing from Gramsci, stated that hegemony, "is understood as accomplished, not without the due measure of legal and legitimate compulsion, but principally by means of winning the active consent of those classes and groups who were subordinated within it" (p. 85).

The importance of hegemony is that it achieves the "active consent" of many through ideological work. That is, force or coercion, such as the use of the police or military to arrest drug dealers and traffickers, is not a part of hegemony. Rather, the concept of hegemony can be compared to the notion of *zeitgeist* or "the spirit of the times." So, the public consensus that enables the police and military to take those actions described earlier would be part of hegemony. During the mid-1980s and early 1990s when the Partnership was most active, a conservative hegemony was the defining feature of life in the United States.

Ideology, on the other hand, represents social and group assumptions rather than individual assumptions. Individuals can subscribe to or believe in particular ideologies, but these ideologies represent social formations. Combining this idea with the notion of hegemony, it be-

comes clear that "a dominant ideology" does not exist alone, but coexists with many different ideologies. The social and cultural terrain, or everyday life as we know it, that this presupposes is never won but must constantly be struggled over.

Keeping the various articulations of illegal drug use mentioned earlier in mind is useful in examining both the assumptions behind and the importance of Peter Jennings' introduction and the "Who Wants" PSA. Through my two analyses, I describe the ideological assumptions of the two texts by linking their components to the various hegemonic forces of the institutions and assumptions behind them. I offer an analysis of the Peter Jennings introduction and the one PSA with the caveat that this analysis reflects my location as a white male heterosexual university professor. It is important to recognize the mediating effects that each reader brings to the meaning-making process. However, my analysis is a continuation of the work of others (Fiske, 1987; Giroux, 1992, 1996) who have argued for a critical pedagogy of representation so as to empower citizens in the critical analysis of our pervasive and persuasive media culture. Also, my analysis aims to combat the frequent pronouncements of social conservatives who are framing and defining a wide variety of policy debates in the United States. Both Peter Jennings' introduction and the PSA were analyzed according to Fiske's (1987) three levels of televisual codes—reality, representation, and ideology—which I elaborate further as the analysis proceeds.

ABC NEWS: PETER JENNINGS' INTRODUCTION

Peter Jennings' introduction was part of a promotional video tape that presented a variety of the Partnership's PSAs broken down by target age groups. This introductory segment is important because it presents the viewpoint and rationale of the Partnership's campaign. First, I will make some general comments about the representations and discourses employed by the Partnership in this introductory segment and then I will offer an analysis of the text of the "Who Wants" PSA.

Peter Jennings' introductory segment appeared after the Partnership's red, white, and blue logo appeared on the screen. This signifying practice served to offer an equivalence of the Partnership's logo with the American flag and mobilized the discourse of nationalism in the fight against illegal drugs, eliciting feelings of patriotism, sacredness, and therefore suggesting it was something worth fighting for. The Partnership was very clever in using this symbol while never calling this campaign a war on drugs, as many politicians persist in doing. Wars have winners and losers. Serious analysis of any aspect of the illegal drug problem will reveal that it is an unwinnable war if the goal is a drug-free America (Young, 1973). That is not to say that representational politics and other productive strategies cannot be employed to reduce the harm associated with the use and abuse of illegal drugs. However, the particular focus of the PSAs is on illegal drug use, which by all accounts is less of a public problem than alcohol and tobacco, particularly if morbidity and mortality statistics are compared for alcohol and tobacco with all other illegal substances (Johnston et al., 1992). The use of Peter Jennings reporting from his desk in the ABC newsroom lends a great deal of credibility to the video and reinforces a patriarchal ideology as it relates to illegal drug use. Jennings' introduction is reminiscent of a kind of *Father Knows Best* nostalgia where the unquestioned head-of-the-household was the father. In other words, a patriarchal ideology is supported to instill a type of fear associated with a "wait-until-your-father-comes-home" child-rearing technique.

The objective discourse of the news as a reliable source of information is crucial in the construction of the antidrug crusade. The portrayal of the drug problem as one of individual responsibility within the objective discourse of the news is of primary importance. Social and political issues are only reported if they can be embodied in the individual, causing the social origins of the problem to be lost. Individual motivation is assumed to be the origin of all action, with social and political forces having little or no culpability.

News-as-discourse strives to control and limit the meanings of the events it presents. This is primarily achieved through strategies of containment—what is included in the news and how news stories are told. For example, Bell (1983) examined the narrative structure of drug-related stories and found a strict categorization of social roles and narrative structure that reinforced commonly held stereotypes. Those stereotypes include the kinds of people who are portrayed as drug dealers and drug users. More often than not, the news portrays drug dealers and users as members of minority groups and socially disempowered groups such as women and children. Additionally, Barthes' (1973) concept of exnomination also is useful in reading this introduction. Exnomination is a process whereby the views of the powerful in society are naturalized and the political nature of discourse is masked as class, gender, racial, and other differences (Fiske, 1987). Exnominated discourse comes to be accepted as commonsense.

THE PARTNERSHIP'S PSA "WHO WANTS"

I have taken a close look at "Who Wants," one of the Partnership's PSAs, to provide substance to the analysis just presented. The storyboard (Figure 8.1) presents the visual image and sound effects and voice-overs of the PSA "Who Wants." The illustration of "Who Wants" was developed by the Partnership and distributed as part of a packet of promotional materials.

"Who Wants" depicts a series of assertive, minority early adolescents refusing what are assumed to be offers of drugs. This strategy is little more than a recapitulation of the "Just Say No" campaign promoted by Nancy Reagan and criticized as simplistic by many professionals in the drug prevention field (Drucker, 1992; Forbes, 1987). According to literature distributed by the Partnership, the "Who Wants" PSA's message is "Most kids don't use drugs, so someone who uses or sells drugs, ends up all alone" (Partnership for a Drug-Free America, 1992). Those refusing the offer of drugs were portrayed with friends or alone.

Partnership for a Drug-Free America

Figure 8.1

In each situation the refusal was presented as unprob-
lematic and easy to do. John Fiske (1987) uses three levels
of analysis to deconstruct television. The first level of
Fiske's codes of television (reality) is made up of social
codes such as appearance, dress, make-up, environment,
behavior, speech, gesture, expression, and sound. Fiske
(1987) noted:

> that 'reality' was already encoded, or rather the only way we can
> perceive and make sense of reality was by the codes of our cul-
> ture...and so, 'reality' was always already encoded, it was never
> 'raw'. (p. 4-5)

In other words, reality, as a function of individual percep-
tion, is defined by familiar social and cultural markers.

In this PSA, the appearance of the teenagers who re-
fused drugs (refusers) was that of normal adolescents—
well-adjusted, well-groomed, polite, articulate, and asser-
tive—if television reality is to be believed. A more accurate
portrayal of adolescents might suggest some of the traits
more commonly associated with this period of develop-
ment—awkwardness, inarticulateness, moodiness, and re-
belliousness. While these latter are not the only traits of
adolescents, and the refusers' ideal traits are undoubtedly
possessed by some adolescents, the heavily skewed presen-
tation of adolescents as well-adjusted and articulate only
coincides with a televisual reality. The dealer was pre-
sented as an object of social ridicule and rejection. His ap-
pearance, when glimpsed in the rapid jump cuts that char-
acterize the PSA, was much the same as the other adoles-
cents.

The dress of both the refusers and the dealer was typi-
cal of early adolescents—bright, colorful sports clothes.
Again, the refusers appeared warmer, due to being shot in
color. There was little difference in the dress of the dealer,
but due to the fact that he was always presented in black
and white, he appeared ominous. Make-up was not evident
but all the refusers were clean-cut and good looking with-
out any blemishes. The face of the dealer was purposefully
not shown until the end when he was alone on a rooftop,

and even then the shot was a distant one projecting his solitary figure against a skyline.

The environment presented another contrast. The refusers were seen in a variety of settings—a school yard, the front steps of a house, a lunch room, a school hallway, and walking down a street—all in the daytime. The dealer was seen in a variety of street settings juxtaposed against the warm, protective environments of the refusers. He was seen sitting on an empty staircase, walking in the street, hanging up a public phone, passing something to another hand, and sitting alone on a rooftop—all at night. This contrast reinforced the feeling of good and evil. The predominant feeling was one of the refusers being on the inside and the dealer being on the outside, wanting desperately to be on the inside.

The behavior, speech, expressions, and gestures of the refusers all suggested an incredulity that someone could be so stupid as to use drugs or to try and get them to buy or use drugs. The refusal lines used in "Who Wants" suggest a depth of conviction and degree of disbelief that, while laudable, is not very common in many adolescents. This fact is borne out by statistics from the Monitoring the Future project (Johnston et al., 1992), especially in relation to alcohol and tobacco. The accumulation of these social codes presents the reality of the PSA.

Fiske (1987) noted that the social codes comprising reality are then encoded electronically by camera, lighting, editing, music, and sound. The camera work in this PSA juxtaposed color imagery with black-and-white imagery. The refusers were presented in color; the dealer was presented in black and white, and his screen time was much shorter. In this thirty-second spot, there were twelve different cuts—six in color and six in black and white. This technical code clearly denoted good and evil. The color shots evoked feelings of warmth and camaraderie, while the black and white shots evoked a sense of alienation, distance, and a cold, harsh reality. The lighting reinforced the notion of good and evil in this particular PSA. The refusers

were presented in full light, whether indoors or out. The dealer appeared in the dark or in dimly lit environments.

The editing technique featured rapid jump cuts between scenes of refusers and scenes of the dealer. The refusers were given more camera time than the scenes of the dealer with the exception of the last shot. The last shot focused on the dealer sitting alone on a rooftop against the backdrop of the skyline and was on screen for approximately eight seconds—double the time of any other shot in the PSA. The previous cuts set up this final shot. The refusers had approximately twice the screen time as the dealer had. The editing process defined good and evil using time. Once established, the closing shot focused on the evil dealer—alone and dejected.

The soundtrack was another marker for the difference between the refusers and the dealer. The shots showing the refusers were not backed by a soundtrack. They were presented as real-time, unedited shots. The refusers talked to one another or addressed their refusal lines to the unseen (in their shots) dealer. For example, in the shot of the three boys playing basketball, it was the sound of the ball bouncing and then the line, "Nahhh, we don't play that!" In contrast, the images of the dealer and his environment were backed by an eerie soundtrack. The use of music or soundtracks in minor keys is a convention used in television and film to announce impending danger or to announce the arrival of the villain. Its use in this PSA was consistent with this convention. Fiske (1987) stated that these technical codings, "transmit the conventional representational codes which shape the representations of narrative, conflict, character, action, dialogue, setting, and casting" (p. 5).

Casting and characterization are not merely about individual roles. They are representational practices that encompass ideological values, such that it is usually quite easy to differentiate the good characters from the bad. Speaking generally, Fiske (1987) believed it possible "to theorize that heroes are socially central types who embody the dominant ideology, whereas villains and victims are

members of deviant or subordinate subcultures who embody the dominant ideology less completely" (9). This assertion can be demonstrated in "Who Wants" through an examination of both the casting and characterization of the actors in the PSA. "Who Wants" presented the refusers as kids doing the things that kids do: playing basketball, chatting in the lunchroom, hanging out on the steps in front of their house, going to a locker, and walking home. In contrast, the dealer was shown alone on a dark stairway lighting up what appears to be a pipe, angrily hanging up a phone on the street, trading drugs for money, avoiding the police, and sitting alone on a rooftop. These characterizations clearly indicated acceptable and unacceptable roles for adolescents and reflect the dominant ideology. That is not to say that the role of drug dealer is a desirable practice, but rather that both the roles of the refusers and the dealer are decontextualized. The PSA cannot answer the following questions: Why were the refusers so easily able to refuse the offers of the dealer? Why did the drug dealer become a drug dealer? What were their respective families and communities like? These questions cannot be answered by a 30 second PSA, and in fact the PSA would rather not have them asked since the portrayal of the participants is based on the ideology of individualism.

The action of the PSA was another unit of analysis. In "Who Wants," the refusers' actions were clearly identifiable and acceptable. Many of the quick shots of the dealer were unclear and unfocused, yet at the same time given an ominous feeling by their location on the street and by the tell-tale soundtrack in a minor key. Also, it was assumed that the dealer was prompting the action by his offer, while the refusers are reacting. The dealer's actions were never seen, but the responses were seen. The hidden action denoted secrecy and illegality. The refusers' reactions became the central action of the PSA and represented acceptable behavior. The major action that focused on the dealer was when he was seen on the rooftop—inactive and alone. The implication of this shot was that dealing will leave you without friends and isolated.

Dialog, or speech, was used to encode the positive position of the refusers and nullify the existence of the dealer. In "Who Wants," there was no dialog as the only speakers are the refusers. The dealer never speaks, but was spoken to by the refusers. The responses directed to the dealer ranged from outright refusal, "Nahhh, we don't play that!" to cold rejection, "Man, forget you!" He was clearly rejected and ostracized for the implied association with drugs. The word "drugs" was not mentioned once in the PSA, but did appear in the logo at the end of the spot.

The technical and representational codes included in this discussion were "organized into coherence and social acceptability by the ideological codes, such as individualism, patriarchy, race, class, materialism, and capitalism" (Fiske, 1987, 5). "Who Wants" was analyzed to uncover the ideology inscribed in the PSA through the combination and interpenetration of the social, technical, and representational codes addressed earlier. The primary ideological work in "Who Wants" and in other PSAs produced by the Partnership was the naturalizing of the dominant patriarchal capitalist ideology which supports the war on certain drugs and portrays individualism as the solution to the drug problem through a belief in the primacy and unity of self. This was largely achieved through the conventions of realism. Fiske (1987) believed television to be "an essentially realistic medium because of its ability to carry a socially convincing sense of the real" (21). In this commercial, reality was naturalized by the social, cultural, and technical codes this study examined. Ideology makes up the fabric of reality, and was rendered invisible by the seeming naturalness of reality. The notion of reality being related to the common-sense view further uncovers its ideological nature. In "Who Wants" the characters, both the refusers and the dealer, are realistic and believable, but without social contexts. The refusers' individuality was highlighted by each one's ability to make bold pronouncements rejecting the presumed offers of the dealer.

Both realism and individualism work to maintain the dominant ideology. Fiske (1987) stated:

> Individualism diverts attention away from any questioning of the social system, for individual 'solutions' to social problems are always possible, and this, when coupled with the belief in the primacy of the self, fits with and underpins the role of realism in naturalizing bourgeois ideology. (p. 153)

The individualism that was valorized by the refusers' ability to aggressively reject the dealer's assumed offers hides a multiplicity of complex issues that form the nexus of the drug problem in the United States. The dealer was presented as an individual and, one might argue, as the epitome of the capitalist ideal—an entrepreneur, albeit an alleged criminal one. This type of individuality is not acceptable to the dominant ideology. However, as demonstrated earlier, tobacco executives are the wealthy beneficiaries of being able to deal a legal drug. This business act is naturalized by capitalist ideology, which not only allows but promotes the aggressive marketing and promotion of any and all legal products, regardless of the health consequences associated with those products. Individuality is only acceptable if all the rules are followed, at least on the surface. The dealer is inevitably part of a larger network of drug dealing activity that may serve as a primary social network. The logic of "Who Wants" did not punish the criminal with arrest or incarceration, but with social isolation from the refusers' social network. There was little if any reference to the social network provided by being a dealer. The assumption of "Who Wants" is that dealers work in isolation. Obviously, this is a ludicrous assumption, since it is widely known that the illegal drug trade is hierarchically structured, in much the same way as legitimate corporations are structured.

DISCUSSION AND CONCLUSIONS

The various articulations I have explored are helpful in describing the Partnership's understanding of drug use in the United States. It is supported by an ideology of individuality. That is, individuals are both responsible if they use illegal drugs and responsible to pull themselves out of drug use by way of personal will power. The other message, im-

plicit both in Peter Jennings' introduction and the "Who Wants" PSA, is that drug use equals abuse and addiction. This understanding supports the current discourse on the prevention of illegal drug use as defined by the current conservative hegemonic forces. While not denying both the individual and social costs of drug abuse, most adults use the legal drug alcohol in responsible ways. Of course, some people become alcoholics—a euphemism for "alcohol addict." Additionally, many Americans "use tobacco," or in other words, are addicted to tobacco. The individual is always located in a social context and, while not denying the power of individual will, we must recognize the many structural forces within American society that promote and condone drug use (Stein, 1990). I would argue that the many distinctions between legal and illegal drugs that antidrug forces highlight are minimal and that a full understanding of the issue of drug use demonstrates that many more people are harmed by legal drugs than by illegal drugs.

Illegal drugs are often used to articulate issues of race and class. The ideologies of race and class are clearly present in both Peter Jennings' introduction and the "Who Wants" PSA. While the Partnership labeled this series of PSAs as part of their "inner-city initiative" the question of race must be raised. Race would not be such an issue if the PSAs that are part of the inner-city initiative could be narrowcast to the intended audience. However, the PSAs are broadcast over network television and included as part of the previews on video cassettes. This means that anyone in the United States with a television and video cassette player is able to see them. This serves to spread the image of the drug user and abuser as being mainly minority groups—a gross distortion of the truth. In "Who Wants," all the characters are minority youth—African-Americans with one Latino. Are minorities the only ones who are at risk for drug abuse? What is the pedagogy of a media message that presents only people of color in both the positive and negative roles? When viewed in the context of most news stories relating to drugs, where the predominant picture of

drug-related criminality was a minority figure (Bell, 1983), the reinforcing of this racial stereotype must be called into question. Cultivation effect theorists (Gerbner et al., 1980; Signorielli, 1990) have demonstrated the racial and ethnic stereotypes propagated by the media in terms of who is presented as the "good guy" and who is presented as the "bad guy." The media are teaching technologies and the cumulative effect of the portrayal of illegal drug use and abuse has mainly served to develop scapegoats in the form of foreign countries, minorities, and inner-city locations. Additionally, the notion of class suggested by the Partnership implicitly suggests a lower-class location through the use of race. The common sense understanding of the lower classes in America is that they are disproportionately located in minority communities. Regardless of the truth of this belief, all studies of drug use demonstrate that class boundaries do not apply. Drugs, both legal and illegal, are used by all strata of society. While there may be differences in the particular substances used, there is little or no difference in rates of drug use.

As an educator, I feel is important to stress the promotion of multiple literacies both at home and in the school. Another aspect of this work (Ludwig, 1994) included focus groups with middle-school children in both urban and rural settings who were asked to provide their interpretation of five Partnership PSAs. This research allowed an evaluation of the explicit message as provided by the Partnership, alongside the critical analysis as shown here and the children's interpretation of the PSAs. This work explored the relationship between the consumption and understanding of the PSAs by the target audience and the "truth" of the PSAs described by the Partnership's promotional materials. The development of critical powers and an understanding of ideology and hegemony is a part of children's vocabulary even though they would not use those terms to describe it. Children are theorists who explore their ever-expanding view of the world by asking questions. It is the responsibility of parents, educators, and other cultural workers to keep that curiosity alive rather than shutting it down

through an insistence on a solitary truth. The empowerment of the classroom as a viable public sphere must not be lost to the calls for a return to the basics. That is not to say that the reading, writing, and math skills are obsolete, but rather that multiple literacies and the ability to analyze the broad variety of images associated with the different media available today is crucial. This does not abandon the moral and ethical imperatives that are part of being an educator, but is rather an acknowledgment that the role of educators and other cultural workers is to promote the creation of active, critical thinkers prepared to question the assumptions of life in late capitalist societies in the hope of keeping democracy alive so as to promote social justice, equality, and equity.

The cultural politics of drug prevention, especially as presented by the Partnership's anti-drug PSAs, are only part of a complex and rapidly changing problem. There are real effects on society as a result of the use and abuse of drugs, both legal and illegal. However, we cannot limit prevention efforts to the relatively few illegal substances the Partnership focuses on. That is not to say that the Partnership's PSAs have not been effective. Surely, most people take them at face value, and in fact the producers undoubtedly believe they are doing important and valuable work. In the sense that the PSAs create a normative value that suggests drug use as nonproductive, unnecessary, and dangerous, good work is being done. In the sense that the PSAs create a normative understanding that scapegoats certain drugs, certain drug users, certain foreign nations, and an intolerance or even hatred of drug users and drug-producing countries, the PSAs can be a force of pernicious evil. Obviously, the PSAs are neither all good nor all bad. Taken as a whole, the PSAs tend to simplify a complex issue and offer little more than platitudes as a way of helping those who most need help. However, individuals' ability to problematize the PSAs by examining the ideological assumptions and hegemonic forces supporting the Partnership's view can be a powerful approach to a better, more nuanced understanding of drugs in the United States. The

identification and understanding of problems related to the use and abuse of drugs is ultimately what will drive the creation of public understanding and policy that can have an impact on how we as a nation deal with drugs of all types and their effects on those who use and abuse them.

REFERENCES

Ang, I. (1985). *Watching Dallas*. London: Methuen.
Ang, I. (1989). "Wanted: Audiences. On the Politics of Empirical Audience Studies," in *Remote Control: Television, Audiences, and Cultural Power*, E. Seiter, H. Borchers, G. Kreutzner, E. Warth, eds., NY: Routledge.
Ang, I. (1991). *Desperately Seeking the Audience*. New York: Routledge.
Barthes, R. (1973). *Mythologies*. London: Paladin.
Bell, P. (1983). "Drugs as News: Defining the Social," *Australian Journal of Cultural Studies*, Vol.1, No. 2, pp. 303-320.
Cotts, C. (1992). "Hard Sell in the Drug War: Condoning the Legal Stuff?" *The Nation*, Vol. 254, No. 9, pp. 300-302.
DiFranza, J. R. (1991). "RJR Nabisco's Cartoon Camel Promotes Camel Cigarettes to Children," *Journal of the American Medical Association*, Vol. 266, No. 22, pp. 3149-3153.
Drucker, E. (1992). "U. S. Drug Policy: Public Health Versus Prohibition," in *The Reduction of Drug-Related Harm*, P. A. O'Hare, R. Newcombe, A. Matthews, E. C. Bunning, and E. Drucker, eds., NY: Routledge, pp. 71-81.
Fiske, J. (1987). *Television Culture*. New York: Methuen.
Forbes, D. (1987). "Saying No to Ron and Nancy: School-Based Drug Abuse Prevention Programs in the 1980s," *Journal of Education*, Vol. 169, No. 3, pp. 80-90.
Forbes, D. (1994). *False Fixes: The Cultural Politics of Drugs, Alcohol, and Addictive Relations*. Albany: State University of New York Press.
Gerbner, G., L. Gross, M. Morgan, and N. Signorielli, (1980). "The 'Mainstreaming' Of America: Violence Profile No. 11," *The Journal of Communication*, Vol. 30, No. 3, pp. 10-29.
Giroux, H. A. (1992). *Border Crossings: Cultural Workers and the Politics of Education*. New York: Routledge.
Giroux, H. A. (1996). *Fugitive Cultures: Race, Violence, and Youth*. New York: Routledge.

Gusfield, J. R. (1963). *Symbolic Crusade: Status Politics and the American Temperance Movement*. Urbana: University of Illinois Press.

Gusfield, J. R. (1981). *The Culture of Public Problems: Drinking-Driving and the Symbolic Order*. Chicago: The University of Chicago Press.

Hall, S. (1982). "The Rediscovery of 'Ideology': Return of the Repressed in Media Studies," in *Culture, Society, and the Media*, M. Gurevitch, ed., NY: Methuen, pp. 56-90.

Hall, S. (1986). "The Problem of Ideology-Marxism Without Guarantees," *Journal of Communication Inquiry*, Vol. 10, No. 2, pp. 28-44.

"Homosexuals Criticize 2 Drug-Free Ads," (1996). *The New York Times*, July 8, p. C7.

Johnston, L. D., P. M. O'Malley, and J.G. Bachman (1992). "Smoking, Drinking, and Illicit Drug Use among American Secondary School Students, College Students, and Young Adults: 1975-1991," NIH Publication No. 93-3480. Rockville, MD: National Institute on Drug Abuse.

Ludwig, M. J. (1994). *Mass Media and Health Education: A Critical Analysis and Reception Study of a Selected Anti-Drug Campaign*. Ph.D. thesis, University Park: The Pennsylvania State University.

Morley, D. (1980). *The Nationwide Audience: Structure and Decoding*. London: British Film Institute.

Morley, D. (1986). *Family Television: Cultural Power and Domestic Leisure*. London: Comedia.

Morley, D. (1989). "Changing Paradigms in Audience Studies," in *Remote Control: Television Audiences and Cultural Power*, E. Seiter, H. Borchers, G. Kreutzner, and E. M. Warth eds., NY: Routledge.

Partnership for a Drug-Free America. (1992). "Inner City Creative" (List of Public Service Announcements), New York: Author.

Partnership for a Drug-Free America. (1994). Fact Sheet (Part of Packet of Promotional Materials). New York: Author.

Reinarman, C., and H.G. Levine (1989). "The Crack Attack: Politics and Media in America's Latest Drug Scare," in *Images of Issues: Typifying Contemporary Social Problems,* J. Best ed., NY: Aldine de Gruyter, pp. 115-138.

Schneider, J. W., and J. I. Kitsuse, eds. (1984). *Studies in the Sociology of Social Problems.* Norwood, NJ: Ablex.

Siegel, L. (1992). "The Criminalization of Pregnant and Child-Rearing Drug Users: An Example of the American 'Harm Maximization Program," in *The Reduction of Drug-Related Harm,* P. A. O'Hare, R. Newcombe, A. Matthews, E. C. Bunning, and E. Drucker, eds., NY: Routledge, pp. 95-107.

Signorielli, N. (1990). "Television's Mean and Dangerous World," in *Cultivation Analysis: New Directions in Media Effects Research,* N. Signorielli and M. Morgan, eds., Newbury Park, CA: Sage, pp. 85-107.

Stein, H. F. (1990). "In What Systems Do Alcohol/Chemical Addictions Make Sense? Clinical Ideologies and Practices as Cultural Metaphors," *Social Science and Medicine,* Vol. 30, No. 9, pp. 987-1000.

Weinstein, J. B. (1993). "The War on Drugs Is Self-Defeating," *The New York Times,* July 8, p. A19.

Young, J. (1973). "The Myth of the Drug Taker in the Mass Media," in *The Manufacture of News: A Reader,* S. Cohen and J. Young, eds., Beverly Hills, CA: Sage, pp. 314-322.

Chapter 9

The Diesel Jeans and Workwear Advertising Campaign and the Commodification of Resistance

Daniel R. Nicholson

INTRODUCTION

A quick glance through any newsstand magazine may incite a number of reactions, but there is one thing most people would probably agree upon: advertisements are changing. Although advertising has been evolving since its inception as an institution, it seems of late that many ads have become quite ambiguous and vague—one may even have trouble deciphering the product being advertised. Douglas Kellner (1995) offers an analysis of a particular Marlboro ad featuring nothing more than a pair of hands holding gloves and a cigarette—there is no mention of product name anywhere:

> The Marlboro ad is one of a genre of contemporary ads which forces the consumer to work at discerning the brand being sold and at deciphering the text to construct meaning. The minimalism of product signifiers appeals to readers jaded with traditional advertising, tired of the same old stale images, and bored with and cynical toward advertising manipulation. (p. 254)

This "genre of contemporary ads" is one I find of particular interest as both cultural indicator and pedagogical tool (i.e., a tool for teaching), and the Diesel Jeans and Work-

wear campaign provides particularly rich texts toward these ends.

When addressing an advertisement as a "cultural artifact" (Frith, 1995), many facets of culture and society can be revealed. Information about marketers' intent and intended target market may be discerned; but often these sales messages are intertwined with social messages relating to power and oppression. With the aid of 20/20 hindsight, one can often see the racism and sexism manifest in (especially) precivil rights advertisements. However, if one were to shift his or her view to more contemporary advertising, the inherent oppression may not be quite so obvious. As Henry Giroux points out, "Cultural workers need a new map for registering and understanding how power works to inscribe desires and identities and create multiple points of antagonism and struggle" (Giroux, 1994, 23).

It is my intention to facilitate a "media literacy" (Kellner, 1995) that will enable consumers to see their position and subjectivity (a subordinate relationship with various forms of power) within the greater "framework" of contemporary capitalism—utilizing advertisements as pedagogical tools toward that end. Aware of their positionality as expressed through advertisements, readers of advertisements can be better informed about the consequences and implications of the choices they make through their purchases, or nonpurchases. I am endorsing a media literacy that will enable the reader to interpret advertisements from a counter hegemonic position. But before getting into counter hegemony, perhaps it would be a good idea to discuss hegemony.

"The nature of hegemony is one of the most important and least understood features of the late twentieth century" (Kincheloe, 1995, 167). One of the reasons it's "least understood" is because it can be a very abstract concept. Hegemony is a form of consensual control. This form of control is often contrasted with coercive control, which involves the threat or use of force and/or violence. When you think of coercive control, images of gangsters, terrorists, and national armies and other policing agencies probably come to mind. Hegemony, on the other hand, is a sort of

society-wide agreement which attempts to maintain a social order among the various members of that society. This may sound like a harmonious situation, but a problem arises in that most nonfictional societies continue a degree of oppression against certain members of the population. We can refer to the oppressed members as the subordinate group, and the people who benefit from this oppression, by social and economic equilibrium or advancement, as the dominant group.

Subordinate groups are deemed 'subordinate' because they are subject to the various, and sometimes seemingly invisible, forms of power the dominant group possesses. For our purposes here, the dominant group can be identified as the producers (in the manufacturing sense) of popular culture. Popular culture is a broad subject, including everything from fashion to television programming, and how such items are used. While popular culture may be thought of as stemming from "the populace," many of its forms are produced by dominant groups, and within the particular frames and guidelines they choose and work to maintain. This choosing of frames and guidelines is an important form of power in that it affects much of what is seen, heard, and discussed, thereby constraining public discourse within those bounds the dominant group deems appropriate.

Hegemony occurs when the subordinate group acquiesces and accepts the 'reality' produced and then maintained by a dominant group. That is to say, the subordinate group has an understanding that their position within society and culture is for the most part, preordained—that is, it is *common sense* that things are the way they are, given the information we have to work with (are bound within). In order to maintain hegemony (and forestall a 'popular' revolt), some concessions must be made in favor of the subordinate class—but these concessions are of the type that will not ultimately disrupt the status quo. It should also be noted that hegemony is an active and ongoing process; it needs maintenance and revision as attitudes and culture shift and change.

An example of hegemony may be the positive affiliation some white working-class males seem to have with the Republican party: The Republican platform does little if anything to improve the social and economic welfare of the working-class, but when it concedes with (perhaps) white working-class male opinions on an issue such as affirmative action, these working-class males accept the whole platform "as the way things ought to be" and perform an ultimately self-detrimental act by voting Republican—that is, voting in tax breaks for corporations and the wealthy (I would like to make it clear that I am in no way endorsing a Democratic platform either). Buying jeans and putting tears in them in order to present an "anti-consumerist" identity is another example of falling prey to hegemony. The cultural producer (manufacturer) accrues a profit while the would-be dissident forfeits capital. These are overly simplified examples, but they do serve my point.

Counter hegemony, on the other hand, "impl[ies] a 'clear theoretic consciousness' which enables people to *comprehend fully* and act on their discontent" [emphasis added] (Femia, 1975, 34). This discontent may come from critical analyses of certain facets of popular culture—an analyses of what is not said, as much as what is said. Looking at advertisements specifically, we can see how this dominant class addresses their particular target audiences, and also what these ads may be saying—sometimes through exclusion—to members of the non-target audience. Another element for consideration, one that is often "not said" but of importance, asks, What does the dominant group stand to gain through this interchange? Are they producing goods for the betterment of society? Are they producing goods because of public demand? Are they producing goods that will help them maintain their own social and economic positions? Are they producing goods that can in some sense be liberatory for consumers?

Analyzing ads critically can help one to see how different aspects of race, class, gender, and sexual orientation sit in relation to the power of the dominant class. Such analyses are counter hegemonic in that they raise aware-

ness of oppression, and, as Lather points out, awareness in turn can lead to action:

> The task of counter hegemonic groups is the development of counter institutions, ideologies, and cultures that provide an ethical alternative to the dominant hegemony, a lived experience of how the world can be different. Counter hegemonic forces work to stymie consensus, to present alternative conceptions of reality, to develop the ripeness of subjective conditions that is a precondition for the struggle toward a more equitable social order. The entry point in terms of individual consciousness is the disjuncture between received versions of reality and lived contradictions. (p. 55-56)

To some, "the struggle toward a more equitable social order," may have revolutionary (read: retaliatory) undertones, but cultural workers would argue that this is in fact democracy in motion.

As Shields (1990) notes, the reader must also learn to be wary of attempts by advertisers to appropriate and present a counter hegemonic stance within their ads in an effort to appeal to those who are concerned with being counter hegemonic:

> Certainly, visual images can be openly resistant to dominant discourses in a culture, serving a counter hegemonic function, however these images are nonetheless produced within a dominant ideology and it is the relation of that dominant ideology to the form of resistance in a visual image that is of particular importance to the scholar of visual communication. (p. 25)

Once you are aware of your relationship to the economic framework of contemporary commercial capitalism, as read through critical analyses of advertisements, you will be better prepared to engage in purchasing decisions that will more accurately reflect your attitude. If a sense of agency with regard to "resisting" the hegemonic establishment is achieved, I would argue that that is a more empowering sense of agency than one which, while viewed as "resistant" by some because of the manner in which it's presented, merely pumps capital back into the system the agent wishes to resist.

THE TARGET MARKET

One of the reasons I chose to work with the Diesel campaign is because I believe it is directed at a very specific target market—the market that has come to be known as Generation X (Macalister, 1994). Generally speaking, this market is comprised of people born between the early to mid 1960s and the mid to late 1970s. I will support this argument further below, but first here is some background.

Although the term "Generation X" originated as the name of a 1980s glam-rock band founded by Billy Idol, it has more recently come to signify a segment of the population characterized in Douglas Coupland's 1991 novel *Generation X: Tales for an Accelerated Culture*. The three main characters of this book are pushing 30 years old and are "underemployed, overeducated, intensely private, and unpredictable." The novel invoked an understanding that this so-called Generation X was indeed a nationwide phenomenon.

Richard Linklater's 1992 film, *Slacker*, was another precursor to the onslaught of attention this age group is receiving. In *Slacker* the camera seems to randomly follow recent college graduates, temporary dropouts, and graduate students as they live their lives in Austin, Texas. The common theme running among the numerous, and never-to-return-to-the-screen-again, "stars" is the desire to espouse their personal conspiracy theories. Linklater's slackers are individuals questioning their forthcoming roles in a society they see as sick and in need of a major overhaul (also see Dunn, 1995). Does one disregard what she or he deems as important just for the sake of taking some fundamentally contradictory, albeit society-approved job in order to pay back student loans?

Advertisers have been interested in the social phenomenon "Generation X" since the 1992 American Magazine Conference in Bermuda, when advertising executive Karen Ritchie delivered her "Farewell Boomers! Hello Generation X!" speech (Huhn, 1993). While delivering a media presentation on the future, Ritchie "realized there was a world beyond Baby Boomers. I realized I didn't know what's

going to happen next. I thought, 'that's pretty stupid. Why don't you know what's going to happen next' ?" (p. M14). What happened next was Ritchie proceeded to inform her fellow ad executives that they were neglecting a major buying force.

However, advertising to this target market proved to be somewhat problematic. *Newsweek* (Giles, 1994) reports that Xers have a highly sensitive "bullshit alarm." Karen Ritchie, who has by now become an "expert" on Generation X, attributes this to the fact that during the years that twentysomethings were watching Saturday-morning cartoons they were assaulted by a barrage of advertising so intense that it had to be addressed by federal legislation. "The first time you realize the super toy you wanted is really only four inches tall you learn a hard lesson. We created a whole generation that believes advertising is lies and hype" (Giles, 1994, 70).

Generation X's awareness of being a target market is of major concern in the industry. An article out of *Marketing News* (December 6, 1993) is titled, "Xers Know They're a Target Market, And They Hate That.." The article states, "marketers have been made to face up to the painful reality that this generation knows what marketers are up to and wants nothing to do with them" (Miller, 1993, 2). In fact, one of the chapters in Coupland's *Generation X* is titled: "I am not a target market."

It becomes apparent that Generation X is typified by advertising/marketing trade journals and popular fiction/nonfiction books, as "jaded with traditional advertising, tired of the same old stale images, and bored with and cynical toward advertising manipulation" (Kellner, 1995, 254). When Generation X became a bona fide target market (see Huhn, 1993), discussion circled around how to reach this media savvy, advertising critical, and even anti-consumerist market. I believe, and hope to exemplify throughout the course of this chapter, that Kellner's emergent "genre of contemporary ads" is in part an effort to reach this resistant market.

Armed with demographic and psychographic information, very intelligent and talented advertisers and marketers attempt to penetrate the wall of resistance this target market is heralded to possess. I intend to expose advertising techniques that attempt to circumvent this counter hegemonic resistance, and by doing so, add to the arsenal of opposition against the oppressiveness inherent in consumption-based capitalism.

SELLING IDENTITY TO GENERATION X

> Advertisements are selling us something else besides consumer goods: in providing us with a structure in which we, and those goods, are interchangeable, they are selling us ourselves. (Williamson, 1978, p. 13)

> A target market all their lives, they are at the same time invisible. And they're angry about it. Every American counterculture has had it out for advertising since advertising became a cultural power, but this generation of young malcontents is taking it personally. (Goldman, 1993, 288)

The "ourselves" of the Generation X market is characterized as antiestablishment, antimaterialist, and antiadvertising (Rushkoff, 1994; Coupland, 1991; Macalister, 1994). How does one go about projecting this identity? Some of the ways, which have become 'trademark' Generation X, are traditional-format scoffing "grunge" music, retro (i.e., old) clothing, "fashion-neutral" flannel shirts, and of course an ongoing aura of irony, and an everpresent aura of apathy. The term *weltschmerz* is most apt here, defined in *Webster's Collegiate Dictionary*, 10th Edition (1993) as, "mental depression or apathy caused by comparison of the actual state of the world with an ideal state."

The questions I am more concerned with are, how do advertisers go about selling this identity back to the "ourselves" of Generation X, and how are advertisers attempting to circumvent the animosity Generation X holds for them? One method is "the wink"—or self-referentiality within an advertisement. According to advertising creatives, the wink is used when they want the reader to recognize

that "we know you know what we're trying to do, but because we're letting you know we know, it makes it okay—because we're so hip to your hippness. Get it?"

A second strategy aimed at this market is to create ads with "visual ambiguity" that force "the consumer to work at discerning the brand being sold and at deciphering the text to construct meaning," as in the Marlboro ad briefly discussed at the beginning of this chapter (Kellner, 1995, 254). This requires basic deconstruction/semiological skills on the part of the reader in order to ascertain the product or intended message. These skills are reputed to be among the Generation X repertoire (Rushkoff, 1994):

> Exposed to consumerism and public relations strategies since we could open our eyes, we GenXers see through the clunky attempts to manipulate our opinions and assets, however shrinking. When we watch commercials, we ignore the products and instead deconstruct the marketing techniques. This is what we love about TV. We have learned that "content" means lies, and that in context lies brilliance. (p. 5)

A third strategy is the commodification of "resistance" itself. These types of ads position their products in terms of antiestablishment scenarios, allowing the consumer to purchase a "resistant" identity along with the product—these ads in effect *provide* the reader with an "oppositional reading" (Hall, 1980). As Kellner (1995) notes: "Media culture [advertising] provides resources for identity and new modes of identity in which look, style, and image replaces such things as action and commitment as constituitives of identity of who one is" (p. 259). Purchasing a resistant identity merely contains activism within the confines of the marketplace. That is, buying into this form of *resistance* "translates the possibility of agency to the privatized act of buying goods rather than engaging in forms of self- and social determination" (Giroux, 1994, 18).

ANALYSIS
The Diesel Jeans and Workwear ad campaign combines these three strategies at various levels in an effort to create a positive association between their products and their in-

tended target market, Generation X. I will proceed to analyze a sampling of these ads, individually at first, and then as a whole. Through the course of analysis I will describe on an individual basis how and why these ads are intended for Generation X, and will then discuss the use of the campaign as a pedagogical tool toward indicating the cultural messages this campaign as a whole presents and represents. In order to facilitate this process I will use Dyer's (1982) three levels of meaning as a template:

1. Level one is comprised of the primary subject matter. In the case of an advertisement this might be the colors, shapes, people, product, typography, and other basic components of an ad. Generally speaking, this might be thought of as the "face value" of the ad.
2. Level two relates to the secondary or conventional subject matter which reflects the wider culture. In relation to an advertisement this might involve how the models in the ad are relating to each other or to the product. This might be thought of as the stories or allegories within the image.
3. The third level of meaning can be described as "those underlying principles which reveal the basic attitudes of a nation, a period, a class, a religious or philosophic persuasion—unconsciously qualified by one personality and condensed into one work" (Dyer, 1982). This third level refers to the ideologies of the culture from which the advertisement has been generated (Frith, 1990).

Level one is concerned with the basic composition of the ad; level two exemplifies the advertisers' relationship to Generation X, and Generation X's relationship to other facets of society; and level three exposes broader ideological and cultural implications that otherwise may remain invisible due to the difficulty of recognizing the ideological and cultural context in which one is immersed.

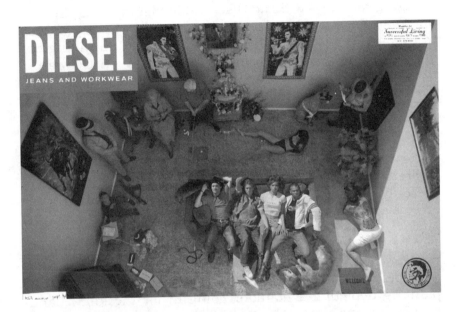

Figure 9.1

Levels one and two

A surface level reading of the first ad (Figure 9.1) reveals a textuality akin to postmodernism; it depicts seemingly fragmented scenes melded together to create an eye-catching montage with no discernible significance—in fact, one may have trouble deciphering exactly what is for sale in this ad. The four people on the couch and the young boy sitting against the wall seem to be the only ones aware of the camera. This, combined with the fact that the four on the couch are cast under an additional source of illumination would indicate they are the models for this product line. The Diesel insignia in the top left corner, the Diesel logo in the bottom right corner, and the little white box that looks something like a government warning on a pack of cigarettes but proclaiming a "guide to successful living" are the only instances of printed text, and are unable to generate even a fraction of the meaning the visual components offer.

The "allegory within the image" (level two) positions the models in a room created to resonate with Generation X. Artifacts of mass-produced culture adorn the walls: a velvet painting depicting a matador going in for the kill; a landscape painting that looks as if it must have been stolen off the wall of a motor-lodge; Elvis tapestries and painting combined with the plastic flowers of a Barbie Doll shrine; also notice the shag carpet remnant. These are emblematic of a recycling or a reusing of culture in order to create one anew, a culture of kitsch. The big screen TV supports the statement that technical equipment is the one consumer category Generation X is willing to spend their few dollars on (Goodman, 1994). It also indicates an immersion within media culture.

What sets this ad, and perhaps the whole campaign, apart, is the use of additional characters/stories that practically *beg* for further deconstruction and meaning. Diesel advertising director Marchiori Maurizio says their "Successful Living" series depicts two worlds: "One is the Diesel world, and one is the world around Diesel. We let

people decide which one is better" (*Newsday*, Dec. 13, 1993).

The floor mat in the bottom right corner "welcomes" the reader to a playground poised for deconstruction. One of the points of interest is the older white-haired man practicing his putting into the open legs of the young woman in her underwear while the older woman, easily perceived as the wife of the man, tends to her knitting and pretends not to see. The location of the man's golf bag on the opposite side of his wife makes it clear that the knitting woman is indeed an integral part of the putting scene. This scenario alludes to the blatant patriarchy, the high divorce rate, and the take-what-you-can-get and suffer-the-consequences-later attitude Generation X experienced while growing up. Tattooed anarchists, a fascist dictator, children, guns, dogs, a woodchuck, a putting patriarch, and subjected women all make up the periphery of the room—when one lives in the "Diesel world," these are the things that are marginalized. Of course, there is a price of admission into the Diesel world—one doesn't just belong—one needs to purchase one's identity by buying into Diesel Jeans and Workwear.

A level one reading of the second ad (Figure 9.2) finds the same three instances of Diesel symbols, and yet another montage of seeming meaninglessness. The Diesel models are the ones laying prone as a result of a four car pile up; all but one of the victims are people of color. "The people born between 1965 and 1968 constitute the most ethnically diverse group of young folks in U.S. history" (Levine, 1994), and Diesel's advertisers, for better or worse, have capitalized on this.

A level two analysis tells a story familiar to Generation X: hazards of a world they did not create strike them down as their obese predecessors kick back in lawn chairs, chomp on some popcorn, and passively observe. The instruments of destruction, the automobiles, have left white skid marks en route to their destiny of creating a gigantic, automotive "X".

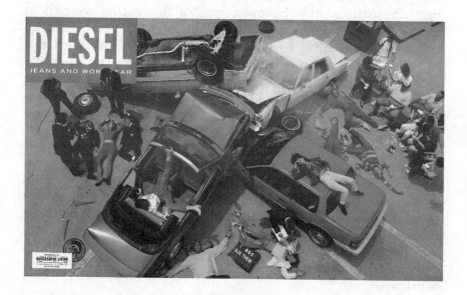

Figure 9.2

The visual story is also replete with stereotypes the advertisers included for the benefit of Generation X's inherent deconstruction abilities. The "Japanese tourists" on one side, pose with one of the victims in order to take advantage of a photo opportunity. The African-American woman in the back of the blue car is expressing a ravenous sexuality dispite her misfortune of being in an accident. And an "ambulance chasing lawyer" complete with a briefcase that says "1-800-SUE THEM" fills out a form on behalf of one of the unconscious victims.

The advertiser hopes to win the hearts of Generation X by the use of "the wink." By employing the blatant use of stereotypes, the advertiser is admitting to relying on this traditional form of advertising. However, because this new audience is so sharp and wise to the ways of advertising, these techniques are reemployed "nostalgically" for the amusement of the reader. The overt function of the stereotypes may have been changed, but these tongue-in-cheek representations still serve the purpose of conveying the messages the stereotypes were traditionally meant to express.

The third ad (Figure 9.3) has less going on visually than the previous two, although it appears to be no less nonsensical. A surface level reading tells the reader very little: three Diesel-clad Xers walk past a government building complete with classical pillars. On the steps of the building is a gaggle of grinning chimps wearing green shorts with their arms poised in a "Heil Hitler" salute. Needless to say, there is more going on here than initially meets the eye.

A level two reading indicates that what we are seeing is "the world around Diesel" through the eyes of inhabitants of the "Diesel world." The chimps signify elected government representatives displaying their allegiance to an unseen, albeit omnipresent, fascist dictator. The blind conformity in fashion (green Diesel (?) shorts) and allegiance (Heil Whomever) amplifies the otherness of this species— these primates couldn't possibly be capable of representing the concerns and needs of the "Diesel world" populace.

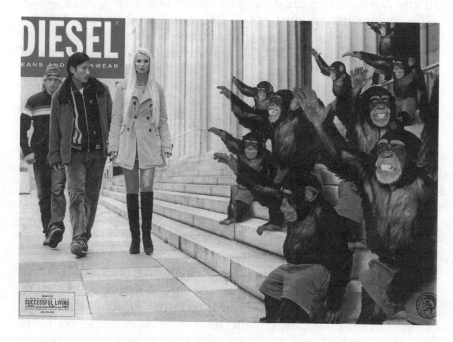

Figure 9.3

This scenario therefore lends itself as an explanation for the apathy (i.e., *weltschmerz*) Generation X is renowned to posses.

It is also of interest that the two white models are unfazed by this scene as they look straight ahead while the Asian-American model glances sideways at the chimps with a look of frightened wonderment on his face. This seems to indicate a realization that as a nonwhite, he is even more subject to the narrow-sighted, or even blind, oppression that is foisted upon him by the troglodytic Old-Boys Club.

The fourth ad (Figure 9.4) features two African-American models in Diesel garb. They are set within a very metallic environment also occupied by sunbathing senior citizens and tanning beds. The three Diesel icons are the only instances of printed text.

The story level once again positions Generation X against its forebearers. The Generation X representatives bite their lip and try not to laugh as the senior citizens ritualistically worship the Sun god. The winter/summer relationship of the people in this ad is given an ironic twist as the winterfolk don summer garb and the summer "kids" are dressed more for winter.

The yellow circle hanging on the wall signifies the ozone hole this older generation has induced, and through which they are able to more directly reap the offerings of the Sun god. The lackey in the soda-jerk outfit waits, with paint brush and bucket of baby oil (also with the ozone hole emblem) in hand, to slather these "fools" as they attempt to make their skin look more like that of the people they've spent their whole lives oppressing.

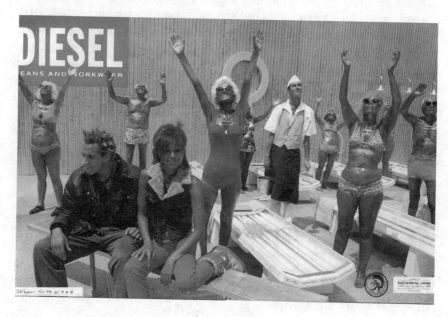

Figure 9.4

The ridiculously reflective and artificial environment amplifies the unnaturalness of this entire scene. The silver "moon boots" worn by the woman Diesel model serve to anchor her and her friend within this other worldly environment, whether they like it or not—the "Diesel world" and "the world around Diesel" are not as separate as one would hope. This ad plays on the fear of environmental degradation and the hopelessness of waiting for the winter generation to make amends. This older generation seems to openly welcome the infractions in the environment it has incurred, even as it ironically utilizes the technology-created "safer" artificial sun of the tanning beds.

When perceived as a cultural artifact, this campaign can be an effective pedagogical tool toward exposing the cultural, racial, political, and environmental criticisms Generation X holds for its inherited society—as this indeed appears to be the intent of the advertisers. The advertisers combine the first two strategies, the wink and intended visual ambiguity, in order to speak to the target market. The wink says "we know most people won't understand these ads, but because of your deconstruction abilities, we know you will." The advertisers then go on to encode criticisms that will resonate with Generation X, once decoded.

Level three

It's the third level of analysis that reveals the real value of this campaign as a pedagogical tool for inciting counter hegemony. The advertisers have granted their audience an authority of "cultural critic," but they only intend the reader, Generation X, to take it so far. As Meehan (1991) says:

> Economics must be considered if we are fully to understand the texts and intertexts of American mass culture. Most cultural production in the United States is done by private, for-profit corporations. These corporations comprise the entertainment/information sector of the American economy and encompass the industries of publishing, television, film, music, cable, and radio [and advertising]. Significantly, American capitalism organizes the creation of cultural artifacts as a process of mass

> production carried out by profit-oriented businesses operating in
> an industrial context. (p. 51)

The ideology of the culture which generated these advertisements (level three) is a profit-oriented one—this is a fact that should not escape media literacy.

The truly media literate will recognize that the advertisers of this campaign have appropriated the resistant, antiestablishment attitudes of Generation X and commodified them for the purpose of selling resistant, antiestablishment identities in order to make money for Diesel. They rely on the frustration, or *weltschmerz*, of their target market and offer an outlet for expressing this discontentment, and in doing so, circumvent the affective agency of the individuals who compose the antiestablishment group. Social activism is replaced by fashion and resistance is contained within the marketplace.

This campaign, and others that employ similar tactics, can be utilized as pedagogical tools for exposing consumer capitalism's ability to accommodate resistant niche markets while simultaneously maintaining the status quo. If you wish to project an aura of resistance, you may buy into this campaign; however if you wish to engage in an action toward facilitating a radicalized democracy, you must think and act in terms of counter hegemony. In a marketplace democracy, money can be thought of as votes, and counter hegemonic acts entail understanding what you are voting for. The media literate who understand the distinction between store-bought resistance and counter hegemony will realize that the revolution cannot be purchased at the shopping mall.

195

REFERENCES

Coupland, D. (1991). *Generation X: Tales For An Accelerated Culture*. NY: St. Martin's Press.

Dunn, S. (1995). *The Official Slacker Handbook*. New York: Warner Books.

Dyer, G. (1982). *Advertising as Communication*, London: Metheun.

Femia, J. (1975). "Hegemony And Consciousness in the Thought of Antonio Gramsci" in *Political Studies*, Vol. 23, No. 1, pp. 29-48.

Frith, K. (1990). "Undressing Advertisements: A Technique for Analyzing Social and Cultural Messages," paper presented at the Association for Education in Journalism and Mass Communication, Minneapolis, MN.

Frith, K. (1995). "Advertising and Mother Nature," in *Feminism, Multiculturalism, and the Media: Global Diversities*, Angharad Valdivia, ed., Thousand Oaks, CA: Sage.

Giles, J. (1994). "Generalizations X," in *Newsweek*, Vol. 123, No. 23, pp. 62-72.

Giroux, H. (1994). *Disturbing Pleasures: Learning Popular Culture*. New York: Routledge.

Goldman, D. (1993). "The X Factor," in *The GenX Reader*, Douglas Rushkoff, ed., New York: Ballantine Books, pp. 287-289.

Hall, S. (1980). "Encoding/Decoding," in *Culture, Media, Language: Working Papers In Cultural Studies, 1972-79*, S. Hall, D. Hobson, A. Lowe and P. Willis, eds., London: Unwin Hyman, pp. 128-138.

Huhn, M. (1993). "Karen Ritchie," in *Adweek*, Vol. 34, No. 49, pp. M14-M16.

Kellner, D. (1995). *Media Studies: Cultural Studies, Identity and Politics Between the Modern and the Postmodern*. New York: Routledge.

Kincheloe, J. (1995). *Toil and Trouble*. New York: Lang.

Lather, P. (1984). "Critical Theory, Curricular Transformation and Feminist Mainstreaming," *Journal of Education*, Vol. 166, No. 1, pp. 49-62.

Macalister, K. (1994). "The X Generation," *HRMagazine*, May.

Meehan, E. (1991). "Holy Commodity Fetish Batman: The Political Economy of a Commercial Intertext," in *The Many Lives of Batman: Critical Approaches to a Superhero and His Media.*, R. Pearson and W. Uricchio eds., Newbury Park, CA: Sage, pp. 47-65.

Merriam-Webster's Collegiate Dictionary Tenth Edition (1993) Springfield, MA: Merriam-Webster, Inc., Editor in Chief: Frederick C. Mish.

Miller, C. (1993). "Xers Know They're a Target Market, and They Hate That," *Marketing News*, Vol. 27, No. 25, pp. 2, 15.

Rushkoff, D. (1994). *The GenX Reader*, New York: Ballantine Books.

Shields, V. (1990). "Advertising Visual Images: Gendered Ways of Seeing and Looking," *Journal of Communication Inquiry*, Vol. 14, No. 2, pp. 25-39.

Williamson, J. (1978). *Decoding Advertisements: Ideology and Meaning in Advertising*, New York: Marion Boyers.

Chapter 10

Cultural Capital: The Cultural Economy of U.S. Advertising

Christian Vermehren

This chapter is based on research carried out at The Pennsylvania State University. The author wishes to thank his advisors, Dr. Bette Kauffman, Dr. Katherine Frith, and Dr. Ronald Bettig for their help and interest in this work.

INTRODUCTION

The United States is often believed to be a society with a high degree of social mobility: people from the middle classes seem to accept the so-called "American dream," which tells us that hard, disciplined labor pays off and leads to prosperity and social success. This "dream" probably originates from the unique history of the U.S. which is itself an example of tremendous success—a nation founded mostly by poor immigrants from Europe who through hard work and effort developed into the economic superpower of the world. Indeed, this historical fact has apparently slowly been incorporated into the U.S. ideology and culture. Most kids in the U.S., for example, grow up learning about how Abe Lincoln, who was born in a log cabin and read books by candlelight, eventually managed to become president of his country. Other charming little stories include the lives of Clarence Thomas and Colin Powell. These are captivating anecdotes, and it is not surprising that many people identify with their characters and think or "dream" that stubborn toil will also take them to

the top of society. But such examples of upward social mobility are unfortunately exceptions to the rule, as statistics and sociological studies have shown us, and as such they are part of the mythology that masks the realities of life in the U.S.

The American dream is without doubt first and foremost about work, morality, and exaggerated economic success. But it is more than that, it is also an important part of American self-identity and the way people in the U.S. see themselves vis-à-vis other countries. The relationship with Europe is especially interesting: on the one hand, Europe is seen as economically inferior, but, on the other hand, it is respected for its old or "high" culture. Although people in the U.S. are often confident about their country's economic opportunities, they are less proud of their cultural heritage. The U.S. may well be the world's leading economy, but old Europe is still seen as the center of cultural power and the arbiter of manners and taste. By the same token, however, Europe is also seen as the prime place of snobbery and conceit, a class system stratified in accordance not only with economic power but also with cultural prestige and rank. U.S. citizens dissociate themselves from such snobbery; they have, after all, never had royalty, nobility or titles which can only be acquired by inheritance. Instead, it is thought, success in the U.S. depends first and foremost on an individual's own initiative, his or her willingness to work.

The purpose of this chapter is to question these myths. I contend that snobbery and cultural discrimination are, in fact, also important elements in the U.S. class system. This is not to say that there are no differences between the role culture plays in the U.S. and Europe, but it would be a mistake to regard cultural stratification as a strictly European phenomenon. As I shall show in this chapter, the U.S. has its own cultural hierarchy, its own cultural *economy* which defines, circulates, and ranks categories such as "high brow" and "low brow" (high brow being, for example, a preference for classical art, opera, and museum, versus a

low brow taste for things like popular music, street art, comic strips, etc.).

The point I want to make is that advertising is an important part of this cultural economy. As we shall see, it distributes cultural codes unequally throughout society, thereby helping to perpetuate cultural stratification. Thus, I do not argue that the media and advertising impose "the American dream" or other ideologies on society. Rather, advertising seems to help prevent such dreams from actualizing, by underscoring the definition of success not only as high income but also, like in Europe, as cultural power. As such, advertising does not work, in my view, primarily through ideological imposition, but rather through a sort of cultural segregation which reinforces the already existing social distinctions in U.S. society. I believe that such cultural segregation is brought about when advertisers conceptualize people as consumers, and when they organize the "market" into neatly distinct segments in accordance with class boundaries. As I shall demonstrate below, some consumer segments are systematically reached through the application of "high" discourses (in media with "high" prestige), while other segments are reached through "low" discourses (in media with "low" reputations). Insofar as this grading of the media and the separation of consumer segments by kind of discourse are homologous to the social hierarchy of the audience, advertising can be seen as a symbolic economy which bolsters the unequal distribution of cultural power.

SYMBOLIC ECONOMIES AND CULTURAL CAPITAL

In order to understand how advertising pertains to the circulation and distribution of cultural power in society, it is first necessary to investigate how symbolic economies function in general. This is exactly what French sociologist Pierre Bourdieu has set out to do. Although his work is by and large neglected by media scholars, it makes up a sophisticated approach to culture which, I think, may be relevant to the study of advertising and social class. I begin with a brief introduction to Bourdieu's approach. I shall be

particularly concerned with his concept of "cultural capital" and subsequently explain how it plays out in U.S. advertising.

Normally, when we talk about capital we refer either to stocks of money or to "capital" in the narrow economic sense as in the theory of Karl Marx (1993). However, Bourdieu uses the term somewhat differently. Capital, he says, can take many different forms. Whereas money or "economic capital" is one case, capital can be understood as a more general concept which includes all kinds of symbolic exchange relations established through a collective, almost religious, *faith* in what counts in society. Thus, if economic capital constitutes an effective form of exchange relations, it is only because of a strong and pervasive social convention about what money is worth and what it can be converted into.

Needless to say, money is the dominant (objectified) form of capital in our society, since it is recognized as a valid means of exchange throughout all social levels. However, in certain areas of society, in what Bourdieu calls "social fields," this overall efficacy of the "money economy" may be suspended, or at least "delayed" by the fact that people struggle primarily over other types of capital, such as prestige, knowledge, or information. This is the case in the fields of science, religion, and in the arts. Such fields do not immediately obey the power of money, but are instead based on other principles of valorization: the quality of a scientific book, for example, does not depend on the number of copies sold, but first and foremost on its ability to explain and discuss a phenomenon in a certain manner.

According to Bourdieu's definition, capital can take a variety of forms and is not restricted to only "capitalist societies." Rather, Bourdieu asserts, the concept of capital is based on a religious mode of thinking and can be traced both to "precapitalist" historical periods and to contemporary nonliterate or "oral" societies. It is a characteristic of these societies that their economies rely primarily on a form of capital which can be circulated in the group through spoken words, body languages, and rituals. Devoid

of writing and other advanced communication technologies, such economies function on an implicit level and are unable to transform into bureaucracies or specialized fields where anonymous individuals struggle across the social space (compare with Goody, 1986; Carey, 1983). Instead, the preservation and accumulation of capital are reduced to the level of practice and to what Bourdieu (1990, 73) calls a practical *mimesis*, whereby capital can be inculcated as specific dispositions in the individual's mind and body or in what Bourdieu calls *habitus* (Bourdieu's argument of mimesis derives from Havelock's 1963 analysis of Plato).

In modern, literate societies, however, different kinds of symbolic economies coexist and overlap with each other, and since they are often supported by advanced technologies and institutions, they become more complex (Bourdieu, 1990, 124-125). This means that capital is preserved and distributed not simply through practice and mimesis, but also through complex institutions such as the exchange system or the educational system and through objectified capital such as money, stocks, art works and literature which can be circulated independent of the physical proximity of individuals. With the appearance of these supporting processes, capital is thus given the conditions of its full realization (Bourdieu, 1990).

The educational system is particularly interesting here in that it is closely linked to the emergence of a relatively new fundamental form of capital which Bourdieu calls "cultural capital." According to Bourdieu, the educational system provides institutionalized capital (e.g., exams and degrees) which some people are able to "invest" in and which in turn will produce a social "return" in terms of a better job, higher income, higher self-esteem and eventually more social power (Bourdieu, 1974; Bourdieu and Boltanski, 1977; Bourdieu, 1979). However, education entails not only knowledge of a specific academic area, but also a general aesthetic competence (i.e., "taste," "high brow") which enables the educated or cultivated person to appropriate valorized cultural objects such as classical music, abstract paintings, etc. (Bourdieu and Passeron, 1977; Bourdieu,

1984). Using the educational system as a springboard, some people are therefore able to distinguish themselves in what Bourdieu calls the "field of consumption" through cultural discrimination directed against social groups deprived of mental or bodily "instruments" for the appropriation of "high" cultural goods. In other words, the unequal distribution of education constitutes a symbolic mode of domination which supplements the economic stratification of society.

Although it is important to acknowledge that capital can take a variety of forms, it is also necessary to understand the hegemonic logic which seems to work in all kinds of economies. According to Bourdieu, the precondition of an economy is that the people recognize the specific capital as given and *natural*. That is to say, in order to participate in society, in order to compete for and accumulate capital, the individual must submit to a process of cultural naturalization by which capital is represented and experienced as inevitable, universal, timeless, and thus unarguable (e.g., nobody questions the value of money, despite its arbitrary nature). By thus *exnominating* capital, as Barthes (1973) would say, and hence by taking the conventional principle of symbolic hierarchization in society for granted, people constitute and perpetuate the specific economy and thereby the unequal distribution of power.

Thus, although symbolic economies and capital exist independently of the individual, they are still rooted in the collective consent of people. As such, social inequality—even the unequal distribution of money—are always based on some kind of *symbolic* violence. "Symbolic violence" is Bourdieu's term for a kind of discrimination or domination which works not through brute force such as military or police actions, but through a gentle and invisible form of power. It is gentle and invisible because it works through the consent of people; it depends, in other words, on what Gramsci (1991) calls a *hegemonic process*. That is, capital presupposes a collective faith in its naturalness or, using Geertz's (1973, 14) word, its "normalness." But insofar as this faith is specific to the field or to the society, it is an

arbitrary or *contingent* faith which, at the same time, is a continuous creation of what Barthes (1970) calls "bad faith." The faith is bad because it is a faith in the transparency of capital misunderstood or *misrecognized* as a universal truth. By the same token, it is bad because it is a faith in the innocence of those people who in fact exert symbolic violence or, conversely, who consent to their own domination (Bourdieu, 1984, 386-396; Bourdieu, 1993, 78-79; Bourdieu, 1990, 68). Faith and bad faith, recognition and misrecognition, are thus two sides of the same coin. They form a sort of ethnocentric ideology which both enables and constrains society. It is an enabling ideology because it functions as a justification of the existing structures and processes, but it is also constraining because it can only work through a denial or a *denegation* of the truth.

ADVERTISING AS OBJECTIFIED CULTURAL ECONOMY

So far I have introduced Bourdieu's concept of cultural capital and indicated how it forms a symbolic economy which works hegemonically primarily based on the educational system. I shall now show how the distribution and circulation of cultural capital is constituted not only through education, as Bourdieu claims, but also through other supporting institutions and technologies, such as the media and advertising. It is surprising that Bourdieu has never been interested in these phenomena, insofar as they occupy central positions in contemporary cultural practices. Let me start with the following quotation from Hall and Whannel (1964):

> Advertisements for the more expensive products appear in those papers and journals which are able to develop a reputation for reaching the wealthier type of reader, the 'decision-maker', 'the opinion leader' or the 'trend-setter'. Household goods, consumer durables, cosmetics and sweets are more heavily advertised in mass-circulated magazines and papers. In each case the advertisement will be adapted in style, appeal and sophistication for the appropriate readership or audience. The stratification by 'brow' within the media is therefore reinforced by a process of grading for income and taste. If the same product is advertised

right across the market, each advertisement will reflect in its style the demands of the appropriate medium. A Bri-nylon fabric is advertised in a gay, carefree manner in *Woman's Own,* but in a suave, modish and expensively restrained way once it reaches the pages of *Queen, About Town* or *Vogue* ... Advertising contributes to cultural stratification in our society. (p. 315)

Hall and Whannel have never investigated advertising and cultural stratification in depth, nor have they related Bourdieu's theory of symbolic economies to their argument. However, the preceding paragraph is interesting, because it indicates that advertising reinforces the distribution of cultural capital which Bourdieu talks about and which he says is instigated by the educational system. That is to say, if Hall and Whannel are right, people with high education (the "decision-maker," the "opinion leader" or the "trend-setter") are targeted through and thus more often exposed to discourses and codes which confirm, stimulate, and perhaps even develop the already acquired cultural capital. At the same time, however, market forces and marketing procedures tend to exclude other social groups from these discourses and instead these people are encouraged to consume and appropriate products which the educated bourgeoisie classify as "low brow."

In the remainder of this chapter I shall attempt to elaborate on this argument by analyzing and comparing small samples of advertisements drawn from U.S. magazines which reach different social classes. The chosen magazines and the types of audience they reach appear in Table 1.

Table 1

Magazines and Cultural Capital of Audiences
by Education of Audience

Magazine	Graduated College	Attended College	Attended High School
Scientific American	62%	37%	1%
The New Yorker	62%	36%	2%
People	21%	68%	9%
US	15%	74%	10%
Petersen's 4Wheel and Off-Road	10%	74%	14%
True Story	2%	62%	23%

SOURCE: *Simmons Study of Media Markets: Total Audiences*, M1, Simmons Market Research Bureau Inc., 1992.

As one can see, U.S. magazines may be organized in a hierarchy based on the level of education of the readers. The top two magazines reach primarily the educated bourgeoisie, the following two reach the petite bourgeoisie, and the last two reach less educated people. Analyzing and comparing advertisements from each of these categories allows us to identify, first, the possible similarity of ads *within* the categories and, second, the possible difference of ads *across* the categories. Such analysis will indicate and illustrate how different symbolic codes circulate through advertising and how this circulation or economy pertains to the existing power structure and the cultural struggle in society.

"High" Advertising: When exploring ads from *Scientific American* and *The New Yorker* it becomes clear that most of them can be classified as what Hall and Whannel (1964)

call sophisticated and "complex" advertisements. In these advertisements the "images and the copy concentrate upon the feelings of luxury or the desirable status pictured; the product takes second place" (p. 328). Furthermore, "hidden psychological feelings are being explored, subtle associations are made, strange, dream-like transformations enacted" (p. 329).

The advertisement for Acura (Figure 10.1), for example, is a close-up photo of a black car (the product) surrounded by several statues of ancient Greek gods partly wrapped in filmy white fabric. These statues serve as strong metonymic signifiers which connote not only high culture in general, but also, more specifically, classical art, old European heritage, and great philosophical progress. By designing this setting, the advertiser invites the reader to make a link between figures already loaded with values/meanings and the Acura car (see Williamson, 1978). In other words, if the advertisement works, the car becomes associated with signs of high culture and eventually itself becomes a symbol for high social status and prestige. By purchasing the Acura car, one can communicate the possession of a high amount of cultural capital. Driving this car will thus distinguish a person from the more deprived social groups who do not have access to the codes of art, history, and philosophy, and the advertisement thereby becomes discriminating in its approach.

The meaning of the picture is, moreover, anchored in and further directed by the caption of the ad, which reads: "It Silently Screams Everything You're Too Polite To Say About Yourself." Once again the discriminating approach is revealed—this time in a verbal form. First, the sentence admits that it is not polite to brag about one's cultural/economic capital, but then immediately after it provides a way to go about this anyway: the car will *scream* what one cannot or should not say! Thus, as we can see, the advertisement is not only indirectly and visually encouraging cultural discrimination, it is also quite openly instructing its readers how to do so.

207

Figure 10.1

Furthermore, in a sophisticated way, we are also told that the visual composition—the car in a setting with Greek statues—is not to suggest any kind of upward social mobility, which of course would be an insult to those who are already on a high level of culture. Rather the sentence indicates that the car is a means of class-confirmation and self-indulgence. Thus, the copy highlights that "in no time you realize this automobile is an elegant display of your own personality traits. Some of which you may not even have known you possessed."

It is interesting that the advertisement also works on a more subtle level, in that it caters to the taste of the educated bourgeoisie by designing the advertisement as an artistic piece of work. Indeed, the picture is not just a photo of the car in an everyday use situation; rather, it is carefully constructed to provide a high aesthetic dimension. The strange but elegant fabric that sometimes seems to vanish into air or sunlight and sometimes seems to be simply covering the genitals of the statues, makes the picture seem somewhat surrealistic and artistic. Thus, viewed out of context and if we abstract from the fact that the car is a mass produced product, this picture could be, if not an oil painting, then at least a well done watercolor. By using the car as just another element in this artistic production, the car merges with the style and becomes, in turn, art itself. Buying the car will therefore not only confirm one's social position, it will also provide one with an aesthetic experience.

In sum, the advertisement is primarily concerned with form and not with function: nowhere are we informed about the technical features of the car (except that it has a "230-horsepower engine"), never are we instructed how to use the car (except as a tool of symbolic violence), and there is no indication of the price. The primary function of the advertisement is to draw on codes of high art and to celebrate the car as distanced from and oppositional to popular culture.

Myth.
[all vodkas are
the same.]
This is but a myth Perpetuated
by those who do not understand
the actual Art
of making vodka. Vodka is a spirit
so distinguished that its production
was Entrusted by the Czars to the
nobility as an honor
A spirit that was given by
Catherine II as a state gift
to Kant and Voltaire.
And there is no vodka
that so compares to the quality
of Stolichnaya CRISTALL.
Its
Filtration process rises above all others.
Every ounce passes over
a bed of pure Quartz crystals,
not once, but twice.
And in between these steps,
it is filtered through virgin granules of
activated carbon made from the wood
of Russia's Native Birch tree.
Thus a spirit so pure as Refined
that it has been called
flawless

Figure 10.2

The same basic approach is applied to the advertisement for Stolichnaya Cristall (Figure 10.2). Although there are no direct visual signs for high culture in this ad, once again the product (the vodka bottle) enters into an artistic composition. Thus, we see that the bottle is placed upon a symmetrically formed cluster of crystals with a black background, in a way that could never be found in the real world: the crystals and the bottle are not portrayed in a use-situation, the elements are composed in a way we would not expect to find in an ordinary home, and the whole construction seems to float in a strange dark space detached from earth and gravity.

Furthermore, the crystals appear in many different sizes, which together make up a chaotic structure. Perhaps the reference here is the recent avant-garde art works which—based on the new chaos theory within physics—manifest structures that simultaneously encompass order and unpredictability. By placing the bottle on the crystals, this chaotic structure shines through the glass and the content of the bottle and becomes a part of the product. Thus, what we see in the bottle is not vodka but a fascinating pattern of crystals, which the alert reader will quickly associate with the brand name, Stolichnaya Cristall. This association underscores the visual invitation to integrate the product and the artistic background. Buying the product will therefore not just provide us with plain vodka (indistinguishable from other brands), it will—like the car in the Acura advertisement—provide us with a dignified aesthetic experience.

This interpretation is, moreover, supported by the copy of the ad. First, the layout of the text resembles that of the picture, in that it consists of both order and unpredictability: the margins are not straight and the text is written in a mixture of fonts and point sizes. Second, we are told that to think all vodkas are the same is wrong; it is a myth, "perpetuated by those who do not understand the actual Art of making vodka." Thus, by arguing that vodkas are different, the text is "validating" the visual comparison and associa-

tion between Stolichnaya Cristall and chaos theory, crystals, art, etc.

In addition, however, it is interesting to note, that like the Acura ad, this advertisement attempts to distance itself from, as it states, "...those who do not understand the actual Art of making vodka." That is, those who do not possess cultural capital and therefore who do not know how to appreciate the "finer" things in life. This discriminating ideology is further emphasized by an attempt to tie the product to the old Russian and European nobility: "Vodka is a spirit so distinguished that its production was Entrusted by the Czars to the nobility as an honor. A spirit that was given by Catherine II as a state gift to Kant and Voltaire." Thus, again the advertisement tries to dignify the product by referring to history, philosophy, and aristocracy. Moreover, by using the word "spirit" instead of, for instance, "alcohol," it manages to give the product a personality. That is to say, the word "spirit" can mean both liquid and a state of mind, and the advertisement thereby facilitates a perception of the product as interchangeable with an aristocratic way of thinking. It is, of course, this personality that the reader, in turn, is supposed to be mirrored in and to feel that he or she can obtain only by purchasing the product ("A[n] [aristocratic] spirit that was given by Catherine II"!). Like the Acura ad, we see that this advertisement is concerned primarily with form: no price is mentioned, and there is no demonstration of the use of the product.

Additional advertisements could, of course, be analyzed in much the same manner as the Acura advertisement and the advertisement for Stolichnaya Cristall. Here it suffices to point out that for the most part, these advertisements sell the product by referring to art codes and by offering instructions of discrimination against popular culture. In sum, it seems that these advertisements immediately underscore cultural hierarchy and place their readers at the top of this hierarchy.

"Low" Advertising: Once we turn our attention to advertisements in *True Story* and *Petersen's 4Wheel and Off-Road,* it becomes clear that advertising does represent a

cultural structure with binary opposites: if the advertisements in *Scientific American* and *The New Yorker* make up one extremity of the structure, the advertisements in *True Story* and *Petersen's 4Wheel and Off-Road* make up another, oppositional one. Thus, here the products are advertised in what Hall and Whannel (1964) describe as a "simple" style. That is to say, in these advertisements,

> "the product is advertised in an attractive setting, pitched slightly forward in tone or 'idealized'. The settings are easily recognizable—the kitchen, the new home, the bedroom—only tidier, more expensively equipped, better planned than the setting in real life. In this *simple* version, the product may even dominate—a close-up of a can of fruit or a bar of chocolate." (p. 328)

The advertisement for Blair (Figure 10.3), portrays a woman in a green outfit sitting on a couch. This advertisement is quite different from the ones analyzed previously. Although the woman is posing in a slightly put-on/artificial manner with almost too perfectly adjusted makeup and hairdo, and although she is (probably) prettier and younger than the average reader, this advertisement applies a more natural, realistic, and recognizable setting. The white couch and the gray curtains behind it make up a familiar setting which anyone can relate to, and help illustrate how and where the product can be used. Furthermore, although the woman and the outfit are presented somewhat aesthetically, this advertisement provides no reference to art or high culture. Quite the contrary, the ad was constructed without much respect to form and abstraction: the word "EVERGREEN" is placed just above the woman's shoulder with no worries about how it might break the visual rhythm of the picture; there are three visually "disturbing" color samples below; and finally a rather big clip-out coupon is placed in the lowest right corner, even though it covers a large part of the picture. These elements are far from artistic, but they are practical and contribute to making the advertisement functional for the consumer.

213

Figure 10.3

This conception of the advertisement is supported further when reading the copy. One first observes the highlighted price: the presented outfit costs "only $34.95"! This information is then followed by a close focus on the product: "Our oversized, cuddly soft acrylic Sweater has an all-over cable design ... is longer to wear over the matching Pants. These pull-ons in 2-way stretch woven polyester feature elastic waist and stirrups, so you can quickly slip them on ... creating the perfect ensemble in a flash." Rather than concentrating on the immateriality or the symbolic aspect of the product, this advertisement is concerned with the substance, the facts, and the functionality.

The same trend holds for the advertisement for Warn (Figure 10.4). Here a close-up of the vehicle (the product) is provided, and the setting is carefully constructed in order to exemplify the use-situation. Thus, the picture of the vehicle driving up an undulating hill, tells us that this vehicle can manage "all" kinds of terrain. Again, we see that the advertisement down plays the aesthetic dimension: smaller pictures, which illustrate additional products and equipment, are placed below the main photograph, and no effort has been made to manipulate the setting in an artistic direction.

Furthermore, the copy emphasizes natural aspects of human beings, which in a high cultural context would be considered inappropriate: "Your palms are sweating, your pulse is racing and your deodorant just failed—Just Another Sunday Drive." Instead of emphasizing the classical body—the ancient Greek statues—as does the Acura advertisement, this advertisement thus celebrates what Bakhtin (1984) calls "the grotesque body." Buying the product becomes a lower bodily and earthy experience instead of a dignified aesthetic one.

Figure 10.4

In conjunction with the Blair ad, the Warn ad makes up an "anti-art" position, where the style of high culture is rejected and reversed. However, this cultural strategy is in a sense imposed from above, insofar as it reflects "the choice of the necessary" (Bourdieu, 1984, 372). The simple advertisement reinforces this process by encouraging people to reject what they are already excluded from.

"Middle" Advertising: So far it has been argued that the advertisements in *Scientific American* and *The New Yorker* make up one pole in the structure of advertising, whereas the advertisements in *True Story* and *Petersen's 4Wheel and Off-Road* make the other. However, it seems that there also exists a middle ground between these two extremes, which is constituted by the advertisements in *People* and *US*. Although these advertisements occasionally may apply both the complex and the simple style, a good portion of them can be classified as what Hall and Whannel (1964) call the "compound" advertisement. In this version, "the product is firmly placed in an attractive and desirable social setting, and the advertiser is working for a fairly simple transfer of feelings from one to the other" (p. 328).

The advertisement for Smirnoff (Figure 10.5), is designed as a compound advertisement, but has much in common with the complex style. In fact, at first glance it may look like a sophisticated advertisement because of its clear reference to high class and because of its seemingly sophisticated experimentation with a black and white background versus the product which is in color. However, a closer look reveals some inconsistencies which justify the conception of it as compound and negotiated.

First of all, although the woman in the picture is "idealized" and provides a strong link to high social status, the presented setting is not manipulated in a surrealistic or dream-like manner. Because of the black-and-white setting, and because of the dress and the hairdo, the woman looks, more than anything else, like a person from the 1940s.

217

Figure 10.5

At first glance, it seems that the advertisement works through a simple association between this upper-class woman and the product. However, as one's eyes slide over to the right toward the Smirnoff bottle, something strange appears: through the bottle, it can be seen that the lady has a (colored) tattoo on her arm! Once this is discovered the whole stylistic rhythm of the picture is broken. How could a seemingly noble lady from the 1940s have a tattoo on her arm? Clearly, what we witness here is a symbolic contradiction: whereas the lady's dress and hairstyle connote high class, a tattoo is a strong symbol for more popular and "lower" brow.

However, this contradiction provides the picture with a new dimension. Viewed in isolation the lady is certainly noble, but the picture is too ordinary to be artistic—there is no reference to high art, no abstraction incorporated in the setting, and the picture thus becomes somewhat boring. By adding the tattoo, the scene becomes suddenly peculiar, but also more fun. The tattoo gives the lady a touch of wildness, a touch of roughness and toughness, and makes us think that she is neither real upper class nor real "low brow." Consequently, she is somewhere in between: "middle brow." It is interesting that this symbolic negotiation between two extremes "acknowledges the legitimacy of the hegemonic definitions" while reserving the right to make "its own ground rules—it operates with exceptions to the rule" (Hall, 1980, 137).

Another example of contradictory brow can be seen in the advertisement for Microsoft (Figure 10.6). Here the situation is the reverse: the main picture portrays a "tough" motorcycle guy with long hair, beard, sunglasses, leather jacket, earrings, etc. Clearly, this is the context where we would normally find tattoos, and—quite so—if we look at his arms we find that they are both filled with them. However, as we begin to read the text, we again discover a contradiction in that it suggests that this man is interested in and possesses a considerable amount of knowledge about Schubert! He says, "I'm in dis bar arguin' with dis jerk about Schubert." Even the sentence itself provides a con-

tradiction, in that it is written in an accent ("dis" bar; "dis" jerk) to further symbolize the motorcycle guy's illegitimate background. But then he demonstrates his legitimate knowledge: "I sez to him [note that the accent now disappears!], 'The essential Schuberterian style is in the unfolding of long melodies both brusque and leisurely. That's the blessed earmark of Schubert's style and it's all anyone needs to sense his distinctive attitude toward musical structures'."

The scene appears funny, because the guy's toughness and knowledge about Schubert are not normally compatible. In fact, the motorcycle lifestyle is a reaction exactly against all that Schubert stands for. Thus, the picture becomes a sort of symbolic irony. The purpose is, of course, to suggest that even a motorcycle guy can acquire cultural capital, but only by purchasing Microsoft's Composer Collection: "And I knows all I knows about Schubert 'cause I got Microsoft Multimedia Schubert." Thus, like the Smirnoff advertisement, this advertisement is negotiating between two extremes. On the one hand, we are told that you do not need to be educated to enjoy classical music. On the other hand, however, by applying symbolic irony, we are also told that subcultures and people with low social status don't normally do so.

As shown, the compound advertisement attempts to bridge between the sophisticated advertisement and the simple ad. It accepts high culture as desirable but at the same time it degrades it by incorporating more popular elements. At first glance it may even seem that this type of advertising transgresses cultural hierarchy, to use the words of Stallybrass and White (1993, 58), by "shifting the very terms of the system itself, by erasing and interrogating the relationships which constitute it." However, as Stallybrass and White (1993) say, the middle-class cultural strategy of combining contradictory elements is in fact, only a disguise of an attempt to demarcate a space *within* the hierarchy,

220

Figure 10.6

between the "high" and the "low." Although the compound
ad pretends that cultural distinctions do not exist, it is, in
fact, negotiating with the ads targeted to the educated
bourgeoisie, which means at least partial acceptance and
thereby indirect support of the cultural hierarchy.

CONCLUSIONS AND PERSPECTIVES
I have taken Sherry's (1987) and others' argument of adver-
tising as a cultural system seriously. I have not only ana-
lyzed individual advertisements, but also indicated the re-
lationship between advertising as a system and the U.S.
cultural economy. I have tried to show how advertising—
both as a system and as an individual cultural product—is
transcoded through the larger cultural economy, and how
it thereby becomes an objectification and reinforcement of
this economy. Furthermore, I have tried to specify this
process of reinforcement by pointing toward how compa-
nies and advertising agencies organize the market into lev-
els of taste. They use, as I have shown, "artistic" ads to
reach the educated bourgeoisie and "functional" ads to
reach lower-class groups, and they thus end up magnifying
the distinction between "high" and "low" culture. However,
the sensitivity of advertising agencies toward cultural dif-
ferences also makes the cultural economy of advertising
complex, in that the middle-class is often identified and
targeted as a separate market segment. This triggers a type
of advertising which contradicts itself, as it were, by com-
bining high elements with low elements.

Advertising can thus be seen as an objectified cultural
economy which seems to help perpetuate cultural stratifi-
cation and class distinctions. To look at advertising in this
way is to reveal the mythical nature of the American dream.
The U.S. is not a classless society and success is not de-
fined in the U.S. only in terms of income and material
things. Through advertising, the educated bourgeoisie is
continually educated in how to appreciate high art and how
to disdain other cultures, whereas the rest of the popula-
tion seems to be excluded, at least statistically, from such
an "education." This differential dissemination of didactic

codes of culture through advertising reinforces, or so it seems, the unequal distribution of cultural power through the educational system.

Several things could be done to further illustrate and validate this conception of advertising as an objectified cultural economy. In this chapter, I have tried to go beyond conventional semiological analysis by focusing not only on individual ads but also on how the intertextual relationship between ads correspond to statistical, demographic categories of the audiences. This step away from the analysis of the ad in itself could be followed up by a traditional content analysis through which the frequency of different types of advertising in different types of media could be measured statistically. Such analysis could also provide more precise information about how the distribution of cultural codes is related to different demographic variables of the audience. Finally, a focus on the reception and production of advertising would be necessary to fully validate some of the hypotheses which I have put forward. A focus on reception and production would indicate not only how and to what extent advertising activates (or deactivates) the cultural capital of the audience, but also whether the difference of type of advertising is due to the advertising agencies' ability to meet the different stylistic demands of the audience or whether it is (primarily or in part) due to the internal struggle and competition between the agencies.

223

REFERENCES

Bakhtin, M. (1984). *Rabelais and His World*. Bloomington: Indiana University Press.

Barthes, R. (1970). "Science and Literature," in *Structuralism: A Reader*, M. Lane, ed., London: Jonathan Cape.

Barthes, R. (1973). *Mythologies*. St. Albans, U.K.: Paladin.

Bourdieu, P. (1974). "The School As a Conservative Force: Scholastic and Cultural Inequalities," in *Contemporary Research in the Sociology of Education*, J. Eggleston, ed., London: Methuen, pp. 32-46.

Bourdieu, P. (1979). *The Inheritors: French Students and Their Relation to Culture*. Chicago and London: University of Chicago Press.

Bourdieu, P. (1984). *Distinction. A Social Critique of the Judgement of Taste*. London: Routledge.

Bourdieu, P. (1990). *The Logic of Practice*. Cambridge, U.K.: Polity Press.

Bourdieu, P. (1993). *The Field of Cultural Production: Essays on Art and Literature*. Cambridge, U.K.: Polity Press.

Bourdieu, P., and L. Boltanski (1977). "Changes in Social Structure and Changes in the Demand for Education," in *Contemporary Europe: Social Structures and Cultural Patterns*, S. Giner and M. Scotford-Archer, eds., London: Routledge and Kegan Paul, pp. 197-227.

Bourdieu, P., and J. C. Passeron (1977). *Reproduction in Education, Society and Culture*. London: Sage.

Carey, J. W. (1983). "Technology and Ideology: The Case of the Telegraph," in *Prospects, An Annual of American Cultural Studies*, J. Salzman, ed., Cambridge, U.K.: Cambridge University Press, pp. 303-325.

Geertz, C. (1973). *Interpretation of Cultures*. New York: Basic Books.

Goody, J. (1986). *The Logic of Writing and the Organization of Society*. Cambridge, U.K.: Cambridge University Press.

Gramsci, A. (1991). *Selections from Cultural Writings*. Cambridge, MA: Harvard University Press.

Hall, S. (1980). "Encoding/Decoding," in *Culture, Media, Language. Working Papers in Cultural Studies 1972-79*, S. Hall, D. Hobson, A. Lowe and P. Willis, eds., London: Unwin Hyman, pp. 128-138.

Hall, S., and P. Whannel (1964). *The Popular Arts.* London: Hutchinson.

Marx, K. (1993). *Das Kapital. A Critique of Political Economy.* Washington, D.C.: Regnery Gateway.

Sherry, J. (1987). "Advertising as a Cultural System," in *Marketing and Semiotics*, J. Umiker-Sebok, ed., New York: Mouton de Gruyter, pp. 441-461.

Stallybrass, P., and A. White (1993). *The Politics & Poetics of Transgression.* Ithaca, New York: Cornell University Press.

Williamson, J. (1978). *Decoding Advertisements: Ideology and Meaning in Advertising.* London: Marion Boyers.

Chapter 11

The Secret of My Desire: Gender, Class, and Sexuality in Lingerie Catalogs

Angharad N. Valdivia

The author would like to thank Katherine Frith, Matthew McAllister, Maria Victoria Ruiz and Anita Specht for their help with this essay.

INTRODUCTION

Although people generally think of advertisements within particular media such as television, newspapers, or women's magazines, another location for advertisements is within the pages of widely disseminated mail-order catalogs. While these catalogs date back to the turn of the century with Sears Roebuck and Montgomery Ward leading in this field, in contemporary times one can get a mail-order catalog to fit nearly every predilection or desire. Thus there are catalogs for French pastries, vintage wines, sadomasochistic (s&m) paraphernalia, sewing equipment, general clothing, health foods, and lingerie, to name but a few of the options. In this case study, we will examine and compare the gendered class representations between two lingerie mail-order catalogs: Victoria's Secret and Frederick's of Hollywood. To do so we will engage in both production and textual analyses informed by recent and past work within feminist media studies as well as critical scholarship on advertising. Of particular interest will be the different

approaches in regard to class inherent within these catalogs.

LITERATURE REVIEW

Feminist media studies have focused on advertising as a nearly logical choice. Since the beginning of the second wave of the women's movement, scholars and activists could not help but notice the abundance of images and representations of women within the ubiquitous instances of advertisements. Not surprisingly there was an accompanying abundance of research of the "sex-role" type which suggested that women were highly stereotyped in the home, as decorative sex objects, dependent on men, and not making important decisions (Shields, forthcoming; Simonton, 1995). Building on those rather conclusive findings, researchers continue to note that advertisers seem to be preoccupied with gender and sexuality (Jhally, 1987), with the most recent advertising research suggesting that depictions of sexuality are on the rise (Fowles, 1996). Pieraccini and Schell (1995) sum up much of the research as such:

> Women have traditionally been exploited by some advertisers to sell products. And in the process, myths about women have been reinforced. Advertisers have sold us the myth that all women must be thin. Advertisers have sold American women the myth that the ideal woman is blond. Media campaigns have reinforced the myth that women must remain youthful to be desirable. The myth communicated is that product use makes a woman sexy. The reality is that sex sells. (p. 123)

Another parallel area of study is the role of women and gender within the current system of advertising. Ewen and Ewen (1992) have amply documented the advertising industry's efforts to position women as consumers in our culture. This process involved giving the word "consumption" more positive connotations, since the word used to be associated with disease and needless and premature waste. Though "consumerism is often represented as a supremely individualistic act" (Williamson, 1987, 230), it is a social act that "makes you feel normal" and can even

cheer you up! Scholars study the role that consumption plays in contemporary women's lives and suggest that it is one of the pleasures and responsibilities that women derive from popular culture (Radner, 1995). As such, women have become both the content and the target of much of advertising.

No study of women and advertising, especially one overlapping with the study of lingerie catalogs, would be complete without consideration of what has come to be known as the "culture of slenderness." It is nearly impossible not to notice that women as represented in popular culture have gotten thinner and thinner. The obsession with ever-thinner bodies has been extensively documented in terms of its existence and of its effects (Wolf, 1991; Bordo, 1993). Bordo (1993) underscores that slenderness is "an ideal of specifically female attractiveness" (p. 205). Studies have linked "the culture of slenderness" with diseases such as anorexia nervosa and bulimia and have detected that girls are dieting at younger and younger ages. Wolf (1991) notes that "the weight of fashion models [has] plummeted to 23 percent below that of ordinary women" (11). The mass media are implicated in this process because they are replete with images of women who fit the slender ideal. This thin ideal of beauty manifests itself in the movies, beauty pageants, television, record covers, and, of course, advertisements, as noted in Pieraccini and Schell (1995).

However, there is a class component to this thin ideal of beauty. As Jackie Onassis reminded us, "One can never be too thin or too rich." In the United States one of the most powerful myths is that of the middle-class (see Vermehren, this volume). That is, people believe that they belong to this mythical middle class while few of them do. While the professional-managerial middle-class amounts to "no more than 20 percent of the U.S. population," the industrial working-class, those working for wages rather than salaries, amount to nearly 70 percent of the population (Ehrenreich, 1990; Lont, 1995). Not only is the working-class under-represented, but also the middle class is repre-

sented as more virtuous (Parenti, 1992) than the more sloppy, less educated, and less intelligent working-class (Andersen, 1995). Scholars note that a component of working-class representation includes the middle class's moral authority in the form of better knowledge, among other things, of diet and nutrition (Ehrenreich, 1990). This has implications in terms of appearance, with the result being that fat is a component of working-class representation, with Archie Bunker (Parenti, 1992) and Roseanne (Lee, 1992) being the two most mentioned examples.

Little is said about advertising and the working-class. However, this omission is very logical since it makes little sense to represent a class that is below the levels of consumption to which we are supposed to aspire. Consequently, even within feminist research, the focus on class remains nearly unexplored. Work such as that of Press (1991) on television issues and Paul and Kauffman (1995) on Hollywood film remain in the minority in terms of focusing on issues of women and the working-class. For example, looking at the index of one of the most recent overviews of feminist scholarship, one finds an abundance of listings regarding advertising and gender; a drastically shorter variety of listings regarding "representation of ethnicity in"; and nothing on advertising and class (e.g., van Zoonen, 1994, 168).

Combining the study of issues of class and gender in advertising might lead us to ask some interesting questions. Of course, most advertisers prefer to target the social groups with higher amounts of disposable incomes. However, in aggregate terms, the disposable income of the ever-increasing working-class suggests that there are goods and services targeted at this segment of the population, which, in fact, is the case (McAllister, 1996). Thus, we need to ask what types of products are targeted at working-class women? Once we ask this question, others follow. Will the appeal to working-class women be different than that to middle-class women? From a feminist perspective, will the gender construction of working-class women differ from that of middle-class women? At the very least, we might

surmise that the "pleasures" associated with a culture of consumption will be mitigated or altogether absent when one considers the scarcity or lack of disposable income.

THE CATALOGS

Production Issues
We combine the study of the content of cultural texts with considerations about their production, because it is important to keep in mind the limits and possibilities in the process of generating and deploying a particular cultural form. Since "the study of culture involves the study of activities and interactions, not just the study of cultural products," we must ask questions about who produces what, how it is produced, how often and under what conditions (O'Connor and Downing, 1995, 10-11). Grounding our textual analysis in this knowledge results in a better informed understanding of the possible meanings of any cultural form.

To begin with, the very notion of having entire catalogs devoted to lingerie is a fairly recent phenomenon. True, Frederick's of Hollywood dates back fifty years, but Victoria's Secret is much more recent. In fact the entire intimate apparel explosion has been seen as part of a backlash against feminism (Faludi, 1991), or as one of the prime examples of the contradictory positions which women are encouraged to occupy (Douglas, 1994). On the one hand, women are supposed to be breadwinners while on the other, they are supposed to maintain their sexiness just below the surface. Actually in recent fashion, lingerie is not even beneath the surface, as it peeks through both tops and bottoms. Yet lingerie is quite a recent invention, in historical terms. "Up until the 1850s, proper middle-class women wore no underpants" (Ewen and Ewen, 1992, 99-100). We must keep in mind, though, that class is relevant. As Simonton (1995) asserts: "According to most ads, to obtain sex appeal one must be rich enough to lie around all day waiting for her mate. This is Victoria's Secret's class distinction" (p.149). Thus, the study of advertising and

gender cannot be discussed without considering issues of class: in this case Victoria's Secret is to middle-class as Frederick's of Hollywood is to working-class.

In the universe of direct mail, Victoria's Secret and Frederick's of Hollywood stand out as two of the most circulated lingerie catalogs. Business for these two catalogs is great. Despite a dip in profits, indeed a posted loss in 1985, the Frederick's of Hollywood catalog posted a $2.4 million profit in 1994 (*Chain Store Age Executive Edition*, 1995). Victoria's Secret catalogs and mall stores grossed $1.8 billion in 1994 (Machan, 1995) and the catalog is considered one of the most successful ventures in the contemporary mail-order business (Brubach, 1993). These catalogs are cultural icons as well as big business.

As one might expect with most goods, the quality and price of lingerie varies drastically, and this is no different with these two catalogs. The very production issues about these two catalogs set them apart. Victoria's Secret speaks to an opulence and abundance by virtue of its frequency of mailing, size, glossiness, variety, and settings. Frederick's of Hollywood, in contrast, is smaller, less frequent, and less varied in setting and variety.

To begin with, Victoria's Secret is usually a full-sized catalog, in terms of being 8.5 in. x 11 in. in size and having over one hundred pages. Everything about the catalog suggests a connection to the Old World and nobility, which is a common tactic in the United States, referring back to European roots, especially England, as a way of staking out an upper-class position. The very heading of the catalog lists "London" right under the title. The 800 telephone number is answered by an English-accented recorded female voice. The address given, should one decide to mail one's order, states that the "North American" office is in Columbus, Ohio, suggesting, perhaps, that the main office is in London or somewhere in England. The catalog itself carries a price, though I've never met anyone who's paid to get it, of $3 in U.S. funds or two pounds in U.K. funds.

In reality, the link to England is far from the truth. The first Victoria's Secret shop was opened in 1982 by Roy

Roymond in a suburban shopping mall in Palo Alto, California (Faludi, 1991, 190). Roymond capitalized on the fashion apparel industry's finding that both intimate apparel and a romanticized notion of the Victorian era were very marketable concepts (Faludi, 1991, 189-191). He also wanted to increase underwear sales to men: thus, the decor and strategy of Victoria as the knowledgeable yet discrete owner. The concept was so successful that the Limited, another apparel chain, bought Roymond out, and we now have shops and catalogs within the reach of nearly every person in the United States.

The use of the word "Victoria" is as well thought out as the connection to England and as misleading. The link to the Victorian era links the catalog and its shoppers to a time in which certain women were demure and pure ladies of leisure. This move is similar to that of the popular singer who named herself "Madonna." For Victorian sexual mores included the near abstinence from and lack of enjoyment of sex, quite the opposite of what is suggested in the catalog's pages.

The question of frequency of mailing is an indeterminate one. A customer service representative informs us that there are 12 regular mailings a year or a "reduced mailing" of six issues a year for those who express the desire for less mail. However nearly all who receive the catalog regularly claim to get from two monthly to nearly daily issues of it. There are also different versions of the catalog: regular, country, city, cruise, sale, and clearance issues. Some issues are shot on location in cruise ships or resorts in such places as Boca Raton, Florida. In sum, one gets frequent and varied catalogs if one is on this mailing list.

Probably because the catalogs are released so often, Victoria's Secret models have achieved a high level of recognition. Readers know particular models and have favorites. There is also a rumor that one of the models is actually a man, though there is great disagreement as to which one that is. Some of the Victoria's Secret models have crossed over into film or television and others have their own line of perfume or clothing. Additionally, and suggest-

ing a heightened level of expenditures in catalog production, the Fall 1996 issue contains some of the top models of the day, including Claudia Schiffer and Linda Evangelista.

Although Frederick's of Hollywood stores and catalogs date back 50 years to 1946, their catalog is smaller, 11 in. x 6 in., thinner, and less frequent. Also, the link of this catalog is to Hollywood, a mecca of the movie industry but also the scene of criminally and sexually laden activities such as those conducted on Hollywood Boulevard. There are no allusions here to a noble place, not even to the more upscale Bel Air or Beverly Hills. Similarly, people on the mailing list confirm their customer service representative's figure of 10 catalogs per year. Frederick's of Hollywood mails only the regular catalog and there are no "on-location" issues. Finally, these catalogs frequently contain yellow, stop-sign shaped notices, taped on the bottom left-hand corner of the front cover of the catalog, stating that unless one orders, "this will be your last catalog." After two of these notices, they really stop sending you the catalog. Finally, there is no apparent continuity in usage of models, and there is definitely no attempt to use the top models of the day.

Even before one engages in textual analysis of these catalogs, the way in which they are marketed and their frequency and size characteristics, mark Victoria's Secret as a much more wealthy enterprise, both in terms of its production and the assumed income of its recipients. In contrast, Frederick's of Hollywood's more measured marketing approach marks it as a less frequent and expenditure-prone project.

Textual Analysis

We analyze cultural texts because we theorize that their repetitive and systematic deployment in our culture contributes to the way we make meaning about our world and that they tell us what is important and valued, and by contrast what is marginal and undervalued, in our culture (Dyer, 1982). Though we do not think that content directly reflects reality, we suggest that it speaks about a culture,

its values, fantasies, desires, and norms. Advertising, in particular, lends itself well to this type of analysis since, as van Zoonen (1994) notes, "it needs to present its message in an extremely short time span, and depends heavily on the successful exploitation of the connotative power of signs" (p. 79). This analysis will be a semiotic one in that through the study of signs it will explore through "denotation, connotation, myth, and ideology" the "processes of signification in the text" (p. 79). As such, we focus on settings, poses, and products as evidence of systems of signification which tell us about our myths and ideologies.

There are many textual components to these two catalogs which mark them as different from each other. However, the differences may be less marked now than in the past, as Frederick's had to change its marketing strategy in order to keep up with the times. After seeing their profits drop in 1985, perhaps due to the Victoria's Secret competition, "Even Frederick's of Hollywood reverted to Victoriana, replacing fright wigs with lace chemises, repainting its walls in ladylike pinks and mauves and banning frontal nudity from its catalogs. ' You can put our catalog on your coffee table now,' George Towson, president of Frederick's says proudly" (Faludi, 1991, 190). Toned-down photographs were less explicit and more Victorian in terms of decor and posing. Indeed their "upgrade" and their rebound were widely covered in the business press (e.g., Kerwin, 1989; Caminiti, 1988; Wilson, 1989; Gill, 1991). Yet despite these changes there are still some very real differences between these catalogs.

THE SETTING

Victoria's Secret

Setting is important to the meaning system in these two catalogs. Not surprisingly settings vary tremendously from one catalog to the other. Victoria's Secret's models can be found in a wide variety of settings. Whether these are indoor or outdoor, they are richly coded with elements that

connote wealth and leisure. For example, jeans ads in the Fall 1996 catalog are pictured in some pastoral dude ranch, with snow-capped mountains in the background and sturdy wooden fences for the models to lean on (Figure (11.1). The look is expansive, as one can see the fences and the prairie drawing out for miles behind the models. Similarly, Spring and Summer editions were shot in sometimes mentioned resorts, but more often in some sort of vague but nevertheless opulent and wealthy setting. The trappings of wealth are evident in the flora and fauna, the structures, and the backgrounds. For example, the Spring models lounge about on Italian-tiled balconies. The floors are either marble or stone or ceramic painted tiles. The background is lush, either palm trees and Caribbean-colored water or some neatly trimmed and landscaped large backyards reminiscent of English country houses. Models lean on stone verandas which stretch out as far as the eye can see or, are set against tree-lined lanes whose fuzzy outlines extend to the horizon. Lots of shots are in yachts, either on their generous decks, with accompanying furniture, or within wood-paneled cabins below decks. Models are sandwiched between stone pillars or arches and large, human height vases, with ocean water in the background. Or better yet, models lean on a deck which precedes a pool or lounge chairs which precede the ocean! City scenes have our models by iron gates, gaily colored pillars, of the type one would find in Italy or Spain, or sitting atop a jeep in a narrow, wooden house-lined street (Spring, 1996, 54-55). Other people are missing.

Figure 11.1

The interiors are plush as well. We see different decors depending on the season. There are always roses. During winter they are white, in spring pink, in summer yellow, and in fall red. Winter issues show Christmas trees in the background, as well as holly and baskets of potpourri. Overall, there are lush interiors, with tall ceilings and plush couches, divans, and loveseats in tones of gold, champagne, and whites. These are trimmed with long tassels and silk fringes. There are huge tufted ottomans. The walls are dark wood-paneling and the floors are covered with rich tapestries. There are also older looking pieces of leather furniture with large brass studs, and wine colored drapes. There are expensively framed mirrors, master's-style paintings in gilded and ornate frames, large armoires, antique makeup tables covered with collections of perfume bottles and carelessly abandoned strands of pearls. There are wool and velvet throws, always either in champagne or burgundy color palettes. Candelabra hang from the ceiling and large candles sit atop ornate mantelpieces. Chintz-covered tables are crowded with silver-framed photographs of elegantly clad people. Models hold blue china teacups and saucers. They read, or more often, they recline or sit by books such as *Legendary Decorators of the Twentieth Century* by Mark Hampton, which sits atop four large wooden bound tomes entitled *Les Pays Bas, Volumes I-IV* (Fall 1996, 29). That one can clearly read the titles of the decorating books underscores the importance of the decor in Victoria's Secret catalogs. For quite often decoration and setting are foregrounded, and the models serve as decoration rather than the other way around. In this particular example (Figure 11.2), the books precede the model who is seated between them and a large ottoman stacked with more large coffee-table books. The model does not even sit at the center of the picture. Rather a framed fireplace and mirror occupy that privileged space.

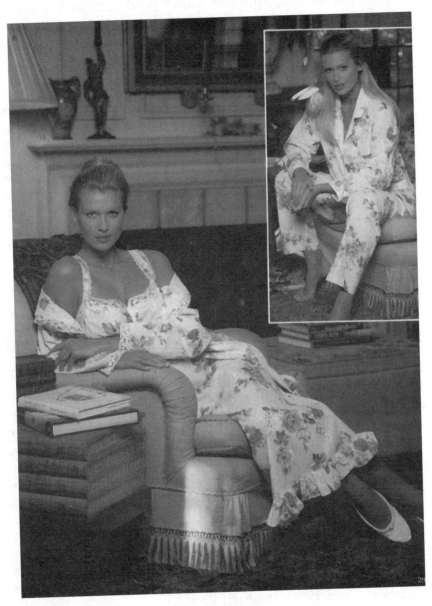

Figure 11.2

Lighting in these interior shots is also important. Seldom do the models sit in full daylight. Daylight is at least filtered if not totally absent. More often they lie in the shadows, signifying either early dawn or late evening. If during the day, there are diaphanous lace or cotton panels covering the windows, shadows of which criss-cross the models' bodies, or there is lush greenery casting shadows on the surroundings. In these schemes window treatments are elaborate. There are French doors and large wrought-iron divided windows which face green outdoor gardens. The feel is one of privacy even if the windows are open, for they always hint of large expanses of property as if these women lounge in grand estates. If at night or early dawn, there are wall length heavy drapes in velvet-like textures matching the shades of gold, champagne, or burgundy that adorn the furniture.

Frederick's of Hollywood

The settings in the pages of Frederick's are less varied. To begin with most of the models are shot against fabric backdrops—i.e., indoors with no background setting. The composition also differs drastically as very few of these settings occupy more than a quarter of a page while many in Victoria's Secret are full-page shots. Indoor shots offer very fuzzy backgrounds in natural hues with the models occupying the foreground. When there is a discernible piece of furniture models are shown on or near beds—denoting sex. Less often models appear on couches. Outdoor shots are in gardens, by pools, or beaches, in the case of swimsuit models. Again the close-up on the model and the small size of each shot prevents the expansive vistas of Victoria's Secret. The outdoor swimsuit shots have a deep blue ocean, not the Caribbean. In one of the few instances where there are six consecutive shots of a white wood veranda, they are all taken in the very same corner. In terms of setting, the variety in Frederick's is much less.

THE POSES

Within advertising analysis, one major area of study has been the pose of the models. Some poses connote activity, while others connote passivity. Still many are polysemic— that is, containing the possibility of more than a single interpretation. There are many possible poses for women yet within the pages of these catalogs there is a rather small variety of poses. Pose is important because it indicates or suggests a level of action, and one of the ways we determine class from gender representations is the relative passivity of the middle-class as compared to the activity of the working-class. This is related to the amount of work that each class mythically does—that is, the middle-class does more mental labor while the working-class engages in manual labor. Also, femininity, being a middle-class construct, positions ideal women as passive and active women as deviant.

Victoria's Secret

In Victoria's Secret catalogs the predominant pose is reclining atop a couch or loveseat. Seldom are models pictured on or near a bed, despite the fact that they are often wearing lingerie or bedclothes. The mode of reclining ranges from a near horizontal position with the upper body propped up on elbows or lots of opulent pillows, the head thrown back or turned sideways, one hand draped over the curve of the hip, to a more upright position, still on a couch or large chair, still with large pillows, but with the weight on the posterior rather than a hip.

The exception to these two modes of reclining, or rather the presence of a sitting position, is in the selling of the satin pajama "inspired by the men's wear classic" (Fall 1996, 6). In these photographs the models are seated, more or less straight, for they have one elbow on a knee or they lean forward with hand-cupped in front of their legs. Yet they have their legs spread open in contrast to nearly all other poses where legs are together or crossed.

Victoria's Secret models seldom stand on their own. When they do, models tend to be leaning or they are shot

so as to suggest an angular rather than a straight-line composition. Models stand with legs crossed or in a modified ballet position, one leg bent in front of the other. Their hands are propped on their waists or hips or tucked in their pockets or belt loops. Quite unusual is the occasion when models are seen walking rather than standing. In these latter instances they are always wearing street clothes. The other favorite pose is leaning against a couch, pillar, wall, chair, veranda, car, fence, chest of drawers, or other props such as camera equipment. Leaners rest their feet, hips, arms, and hands on these various objects. They do so, either looking at us or away from us.

In terms of facial expressions, the look of Victoria's Secret could be classified as "demure." The models have slight smiles on their faces, their perfectly outlined lips closed. Sometimes they have a slightly open lip smile or a tooth-showing look. They seldom look directly at the camera. The three-quarter look is much more prevalent. Quite often they are looking away from the camera onto a dreamy beyond. Other times they are looking at themselves in what has been called a "narcissist" position. Sometimes they squint at the camera or at the beyond in an "I dare you to come get me look." But much more often the gaze is rather inviting and expectant.

Frederick's of Hollywood

In Frederick's of Hollywood models stand more often than they recline. This may be because Frederick's rarely has a setting which means the model has to stand against a backdrop. However, many of the standing models have both feet set firmly on the ground, hands on their hips, and stare straight at the camera. We also get body cropping which has been heavily criticized within feminist scholarship as evidence of the objectification of women (Shields, forthcoming). For instance in both panty hose and bra pages, the Victoria's Secret catalogs still show all or most of the model. In contrast Frederick's has many leg, waist, chest, and head shots. Finally, in Frederick's there are a

number of two or three-model shots whereas there were none of these in Victoria's Secret.

In terms of gaze and head position, Frederick's models stare at the camera far more often and at themselves or into the distance far less often than do Victoria's models. Frederick's catalogs have many more instances of open lips with gritted teeth and the presence of closed eyes, especially in swimsuit shots. There are also more open smile or near laughter looks.

The pose of the Victoria's Secret models is much more vulnerable and passive than that of Frederick's of Hollywood models. That the latter models engage the camera, and therefore the implied viewer, directly, grants them a much more powerful stance than the former's indirect gaze. This speaks to different standards of sexual allure—that is, demureness is sexy in a middle-class setting and directness is sexy in a working-class setting. Still, the former leaves women much less agency than the latter.

THE PRODUCTS
Direct mail marketers segment their audiences by demographics such as age, income, and education. While social class is not ostensibly considered a demographic, nonetheless it is, obviously, implied. For example, catalogs with elaborate wine storing structures would appeal to those with considerable amounts of disposable income while catalogs full of inexpensive gadgets might appeal to a lower level of income. However, since both of these catalogs sell lingerie, we have to consider additional signifiers of class difference. Price is one basic starting point, while the other differences are mostly based on the connotative value of certain types of apparel and other intimate products.

Neither catalog prices its products at a stratospheric level, though Victoria's Secret has, on the average, costlier items than Frederick's of Hollywood. While Victoria's Secret uses more signifiers of wealth in their illustrations, price alone does not account for the class demarcations. For example, the 1996 Winter Sale edition of Victoria's Secret notes that all bras sell between $9.99 and $12.99. Freder-

ick's of Hollywood sells regular bras for between $18 and $30.

The materials and textures used in the products account for some of the price difference and much of the class connotations. For example, in terms of underwear, Victoria's Secret silk is more expensive than the Frederick's of Hollywood lycra or sheer mesh. Velvet, velour, cashmere, chenille, chamois, lambswool, clothes wool, and linen in Victoria's Secret are more expensive than the rayon or polyester clothing in Frederick's of Hollywood. However, there are also materials which though more expensive have different connotations which correlate inversely between class and price. Leather, for example, is an expensive material. Yet it is used in different types of garments in the two catalogs. In the pages of Victoria's Secret we can find a fully lined lambskin leather peacoat for $399 (Fall 1996, 108) whereas we can find no equivalent item in Frederick's. We can however find a variety of "leather-look" products ranging from bustiette to open-cup playsuits with matching vinyl-cuffed stockings, and entire vinyl bodysuits in white, black and red for $49 in Frederick's (Issue 402, 1995, 53).

Likewise dress and lingerie styles differ in these two catalogs. In Victoria's Secret there are formal and informal night dresses as well as "dress for success" day outfits and comfortable leisure time outfits which include sweater and skirt sets and leggings and sweatshirts. Colors are usually solid in rich dark tones, beiges, or pastels with some pinstripe and fewer floral prints. In Frederick's dresses come in a variety of prints ranging from red-and-white gingham to daisies on a blue background, psychedelic stripes, floral and fruit prints, and stars and stripes. Colors are both very bright and pastel. While Victoria's Secret offers sweatpants and the like as leisure wear, Frederick's has bodysuits with lace-up necklines or with sheer material except for the molded bra shaping and the "daring bikini pants." There is a lot more skin showing in the clothes pages of Frederick's, from cleavage to midriff to thigh than there is in Victoria's Secret.

Likewise there is more skin, color, and product variety showing in Frederick's lingerie section. For instance, there are cupless bras as well as a variety of garter belts, thigh high, knee high, garter, and cutaway suspender hose. The lingerie comes in a broad variety of colors, including turquoise, as well as prints, such as bandanna (for country girl curves), blue gingham, and a print of kissing cherubs. The variety extends to type of lingerie with the already mentioned garter belts and hose, to bustiers, bone-laced cinchers, body stockings, and corsets. There is a large variety of girdle-style wear in Frederick's in the form of panties, full ("body-sculpting power slips") and half slips, and full-length control hose. Finally, Frederick's offers padded girdles (for those whose project is to enhance rather than reduce), fanny lifters, silicone breast enhancers, and silicone breasts.

Lingerie in Victoria's Secret primarily comes in solid colors, usually with a champagne tint, or in little florals. The bulk of the merchandise consists of panties, bras, slips, and teddies. There has been a boom in the Miracle bra, which comes in a variety of colors and textures. Girdle-style wear appears under names such as "shapers" and "cinchers," and there is little variety of these. There are no enhancers in the Victoria's Secret catalogs.

The catalogs also differ in the variety of sizes offered. While most of the Victoria's Secret products run from XS to XL sizes, the Frederick's catalog has many styles available in plus sizes. Both catalogs offer the same range of bra sizes.

There are other products in these two catalogs which, though the same in name, differ drastically in form. For example, both catalogs sell jeans. Yet in Victoria's Secret you can find their "London" jeans, which come in four different size types (classic, slim, petite, and tall) and in sixteen shades or colors for only $29, when on sale. In later catalogs you can also find stretch denim in different styles (e.g., hip hugger) and slightly more expensive ($39). All of these jeans are shown by models in outdoor stables or prairies, leaning against hitching posts or fences, as if they were

just about to ride horses. Other than the stretch denim, jeans are worn loosely and with complementing turtlenecks or shirts.

On the other hand, in Frederick's there are more types of jeans, and none of them come in the variety of sizes and colors as the "London" jeans. So we have hip hugger, side zipper, double-laced, and cotton-denim jeans, all of which are worn skintight with bare midriff. There is an additional "thong-style" stretch-denim jean, which simulates a thong look in the back by placing a denim inset on a background of black denim.

Finally, in addition to the availability of different types, prices, sizes, and colors of clothing, Frederick's has items that are not sold in Victoria's Secret (Figure 11.3). These include wigs and silicone inserts. Also there are masquerade-like sets such as harem girl, Spanish *senorita*, pirate, and biker chick. Skintight gold lame hip huggers, vamp mules, crotchless panties, and babydoll attire can only be found in Frederick's.

CONCLUSIONS
The popularity of these catalogs is borne out by their increasing annual sales and profits. While it's evident that these catalogs construct gender in a particular manner, the focus of this chapter was on the way that sexuality is represented in class specific terms. That is, to be sexually alluring has a different set of characteristics in the pages of Victoria's Secret than it does in the pages of Frederick's of Hollywood.

To begin with, the Victoria's Secret style implies a life of educated and opulent leisure. Models lounge around either indoors or outdoors in plush, comfortable, private, and expansive settings. They lie alone and alongside books and pools or Caribbean waters. They don't seem to have to hurry or worry about working. They appear forever ready to enjoy sex in a relaxed and comfortable setting. Even the outdoor clothes pages fit this mold, with the exception of a few models shown around some sort of media equipment. Victoria's Secret women are women of leisure with time to

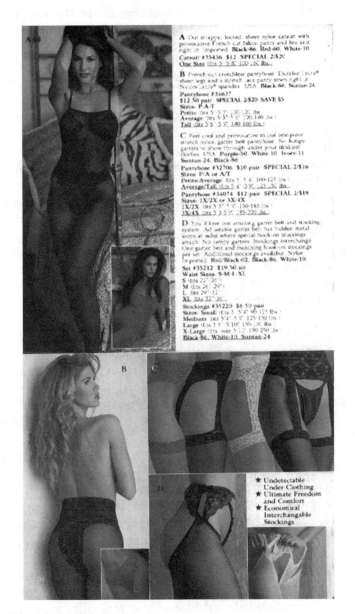

Figure 11.3

read the classics and current coffee-table books. Their reclining pose, their crossed legs, the high-quality materials used in their garments, and the rich textures, all speak of a life of leisure, albeit with a "kept woman" aura. For if they don't work or even stand up, someone must support them financially and domestically. Perhaps, in response to this generous support, they are demure in gaze and gait. They don't own the space which they occupy, they merely adorn it which is why the focus is on the decor as much as on the model. As kept women they are like part of the furniture or the well-trimmed grounds.

Frederick's of Hollywood women appear less wealthy, yet they are more imposing. Standing most of the time and staring at us from their confident and stable position, theirs is a more active look. They wear more revealing and less comfortable clothing (in terms of materials, cut, and shape) yet they are on the move. There is also more latitude for variety of body types in this catalog. Larger sizes and many options in types of girdles speak to the presence of less than slender women, while padded underwear speaks to the presence of unwillingly thin women. Wigs and prosthetic breasts imply that, for whatever reasons, women need these devices yet cannot afford the more permanent solutions. That these products do not even appear on Victoria's Secret pages suggests that for that socio-economic class of women, surgical breast enhancement and hair replacement or permanents are assumed to be the norm. Also, the tyranny of the slender ideal is greater in a catalog where it is assumed that everyone falls within the XS-XL size spectrum. Frederick's women have more options in terms of sizes, while Victoria's Secret women may be assumed to be able to afford health spas or surgical reduction.

Thus we get a trade-off in terms of the comfort and control that the representation of middle and working-class sexuality offers. While middle-class sexuality may be more opulent and leisurely (these women appear to engage in nothing but), there is a troublesome component of passivity. These women look as if they are waiting for or waving

off their visitors. In contrast, Frederick's women may not function in as lush a setting, but they look more in control of their sexuality, in terms of when it happens and with whom. Their pose and gaze imply that they won't wait. Though they are ready, they are also ready to walk. They can be more active in the game of sex.

Neither option is entirely without contradictory components. Both catalogs offer a sexualized representation of women. Both catalogs encourage consumption. Surprisingly enough, in some cases items in the Frederick's of Hollywood catalog are more expensive than their counterparts in Victoria's Secret. Both catalogs suggest that part of women's work is to encourage sex with male partners. This, then, becomes an additional component of domestic work, one that has always been there but now has the twist of Victorian sexiness. Thus, we are still waiting for that utopian space where women will be free to enjoy their sexuality as they please and women will have the ability to be comfortable without sacrificing their independence and agency in the process.

248

REFERENCES

Andersen, Robin (1995). *Consumer Culture and TV Programming*. Boulder, CO: Westview Press.

Bordo, Susan (1993). *Unbearable Weight: Feminism, Western Culture and the Body*. Berkeley, CA: University of California Press.

Brubach, Holly (1993). "Mail Order America," *The New York Times*, Nov. 21, pp. 54-61+.

Caminiti, Susan (1988). "The Leading Man of Lingerie." *Fortune*, Vol. 118, pp. 163-164.

Chain Store Age Executive Edition (1995). March, 162.

Douglas, Susan J. (1994). *Where the Girls Are: Growing Up Female with the Mass Media*. New York: Random House.

Dyer, Gillian (1982). *Advertising as Communication*. London: Methuen.

Ehrenreich, Barbara (1990). "The Silenced Majority," *Utne Reader*, January/February.

Ewen, Stuart, and Elizabeth Ewen (1992). *Channels of Desire: Mass Images and the Shaping of American Consciousness*. Minneapolis: University of Minnesota Press.

Faludi, Susan (1991). *Backlash: The Undeclared War against American Women*. New York: Crown.

Fowles, Jib (1996). *Advertising and Popular Culture*. Thousand Oaks, CA: Sage.

Gill, Penny (1991). "Desleazification Pays Off." *Stores*. Vol. 73, pp. 44-46+.

Jhally, Sut (1987). *The Codes of Advertising*. London: Frances Pinter.

Kerwin, Kathleen (1989). "Frederick's of Hollywood Trades Its X Rating for an R," *Business Week*, Dec. 11, p. 64.

Lee, Janet (1992). "Subversive Sitcoms: Roseanne as Inspiration for Feminist Resistance," *Women's Studies*, Vol. 21.

Lont, Cynthia M. (1995) *Women and Media: Content/Careers/Criticism*. Boston: Wadsworth.

Machan, Dyan (1995). "Sharing Victoria's Secret," *Forbes*, Vol. 155, pp. 132-133.

McAllister, Matthew P. (1996). *The Commercialization of American Culture: New Advertising, Control, and Democracy*. Thousand Oaks, CA: Sage.

O'Connor, Alan, and John Downing (1995). "Culture and Communication" in *Questioning the Media: A Critical Introduction*, J. Downing, A. Mohammadi and A. Sreberny-Mohammadi, eds., Thousand Oaks, CA: Sage.

Parenti, Michael (1992). *Make Believe Media: The Politics of Entertainment*. New York: St. Martin's Press.

Paul, Jasmine, and Bette J. Kauffman (1995). "Missing Persons: Working-Class Women and the Movies, 1940-1990," in *Feminism, Multiculturalism and the Media: Global Diversities*, A. N. Valdivia, ed., Thousand Oaks, CA: Sage.

Pieraccini, Tina, and Robert Schell (1995). "You're Not Getting Older—You're Getting Better!" in *Women and Media: Content/Careers/Criticism*, C. M. Lont. ed., Boston: Wadsworth.

Press, Andrea (1991). *Women Watching Television: Gender, Class and Generation in the American Television Experience*. Philadelphia: University of Pennsylvania Press.

Radner, Hilary (1995). *Shopping Around: Feminine Culture and the Pursuit of Pleasure*. New York: Routledge.

Shields, Vicky (forthcoming). "Advertising: Overview" entry in the "Communications and Culture" section of the *Global Women's Encyclopedia*, C. Kramerae and D. Spender, eds., London: Harvester-Wheatsheaf.

Simonton, Ann J. (1995). "Women for Sale" in *Women and Media: Content/Careers/Criticism*, C. M. Lont, ed., Boston: Wadsworth.

van Zoonen, Liesbet (1994). *Feminist Media Studies*. Thousand Oaks, CA: Sage.

Vermehren, Christian (1997). "Cultural Capital: The Cultural Economy of U.S. Advertising," in *Undressing the Ad:*

Reading Culture in Advertising, Katherine T. Frith, ed., New York: Peter Lang, pp. 211-241.

Williamson, Judith (1987). *Consuming Passions: The Dynamics of Popular Culture.* New York: Marion Boyers.

Wilson, Marianne (1989). "The De-sleazification of Frederick's," *Chain Store Age Executive with Shopping Center Age*, Sept., pp. 94-96.

Wolf, Naomi (1991). *The Beauty Myth: How Images of Beauty Are Used against Women.* New York: Morrow.

Studies in the Postmodern Theory of Education

General Editors
Joe L. Kincheloe & Shirley R. Steinberg

Counterpoints publishes the most compelling and imaginative books being written in education today. Grounded on the theoretical advances in criticalism, feminism and postmodernism in the last two decades of the twentieth century, Counterpoints engages the meaning of these innovations in various forms of educational expression. Committed to the proposition that theoretical literature should be accessible to a variety of audiences, the series insists that its authors avoid esoteric and jargonistic languages that transform educational scholarship into an elite discourse for the initiated. Scholarly work matters only to the degree it affects consciousness and practice at multiple sites. Counterpoints' editorial policy is based on these principles and the ability of scholars to break new ground, to open new conversations, to go where educators have never gone before.

For additional information about this series or for the submission of manuscripts, please contact:

Joe L. Kincheloe & Shirley R. Steinberg
637 West Foster Avenue
State College, PA 16801

4. And when ye shall receive these things, I would exhort you that ye would ask God, the Eternal Father, in the name of Christ, if these things are not true; and if ye shall ask with a sincere heart, with real intent, having faith in Christ, he will manifest the truth of it unto you, by the power of the Holy Ghost.

5. And by the power of the Holy Ghost ye may know the truth of all things.

6. And whatsoever thing is good is just and true; wherefore, nothing that is good denieth the Christ, but acknowledgeth that he is.

7. And ye may know that he is, by the power of the Holy Ghost; wherefore I would exhort you that ye deny not the power of God; for he worketh by power, according to the faith of the children of men, the same today and tomorrow, and forever.

8. And again, I exhort you, my brethren, that ye deny not the gifts of God, for they are many; and they come from the same

VERSE 4. *By the Power of the Holy Ghost ye may know the truth of all things.* Moroni here gives us the *key* that by its use a testimony of the truthfulness of the BOOK OF MORMON may be obtained. *Prayer is that key.* That key is the means whereby will be unlocked the vast store of knowledge and information that lies hidden between its covers. Earnest prayer to the Father in the Name of Christ will reveal the truth of the Sacred Record to the sincere seeker. Not a doubting prayer, wavering betwixt uncertainty and misgiving; not vacillating because of the faults alleged found therein (*See,* Inspired Preface; Mormon 8:2; 9:30-31), but a prayer seeking neither pretext nor excuse; one of real intent, coming from a thankful heart and a mind open to the promptings of the Holy Ghost, by Whose Power God will make known, or make the truth of the Book of Mormon manifest.

Not only will the truthfulness of the Book of Mormon be made known to the prayerful seeker after truth, but by that same Power, which is the Power of the Holy Ghost, the truth of all things will be manifest. That Power is as a still small voice which comes from the Father, to lead, and to guide, and to enlighten the way before the one who earnestly searches for truth.

VERSES 5-7. *Whatsoever thing is good is just and true.* "All things which are good cometh of God," (Moroni 7:12) and confirming Moroni's words, is the voice of the Lord Himself declaring the source whence springs the realization of our greatest hope, or in other words, the supreme and highest good from which all our blessings come: "Good cometh of none save it be of Me" (*Jesus Christ,* Ether 4:12). Moroni therefore draws the only logical conclusion, "Whatsoever thing is good is just and true." (v. 6)

The words of the Lord, spoken by all His holy prophets, are *good tidings; they are just and true.* Speaking of these words to Moroni, the Lord said: "I am He Who speaketh." (Ether 4:8) Benjamin, one of the great Prophet-Kings of the Nephites, when about to lay aside his mortal clothing, in an address to his much-loved people, said: "There is not any among you . . . that have not been taught . . . concerning the records which contain the prophecies which have been spoken by the holy prophets, even down to the time our father, Lehi, left Jerusalem; And also, all that has been spoken by our fathers until now. And behold, also, they spake that which was *commanded them of the Lord;* therefore, *they are just and true.*" (Mosiah 2:34-35)

VERSES 8-9. *Every good gift cometh of Christ.* For the benefit and betterment of His children who seek after Him, God, the Father, has ordained that holy gifts,

God. And there are different ways that these gifts are administered; but it is the same God who worketh all in all; and they are given by the manifestation of the Spirit of God unto men, to profit them.

9. For behold, to one is given by the Spirit of God, that he may teach the word of wisdom;

10. And to another, that he may teach the word of knowledge by the same Spirit;

11. And to another, exceeding great faith; and to another, the gifts of healing by the same Spirit;

12. And again, to another, that he may work mighty miracles;

13. And again, to another, that he may prophesy concerning all things;

14. And again, to another, the beholding of angels and ministering spirits;

15. And again, to another, all kinds of tongues;

16. And again, to another, the interpretation of languages and of divers kinds of tongues.

17. And all these gifts come by the Spirit of Christ; and they come unto every man severally, according as he will.

18. And I would exhort you, my beloved brethren, that ye remember that every good gift cometh of Christ.

wrought by His Spirit, should be the portion of the faithful among them. There are some who call these gifts, miracles. They are because we do not understand them. But those who do not believe in Christ, and have no faith in His Power — to excuse their unbelief — deny them. They loosely use the word, accidents. However, let us remember that they are really not so. They are the inspirations of God. His gifts are many, and Moroni says that they are administered in many different ways. God gives His gifts that His children may profit thereby. Surely, to the humble and true, they are almost inspiring, certainly inspiriting. But to the proud and haughty, "and he that shall deny these things, unto him will I show no greater things." (Jesus Christ, Ether 4:8)

"But to him that believeth these things which I have spoken, him will I visit with the manifestations of My Spirit, and he shall know and bear record. For because of My Spirit he shall know these things are true; for it persuadeth men to do good. And whatsoever thing persuadeth men to do good is of Me; for good cometh of none save it be of Me. . . ." (Ether 4:11-12)

Further, the Lord said: "I am the same that leadeth men to all good." (Ibid., 4:12) Wherefore, we conclude that everything that is good, everything that is just and true, witnesseth that Christ is; that He lives, and the knowledge thereof is confirmed to the righteous by the Power of the Holy Ghost. The Power of the Holy Ghost, is also called by Moroni the Power of God (v. 7), which Power he exhorts be not denied, for by it, the Lord manifests the truth of all things even to the working of mighty miracles and in giving His precious gifts to the believer.

Moroni enumerates many of God's gifts, and assures us that "Every good gift cometh of Christ." (v. 8) Which thought leads us to another in which we can be comforted: "There is enough in revealed and natural religion to establish beyond a doubt the hope in Christ which we cherish. Let us accept His gifts with grateful hearts, and leave the mysteries surrounding them to that day, as we have said before, when the things we know not now, we shall know hereafter. Again, we are comforted by the knowledge that there is a wisdom we cannot fathom; there is a Power we cannot grasp. "For behold, I am God; and I am a God of miracles; and I will show unto the world that I am the same yesterday, today, and forever; and I work

19. And I would exhort you, my beloved brethren, that ye remember that he is the same yesterday, today, and forever, and that all these gifts of which I have spoken, which are spiritual, never will be done away, even as long as the world shall stand, only according to the unbelief of the children of men.

20. Wherefore, there must be faith; and if there must be faith there must also be hope; and if there must be hope there must also be charity.

21. And except ye have charity ye can in nowise be saved in the kingdom of God; neither can ye be saved in the kingdom of God if ye have not faith; neither can ye if ye have no hope.

22. And if ye have no hope ye must needs be in despair; and despair cometh because of iniquity.

23. And Christ truly said unto our fathers: If ye have faith ye can do all things which are expedient unto me.

24. And now I speak unto all the ends of the earth—that if the day cometh that the power and

not among the children of men save it be according to their faith." (II Nephi 27:23) *The working of miracles* is a Heavenly Science, little understood by men. However, *the Great Scientist of the Universe* knows all, and there is nothing that He does not understand.

VERSES 20-23. *Faith, hope, and charity.* Reference is hereby made to the entire Chapters: Ether 12; Moroni 7; also II Nephi 26:30; 33:7-9; Alma 7:24.

VERSES 24-26. *If the day cometh that the Power and gifts of God shall be done away among you, it shall be because of unbelief.* Unbelief in the Majesty of Christ, robs many otherwise upright people of the knowledge pertaining to "greater things" (Ether 4:4-13) which God has in store for them, if only they repent and turn to Him. When Moroni was in the process of making an abridgment of King Mosiah's translation of the Jaredite Records found upon the Twenty-four Gold Plates of Ether, the Lord in instructing him to seal up the interpretation thereof (King Mosiah's interpretation of the things which in vision the Brother of Jared saw) said: "For they shall not go forth unto the Gentiles until the day that they shall repent of their iniquity, and become clean before the Lord." (*Ibid.*, 4:6)

"And in that day that they shall exercise faith in Me, saith the Lord, even as the Brother of Jared did, that they may become sanctified in Me, then will I manifest unto them the things which the Brother of Jared saw, even to the unfolding unto them all My revelations, saith Jesus Christ, the Son of God, the Father of the Heavens and the Earth, and all things that in them are." (*Ibid.*, 4-7) At the same time, the Lord further said: "Come unto Me, O ye Gentiles, and I will show you greater things, the knowledge which is hid up because of unbelief." (*Ibid.*, 4:13)

We can understand more fully the tragedy of the Nephites' destruction, and in it see fulfilled the words of Father Lehi: "Wherefore, I, Lehi, have obtained a promise, that inasmuch as those whom the Lord God shall bring out of Jerusalem shall keep His commandments, they shall be blessed upon the face of this land, and there shall be none to molest them, nor to take away the Land of their Inheritance; and they shall dwell safely forever. But, behold, when the time cometh that they shall dwindle in *unbelief*, after they have received so great blessings from the hand of the Lord — having a knowledge of the creation of the Earth, and all men, knowing the great and marvelous works of the Lord from the Creation of the World; having power given them to do all things by faith; having all the commandments from the

gifts of God shall be done away among you, it shall be because of unbelief.

25. And wo be unto the children of men if this be the case; for there shall be none that doeth good among you, no not one. For if there be one among you that doeth good, he shall work by the power and gifts of God.

26. And wo unto them who shall do these things away and die, for they die in their sins, and they cannot be saved in the kingdom of God; and I speak it according to the words of Christ; and I lie not.

beginning, and having been brought by His infinite goodness into this precious Land of Promise — behold, I say, if the day shall come that they will reject the Holy One of Israel, the true Messiah, their Redeemer and their God, behold, the judgments of Him that is just shall rest upon them." (II Nephi 1:9-10)

The Sacred Record shows how literally fulfilled were Lehi's words, as also it reveals that the great things which the Brother of Jared saw on the mount were made known to the Nephites at Christ's command: "And after Christ truly had showed Himself to His people, He commanded that they should be made manifest." (Ether 4:2) That is, the full record.

Moroni wrote: "I have written upon these plates the very things which the Brother of Jared saw; and there never were greater things made manifest than those which were made manifest to the Brother of Jared." (Ibid., 4:4)

The Nephites had knowledge of these things, we (Latter-day Saints) do not. Nevertheless, and in spite of our present slothfulness wherein is neglect of righteous living, we are promised that they will be made known unto us when in faithfulness we come unto the Lord. (Ibid., 4:6-7) These things which the Brother of Jared saw, were made known to the Nephites when they were righteous, after the visit to them of the Resurrected Redeemer. When the Nephites began to fall away from belief in Him, He took the record of these things from them, and commanded that it be hid up. (Ibid., 4:3) The promise of the Lord is sure. That knowledge will be given to us when our belief in Him, and our faith and our works of righteousness, are like unto the Nephites of that generation.

Remember this, God does not show forth His glory nor His might, unto the working of His works, unto men who do not believe that He is. "For if there be no faith among the children of men God can do no miracle among them. . . ." Also, "And I, Moroni . . . said . . . I know that Thou workest unto the children of men according to their faith." (Ibid., 12:29)

Wo be unto them that deny and deride the gifts of God, and therein die with that lie on their lips, for they also deny Christ unto Whom they must come or they cannot be saved. (See I Nephi 13:40)

The destruction of the Nephites also confirms Moroni's prophetic utterance. Although his words of prophecy were written by him sometime after the Nephites' tragic end we may see in them a warning to us not to let indifference and unbelief rob us of our faith in God, nor let indolence and slothfulness dim our vision wherein we see Everlasting Life and eternal rest in the Kingdom of God. Moroni's words are to us and to all mankind: "And now I speak unto all the ends of the Earth — that if the day cometh that the Power and gifts of God shall be done away among you, it shall be because of unbelief. And wo be unto the children of men if this be the case; for there shall be none that doeth good among you, no not one. For if there be one among you that doeth good, he shall work by the Power and gifts of God." (vv. 24-25) In a word, that was the Nephites' transgression. They were destroyed because of unbelief which led to all manner of iniquity.

27. And I exhort you to remember these things; for the time speedily cometh that ye shall know that I lie not, for ye shall see me at the bar of God; and the Lord God will say unto you: Did I not declare my words unto you, which were written by this man, like as one crying from the dead, yea, even as one speaking out of the dust?

28. I declare these things unto the fulfilling of the prophecies.

And behold, they shall proceed forth out of the mouth of the everlasting God; and his word shall hiss forth from generation to generation.

29. And God shall show unto you, that that which I have written is true.

30. And again I would exhort you that ye would come unto Christ, and lay hold upon every good gift, and touch not the evil gift, nor the unclean thing.

VERSES 27-34. *God shall show unto you, that that which I have written is true.* Moroni's exhortation to remember the things of which he wrote was a gentle reproof, yet a serious one, to those unto whom his words should come, for their unbelief. He urges them to keep in mind his testimony of Christ which will surely stand against them at the last day unless they receive it, and abide it. The time is fast approaching; "It speedily cometh," he says, "that ye shall know that I lie not." And as a witness at the Judgment Bar of God when the Remnant of the Lamanites shall stand before Him to be judged, with nothing under which to hide, they will be forced to admit that *the saving grace of Christ* was declared unto them by "this man, like as one crying from the dead, even as one speaking out of the dust." Moroni, by the spirit of prophecy, saw the coming forth of his words in the manner that history records of these last days. Out of the Hill Cumorah through the instrumentality of Joseph, the Seer, then to the Remnant of Moroni's brethren, came his words, thus fulfilling Moroni's prophecy herein recorded.

Moroni's words which he wrote were in fulfillment of the promise made by the Lord, which was recorded by many of the Nephite prophets, that Christ would be preached and His Gospel declared to the Lamanites of the latter days. "For they shall proceed forth out of the mouth of the everlasting God." We can understand more fully Moroni's statement when we remember the Lord's Own words concerning the words of His servants, *"For I am He Who speaketh."* (Ether 4:8-10; II Nephi 20: 39) Until the end of time, that none shall have an excuse, or as long as "there shall be one man upon the face" of the Earth "to be saved," (Moroni 7:36) the testimony of Christ which Moroni herein bears, which is the spirit of prophecy, "shall hiss forth from generation to generation." (Isaiah uses the word, *hiss*, in Chapter 5, verse 26 of the Book under his name)

Moroni again appeals to those unto whom his words shall come, that "Ye would come unto Christ, and lay hold upon every good gift, and touch not the evil gift, nor the unclean thing." (*See*, Ether 4:11-12; *unclean* — see concordance of the word listed below)

UNCLEAN—

1 Nephi	10:21	U. before the judgment-seat of God
	21	And no u. thing can dwell with God
	11:31	Diseases, and with devils, and u. spirits
	31	The devils and the u. spirits were cast
	15:34	There cannot any u. thing enter into

31. And awake, and arise from the dust, O Jerusalem; yea, and put on thy beautiful garments, O daughters of Zion; and strengthen thy stakes and enlarge thy borders forever, that thou mayest no more be confounded, that the covenants of the Eternal Father which he hath made unto thee, O house of Israel, may be fulfilled.

32. Yea, come unto Christ, and be perfected in him, and deny yourselves of all ungodliness; and if ye shall deny yourselves of all ungodliness and love God with all your might, mind and strength, then is his grace sufficient for you, that by his grace ye may be perfect in Christ; and if by the grace of God ye are perfect in Christ, ye can in nowise deny the power of God.

33. And again, if ye by the grace of God are perfect in Christ, and deny not his power, then are ye sanctified in Christ by the grace of God, through the shed-

2 Nephi	8:24	Into thee the uncircumcised and the u.
	16:5	Because I am a man of u. lips
	5	I dwell in the midst of a people of u.
Alma	5:57	Separate, and touch not their u. things
	7:21	Or anything which is u. be received in
	11:37	No. u. thing can inherit the kingdom of
	40:26	For they are u., and
	26	No u. thing can inherit the kingdom of
Helaman	8:25	Where nothing can come which is u.
3 Nephi	7:19	Did he cast out devils and u. spirits
	20:36	Come unto thee the uncircumcised and the u.
	41	Touch not that which is u.
3 Nephi	27:19	No u. thing can enter into his kingdom
Moroni	10:30	Touch not the evil gift, not the u. thing

UNCLEANNESS—

2 Nephi	9:14	Have a perfect knowledge of . . . our u.
	40	The words of truth are hard against all u.
Mormon	9:28	Strip yourselves of all u.

VERSE 31. *O Jerusalem.* Familiar with the prophecies of Isaiah, a copy of which the Nephites had upon the Brass Plates of Laban, and copies of which were widely distributed among them, Moroni herewith recorded a prayerful injunction to the members of the Church of God. He uses Isaiah's phrase, O Jerusalem, to express his beautiful hope that the earthly tabernacle of God's Kingdom should grow, and that no longer would the travails and the pains, and the perplexities of existence, hamper the enlargements "of its borders forever," or in other words, until the kingdoms of the Earth shall become the Kingdom of God. As the Kingdom of God grows in extent, and in strength, and in power, we may look forward to the continuing fulfillment of the "Covenant of the Eternal Father which He hath made unto thee, O House of Israel."

VERSES 32-33. *Yea, come unto Christ.* Take upon you the Name of Christ, and by obedience to His commands "be perfected in Him." Follow not any evil inclinations of the flesh, but "Love God with all your might, mind, and strength." Then, in His atoning blood—He doing for us that which we could not do for ourselves—

ding of the blood of Christ, which is in the covenant of the Father unto the remission of your sins, that ye become holy, without spot.

34. And now I bid unto all, farewell. I soon go to rest in the paradise of God, until my spirit and body shall again reunite, and I am brought forth triumphant through the air, to meet you before the pleasing bar of the great Jehovah, the Eternal Judge of both quick and dead. Amen.

we are made perfect in Him, if we keep the commandments He has given us. Our sins are therein forgiven, and we become perfect in Christ. We stand spotless before His Judgment Seat at the Last Day, and with the knowledge therein imparted, we "Can in nowise deny the Power of God."

VERSE 34. *And now I bid unto all, farewell.* Almost alone, with the remains all about him of what once was an enlightened people, but who had gone astray, Moroni, bereaved and destitute of all but the hope he had in Christ, solemnly bids a heartfelt *Farewell* to those of his brethren who shall live to witness God's mercy and His long-suffering. He enters calmly and even joyously upon the prospect that awaits the faithful; and rejoices therein. "I soon go to rest," he says, "in the Paradise[1] of God, until my spirit and body shall again reunite, and I am brought forth triumphant through the air, to meet you before the pleasing Bar[2] of the Great Jehovah, the Eternal Judge of both quick and dead. AMEN."

MORONI

Moroni was the son of Mormon, and the last representative of the Nephite race. He was an officer under his father and commanded a corps of ten thousand men at the battle of Cumorah. He wrote the concluding portions of the Book of Mormon, from the commencement of the 8th chapter of the book bearing his father's name to the end of the volume. This includes the book bearing his own name and his abridgment of the history of the Jaredites known to us as the Book of Ether. He takes up the history of the continent from the time of the slaughter at Cumorah and tells us (400 A.D.) that "the Lamanites are at war one with another and the face of the land is one continued round of murder and bloodshed; and no man knoweth the end of the war." And again, yet later, he writes, "Their wars are exceeding fierce among themselves, and because of their hatred they put to death every Nephite that will not deny the Christ, and I, Moroni, will not deny the Christ, wherefore I wander whithersoever I can, for the safety of mine own life." Such was the sad condition of the Lamanite race in the early part of the fifth century after Christ. There (421 A.D.) the inspired record closes; thenceforth we have nothing but uncertain tradition until the veil was withdrawn by the discovery of America.

In the course of nature Moroni died and in the Lord's due time he was resurrected.[3] The sacred records and other holy things, buried in Cumorah, still remained

[1]"And then shall it come to pass, that the spirits of those who are righteous are received into a state of happiness, which is called paradise, a state of rest, a state of peace, where they shall rest from all their troubles and from all care, and sorrow." (Alma 40:12-14; II Nephi 9:13; IV Nephi 1:14)

[2]"Finally, I bid you farewell, until I shall meet you before the pleasing Bar of God, which Bar striketh the wicked with awful dread and fear." (Jacob, Nephi's brother, shortly before dying. Jacob 6:13)

[3]Joseph Smith's answer to the question, How and where did you obtain the Book of Mormon?—Moroni, who deposited the plates (from whence the Book of Mormon was translated) in a hill in Manchester, Ontario County, New York, being *dead and raised again* therefrom, appeared unto me, and told me where they were, and gave me directions how to obtain them. I obtained them, and the Urim and Thummim with them, by the means of which I translated the plates and thus came the Book of Mormon.

in his care. On him the duty fell to watch that no unsanctified hands disturbed their rest. When the time set in the councils of heaven for their translation came he delivered them to the instrument chosen by the Holy Ones, Joseph Smith, the prophet, who, when he had accomplished his work, returned them to Moroni, who still keeps ward and watch over these treasures.

But was there any fear that the records would be disturbed by unholy hands? We believe there was. It must not be forgotten that the Lamanites of the days of Moroni were not the benighted savages of earlier centuries. They were not the pure blood of Laman and his associates. They were dissenters from the Nephites, apostates from the true church; and they were as well acquainted with the fact that the records existed as the prophet himself. In the days of Mormon he removed the plates from the hill Shim, for the very reason that he feared the Lamanites would get hold of and destroy them. There was the same reason for fear should they discover their resting place in Cumorah.

The tradition of the existence of these records remained for long ages with the Lamanites; undoubtedly growing fainter and fainter and more confused as the centuries rolled by, but still not entirely extinguished. Indeed the remembrance is not utterly obliterated in the minds of some of Lehi's children to this very day.

So strong was this recollection in earlier days, that we are told of a time when a council of wise men, with royal consent, made an attempt to rewrite them. How successful they were we have no means of telling; but this we know, that when the Spaniards conquered Mexico the land was full of sacred books. These so much resembled the Bible of the Christians that the Catholic priests came to the conclusion that it was a trick of the devil to imitate the holy scriptures, and in this way lead the souls of the Indians to perdition. In their bigoted zeal they burned every copy of these books or charts that they could find, and inflicted abominably cruel punishments upon those who were found concealing them. In this way almost every copy of these valuable works was destroyed.

Though the original records were hidden by the power of God, it is quite possible that many copies of the scriptures remained in the hands of the Lamanites when the Nephites were destroyed. In the Book of Mormon frequent reference is made to the abundance of these copies. No doubt in the last desolating wars between the Nephites and Lamanites but little care was taken of these scriptures. Both peoples had sunken deep in iniquity; they cared nothing for the word of God, and probably, as we may infer from Mormon's apprehensions, the Lamanites destroyed all the copies of the holy books that they found. Still, it is not improbable that some few of these works remained untouched; and when the Lamanites had gotten over their first overwhelming bitterness and aversion to everything Nephite, and again began to grow in civilization, they would search for these records, if for nothing else than as valued curiosities; though we think they sometimes prized them much more highly.

The plates having been guarded by the power of God, were translated by the same power. No book was ever translated more accurately; none, by human wisdom, as faultlessly as the Book of Mormon.[4]

Joseph Smith, the youth whom God honored by making him the instrument in His hands of restoring these precious records to the knowledge of mankind, was born in the town of Sharon, Windsor County, Vermont, on the 23rd of December, 1805. When about ten years of age his parents, with their family, moved to Palmyra in the State of New York, in the vicinity of which place he lived for about eleven years; the later portion of the time in a village called Manchester. Joseph helped his father on the farm, hired out at day-work, and passed his years very much after the

[4]In council with the Twelve Apostles, Joseph Smith said, I told the brethren that the Book of Mormon was the most correct of any book on earth, and the keystone of our religion, and a man would get nearer to God by abiding by its precepts, than by any other book.

manner common to young men in the rural districts. His advantages for obtaining anything beyond the rudiments of education were exceedingly small: he could read without much difficulty, write an imperfect hand, and had but a very limited understanding of arithmetic.

The circumstances attending Joseph's first vision in the early spring of 1820, when he saw the Father and the Son, have been so often published, and must necessarily be so familiar to our readers, that with this bare reference to the fact we will pass them by. It is sufficient for the purpose of our present research to know that this marvelously important event did happen. Then and there the cornerstone was laid of the vast fabric to God's glory of which Joseph was the master builder, when mortal beings alone are considered.

* * * * *

Before laying aside the pen, I want to thank my many friends who have so greatly contributed to the work of compiling this COMMENTARY. Their words of encouragement shored up my strength unto its completion. *I thank you.*

Now, a final word concerning the Sacred Record. The *Book of Mormon* has, and has had, many unfair critics, mainly among those unfamiliar with its contents, and who do not wish to be enlightened. Some say it is a pious fraud; others, it is foolishness, and still others, it is contrary to known facts. It is uncouth, they say, as also it is unlettered. It gives nothing new by which men may be raised to higher levels of goodness and purity.

That last assertion may be correct in the fullest possible sense. The Angel Moroni told the Prophet Joseph Smith that the Sacred Record contains *the Gospel of Jesus Christ in its fulness.* Which Gospel is not something new! It was preached by Adam, and all God's holy prophets since that time. It was also declared by the Apostles of old; therefore, we repeat, *"It is not new."* However, the Book of Mormon does present *as scripture* for the first time many sacred principles which have been part of the Gospel from the beginning.

That is where the Latter-day Saints stand. We do not disclaim that position, we proclaim it. The Book of Mormon affirms the Gospel of Christ, and insists that "all men must come unto Him, (Jesus Christ), or they cannot be saved."

Moreover, contrary to what its critics say, the Book of Mormon meets every honest criticism, and justifies itself before the highest tribunal in the world—*man's conscience*—that court of righteous and holy decisions. And here, the Book of Mormon stands before the world, and says: "These are proofs of my origin, these are witnesses to my greatness and my immortality.

—P. C. R.

INDEX

They are made immune to death and disaster, 223
29.—Mormon's warning to those who spurn the words and works of the Lord, 230
30.—Mormon calls the Gentiles to repentance, 240

FOURTH NEPHI—The church of Christ flourishes—Nephites and Lamanites converted—They have all things in common—Two centuries of righteousness followed by division and degeneracy—Amos and Ammaron in turn keep the records, 245

Chapter 1.—THE BOOK OF MORMON —Ammaron's charge to Mormon respecting the sacred engravings—War and wickedness —The three Nephite disciples depart—Mormon restrained from preaching—Predictions of Abinadi and Samuel the Lamanite fulfilled, 253

2.—Mormon leads the Nephite armies—More of the Gadianton robbers—By treaty the land northward is given to the Nephites, and the land southward to the Lamanites, 258

3.—Nephites continue in wickedness—Mormon refuses to be their military leader —His address to future generations—The twelve to judge the house of Israel, 263

4.—Nephites begin a war of revenge upon Lamanites—Nephites no longer prevail—The sacred record taken from the hill Shim, 268

5.—Mormon relents and again leads Nephites—Lamanites outnumber Nephites—Crime and carnage—Mormon's abridgment of the records, 273

6.—The hill Cumorah and its records—The final struggle between the two nations —Lamanites victorious—Twenty-four Nephites survive, 278

7.—Mormon affirms to Lamanites that they are of Israel—Admonishes them for their salvation, 283

8.—Moroni finishes his father's record—After carnage of Cumorah—Mormon among the slain—Lamanites and robbers possess the land—Mormon's record to come out of the earth—Conditions and calamities of latter days depicted, 288

9.—Moroni's address to unbelievers—His testimony concerning the Christ—The Nephite language known as reformed Egyptian, 304

Chapter 1.—THE BOOK OF MORONI —Moroni's desolate state—He writes, hoping for the welfare of the Lamanites, 322

2.—Concerning the bestowal of the Holy Ghost by the Nephite twelve, 325

3.—Concerning the ordination of priests and teachers, 327
4.—Mode of administering the sacramental bread, 329
5.—Mode of administering the sacramental wine, 329
6.—Conditions and mode of baptism—Church discipline, 331
7.—Moroni presents Mormon's teachings on faith, hope, charity, 334
8.—Mormon's epistle to Moroni—Little children have no need of repentance or baptism, 350
9.—The second epistle of Mormon to his son, Moroni—Atrocities committed by Lamanites and Nephites—A father's last and affectionate admonition, 357
10.—Moroni's farewell to the Lamanites —Conditions on which individual testimony to the truth of the Book of Mormon may be obtained—Moroni seals up the record of his people, 362

Chariots, of Nephites, 61
of Gentiles to be destroyed, 195
Charity, Faith, hope, and, Mormon on, 344
Chastity, precious above all things, 358
Chickens, as a hen gathers her, 121-122
Chief Judges, those who were angry were chiefly the Chief Judges, 87
Chiefs, over tribes, 89, 91
Child, type of humility, 142
Mormon, a sober, 253
the Holy, 350
Childlike, Why, 142
Children, brought to Christ, 173
blessed by Christ, a wonderful scene, 174
ministered to by angels, 174
speak marvelous things, 209
and women, sacrificed to idols, 270-272
baptism of, a mockery before God, 351
saved by Atonement of Christ, 353
little, alive in Christ, 352-354
Christ, ministry of, among the Nephites, 137ff
Christ, Names of, by Nephi, son of Helaman, 93
by Moses, 190
time of coming, predicted, 47
time reckoned from coming of, 54
not manifest personally unto Gentiles, 162ff
Church to be called in Name of, 214
Titles of,
Redeemer, 351
Son of Righteousness, 206
Father and Son, 307
Author and Finisher of faith, 332
Signs, of His first advent, 45
fulfilled, 49
destruction at time of His death, 97
lifted up on the cross, 216

Contrite, spirit and broken heart, an acceptable offering in place of Mosaic sacrifices, 119, 149
Converts, many made by sign of Christ's birth, 55
Countenance, of Jesus, 183
Covenant, of evil, 88
not all fulfilled by Christ at that time, 161
to be fulfilled in Last Days, 193-194
the, is already beginning to be fulfilled, 230
Cracks, in earth, 98
Created, the things God hath, marvelous in your eyes, are not, 308
Creature, every, Gospel for, 310
Cross, of Crucifixion, Christ speaks of, 216
Crucifixion, affirmed by Christ, 139-140
Cumorah, Hill, named by Nephites, 278
Mormon hides Records in, 279
scene of final battle between Nephites and Lamanites, 288
called Ramah by Jaredites, See, Ether 15:11
Cunning, of the devil, 194
Cup, Sacramental, 177
Cures, miraculous, 209-210
Curse, on the land, 62ff
of Adam taken from children, 351
Custom, of appointing gifted leaders, 60
Cyrus, the Mighty Prince of Persia, 79

— D —

Damnation, resurrection of, 208
for corruptors of Word, 299-300
Dark, and loathesome people, the Lamanites, 276
Darkness, no, for two days and a night, 48
three days of, 98
disperses, 122
deeds of, 86
upon face of the land, 98
Day, of the Lord, great and dreadful, 206
Day, the, cometh that shall burn as an over, 206
Days, three, of darkness, 98
Defiance, of law, 88
Delightsome, people, 246
Den, of wild beasts, three Disciples cast into, 225
Denieth, he that, these things, knoweth not the Gospel of Jesus Christ, 306
Deny, who can, His sayings, 310
Depravity, of Nephites, 359
Destruction, great and terrible, 98
Disciples, Christ calls and commissions His, 140
names given, 181
baptized, 182
the Holy Ghost given to the, 182
given authority to give the Holy Ghost, 179
work of, 210

each of the Twelve granted his wish, 223
three elect to remain on earth until the Lord shall come in His glory, 223
to be judged by the Apostles Christ chose at Ancient Jerusalem, 266
Three Disciples depart from midst of Nephites, 255
Three Disciples seen by Mormon and Moroni, 226, 290
Disciple, of Christ, Mormon, a, 74
Disputations, forbidden by Jesus Christ, 140, 213
Division, into tribes, 89
between Church and unbelievers, 249
Divorcement, condemned by Christ, save for fornication, 150
Dust, Records shall speak from the, 365
Dwindling, in unbelief, distinguished from wilfull rebellion, 250
causes cessation of miracles, 310

— E —

Egyptian, Reformed, Nephite language known as, 311
Elijah, and his mission, 206-207
Engravings, on the Plates, characters used in the, 311
Epistle, Giddianhi to Lachoneus, 57
Lamanite King to Mormon, 264
Mormon to Lamanite King, 278
Mormon to his son, Moroni, (first) 350
Mormon to his son, Moroni, (second) 357
Error, infant baptism, a gross, 351
Eternal Father, proclaims the Christ, 137
Sacramental prayers addressed to, 329-330
covenants of, with Israel, 368
Eternal Life, hope for, 347
Eternity, God unchangeable throughout, 353
Evil, comes from the devil, 338
Exhortation, Moroni's final, 362
Eye, of faith
is light of body, 155
mote in brother's, 157
change in twinkling of an, 224
single to the glory of God, 291
Eyes, of blind opened, 209
Ezekiel's, prophecy concerning Land of Israel's inheritance, 78

— F —

Faith, protects, 156
a power in righteous living, 94
hope and charity, 334
Fall, of Man, explained by Mormon, 307
Families, prayer in, enjoined, 178
Fasting, 154
Father, of contention, the devil, 141
and Son, 141
Our, Who art in Heaven, 154

Faults, if there be, they be the, of men, 294
Feet, of Christ, men worship at the, 173
 prints of nails in, 139
Field, lilies of the, 156
Figs, not gathered from thistles, 158
Filthiness, moral, 305
Final, struggle between Nephites and Lamanites, 279
 Lamanites, successful in, 279
Finger, of Christ, touches Disciples with, 224
Fire, in danger of hell, 150
 little children encircled by, 174-175
 like a refiner's, 202
 Nephite Disciples, cast into, 249
 baptism of, 119, 147
Fires, great, attest the Savior's Crucifixion, 97
Flesh and Blood, of Christ, how administered, 327-328
Flight, of Jacob, 91
 of Mormon, 274
Fold, yet another, to hear Christ, 162, 164, 165
 other sheep not of this, 162
Followers, of Christ, 332, 346-347
Food, kept from Robbers, 66
 no chance for Robbers to get, 65
Fool, calling brother, forbidden, 150
Forgive us our debts, as we forgive our debtors, 154
Forgiveness, granted as often as sought, 331
Form, of godliness, 344
Fornication, sole justification for divorce, 150
Fornications, of Angola, insufficient, 258
Foundation, sandy, (figurative), 143
Fountain, a bitter, cannot bring forth good water, 335-336
Fragments, of rock, broken into at time of Savior's Crucifixion, 98
Freedom, defended against Gadianton Robbers, 55
Fruits, of repentance, 353
Fruits, men known by their, 158
Fulness, of the Gospel, 191
 of the Gentiles, 165
 of Joy, 222, 224
Furnace, Three Disciples, cast into, of fire, 225, 249
Fury, to be executed, 195

— G —

Gad, City of, 101
Gadiandi, City of, 99
Gadianton, Robbers, 49
 re-established in mountains, 49
 among Lamanites, 49
 become numerous, 55
 gain advantage over Nephites, 56
 land northward, given to, by treaty, 262
Gadiomnah, City of, 99
Gain, churches built for, 248

Plates not to be used for, 291
Gall, of bitterness, wicked in, 299
Game, none found, in lands deserted by Nephites, 65
 scarcity of, hinders Robbers, 68
Gate, to Kingdom of God, 158, 222
Gates, of hell, 142, 177
Gathering of Israel, 165, 193
Gay, Padre, statement of, concerning gold plates, 318
Generations, four after the birth of Christ, 222
 three, from the time of Christ, pass away in righteousness, I Nephi 12:11
 prophecies, concerning future, 208
Gentiles, a marvelous work among, 227
 the Three Disciples among, 226
 to bring forth book, 285
 Gospel to come through, 193
 prayed for by Moroni, (See, Ether 12:36)
 written to by Mormon, 266
 glorious destiny of the repentant, 165
 blessed are the, 165
 Hearken, O ye, and hear the words of Jesus Christ, 240
Giddianhi, writes to Lachoneus, 57
 hideous appearance of soldiers of, 66
 people of, slaughtered, 67
 beaten, 67
 slain and his successor hanged, 67
 biographical notes, 61
Gidgiddoni, Chief Captain of Nephite Armies, 60
 a prophet, great and marvelous were the words of, 83
 defeats Gadianton Robbers, 67
 establishes peace, 83
 biographical notes, 63
Gift, lay hold on the good, touch not the evil, 365
 every good, cometh from Christ, 362
 the heavenly, 245
Gifts, varied manifestations of, 361
 taken from among people because of unbelief, 310
Gimgimno, City of, 100
Giving and lending, 151
Glory, the Son of God to come in great, 208
 rendered unto Jesus at His visitation to Nephites, 189
God, then will ye say that there is no, 304
God, of miracles, 308
 unchangeable, 351
Gold plates, statement of Padre Gay, concerning, 318
Golden Rule, The, 158
Good, inspired of God, 335-336
Gospel, Church built upon, 215
 denied by those who do not know it (the Gospel), 306

prophecy of Christ, actually fulfilled, 201, 256, 260
the prophet of Israel, mentioned by the Savior, 190
Sanctification, result of penitence and obedience, 366-367
Satan, hath great power among the people, 85
Scriptures, other, 200
Sermon, on the Mount, retold, 147ff
Servant, of the devil, 337
Sheaves, Lord's people to be gather as, 190
Sheep, of other folds, of Christ, 162, 164
Sheep of another fold, spoken of to the Jews, 162, 164
Shem, Land of, 261
Shemnon, one of Christ's Disciples, 181
Shim, the Hill, Sacred Record taken from, 272
where Ammaron deposited the Sacred Things, 253
Show, unto me, or ye shall be smitten, 294
Siege of Robbers against the People of Nephi, 67
Signs, of the Savior's birth appear, 47, 96, 98
predicted, attest Savior's Crucifixion, 96
of the Father's work, 193
Silence, in the Land for many hours, 121
Sins, of the world, Jesus Christ slain for, 139
Sjodahl, Janne M., 5
Skins, of righteous Lamanites became white, 56
Society, of the Robbers, secret, 58
Son of God, must appear, they began to know that the, shortly, 47-48
Soothsayers, condemned, 195
Sorceries, 256
Speak, I, unto you as if ye were present, 302
Spurneth, wo unto him that, at the doings of the Lord, 233
Star, new, predicted as sign of Christ's birth, appears, 48
Sting, of death, 284
Storm, there was or arose a great, 97
Synagogues, hypocrites in, 153

— T —

Teachers, ordination of, 325
Teachings, of Jesus, not a hundredth part written, 208
Tempest, at time of Christ's death, 97
Temple, crowd of people assembled near, at time of Christ's appearance, 138
Temptation, admonishment to avoid, 154, 177
lead us not into, 154
Testified, many of those who, were secretly put to death, 87
Testimony, conditions upon which an individual, may be obtained, 360
of three, concerning the Nephite Record, (See, Ether 5)

Thanks, to be given to God, 122ff
Thine, For, is the Kingdom, and the power, and the glory, forever, 154
Things, all, are written by the Father, 220
men to be judged by the, written in the books, 220
Three Disciples elect to remain on the Earth until the Lord comes in His glory, 223
never to taste of death, 226
minister among Nephites, 225
taken from among people because of wickedness, 255
minister to Mormon and Moroni, 290
transfiguration of, 224
Thunder, at death of Christ, 97
Time, reckoning of, Nephite, changed after Christ's birth, 54
Timothy, brother of Nephi, raised from the dead, 181
one of Christ's Disciples, 181
Tithes, and offerings, Malachi's words concerning, given to the Nephites, (Compare Malachi 3) 202
the Lord robbed of, 204
Tribes, of Israel, word of God, to, 162
Nephites separate into, 162
united against King Jacob, 91
agree not to fight each other, 91
the Lost, 162, 196

— U —

Unbelief, miracles cease because of, 310
Unbelieving, O then ye, turn unto the Lord, 305
Unchangeable, Being, an, 309
Unite, people, for defense against robbers, 55
Unworthily, not to eat and drink sacrament, 178

— V —

Variableness, no, in God, 306
Vengeance, of God, blood of Saints, to cry for, 195
sword of, 303
Vessels, of the Lord, be ye clean that bear the, of the Lord, 192
the Lord's, called chosen, 342-343
Virtue, dear above all things, 356
Visage, of the Lord's Servant, was marred, 192
Voice, of the Lord to the people, following the Crucifixion, 100
again the, from Heaven, 121
of the Father, proclaiming the Christ, 138

— W —

War, and wickedness, 254
War, as recorded by Mormon, 254
Wars, final between Nephites and Lamanites, 279